Design and Expression
in the Visual Arts

John F. A. Taylor

"If you have any music that may not be heard, to 't again."

Othello, III, i

Dover Publications, Inc., New York

Published in Canada by General Publishing Com-
pany, Ltd., 30 Lesmill Road, Don Mills, Toronto,
Ontario.
Published in the United Kingdom by Constable
and Company, Ltd., 10 Orange Street, London WC 2.

Design and Expression in the Visual Arts is a new
work, first published by Dover Publications, Inc.,
in 1964.

International Standard Book Number: 0-486-21195-9
Library of Congress Catalog Card Number: 63-19502

Manufactured in the United States of America
Dover Publications, Inc.
180 Varick Street
New York, N.Y. 10014

to Elizabeth Frost Taylor

Preface

A century ago there was still room for the conception of the artist as a liberating spirit who performed the protestant act for his generation. Today the voice of protest is almost unheard in the universal priesthood of all believers.

In every season of the human story the inheritance of tradition is a problem. A waking generation treats that problem as an occasion for self-renewal. For it is the universal tendency of all human institutions, even of institutions conceived in protest, to congeal, to harden into stereotypes, to vacate their functions, so that the experience which they once quickened dies within them. Ideally, a man, as he grows old, grows wiser. The forms he lives by do not. They remain steadfastly as they were, sufficient only to him who knows what is at stake in affirming them. That is why human institutions die, not because their forms have altered, but because men have in dumb fatigue forgotten their use and meaning. Their meaning, all meaning that they did ever have, lay solely in their being an answer to challenges. They suffice to those who know still their challenges, or can bring themselves to know them. To men ignorant of their challenges they must appear a poor patrimony, a pale empty inheritance in which one reads, for want either of sympathy or of imagination, the Book of the Dead.

Such was the circumstance of art which, now a century ago, men protested against and saw need to mend. They saw themselves committed to an empty repetition of forms which no longer held the quick content of their lives. The fault, as some of them had the wit to know, was not in the inheritance. The fault was in the error of supposing that it could be inherited passively, simply repeated in a ritual act, ceremonially, without thought of its relevance or care for the self-respect which had generated it. Therefore, in the frankest reaffirmation of the authentic spirit of the tradition, out of belief invincible in themselves, they set upon a reformation of it.

The real peril of a reformation is never with the reformers. The real peril is with those who inherit immediately from them. For the second generation, and still more the third, must experience a perplexity which the first was not required to face. They must decide the fateful question what to do with their freedom. They must decide what freedom is for, what they are for. What they are against the former generation has already well enough defined. Nothing is so perfectly deranging to revolutionaries as to discover all the idols broken, for when there are no idols left to break, they are constrained then to look no longer outward on things, but inward on themselves. The old covenant has been destroyed; a new covenant is still to make; and men look upon the abyss of indifferency which must confront them, as it must confront all men, who permit themselves, in a naked arrest, to see the tasks of freedom. For freedom is a task of the living, not a luxury of the indolent or a dispensation of the dead. The one thing which men can least endure is to live without covenant, without relation, without community, without affirmation or loyalty, in the passive sufferance of raindrop and of stone.

This work is an essay, not a book. Properly, it is a preface only, a preface to the visual arts, incomplete as all prefaces are incomplete which aspire to mark a path but not to traverse it farther than to show its importance. I regard the undertaking of an essay in the theory of the visual arts as in our day profoundly necessary, necessary exactly in the measure that these arts are prized, and most necessary for those who prize them most. In more settled hours, when men's directions are stably grounded, theory is a dispensable commodity. For men then live, as they should always aspire to live, in the exercise of their free spontaneity. What need for reflection if the simple living be an unpremeditated joy and celebration of our wholeness? But in unsettled hours, when men are vexed by the conflicts of all their institutions and by an indecision concerning the path of art, the absence of theory will paralyze their acts. For then it becomes necessary to understand, just because we float in a sea of change, that the sea itself does not change. Beneath every tempest that whips the surface of the sea the sea-floor preserves still its steadfast contour, a shape so fundamental as to defy time and to blunt erosion. The effect of the manifold collisions of tendency in our day has been to obscure the fundamental unity of art new and old, to efface the essential community which artists of all times share.

In every domain of human activity the sense of the human community is capable of recession. In our day it recedes. In such a season there can be no act so indispensable as to recall that there are constancies in every domain which novelty may blur but is forbidden ever to repeal.

Such constancies are the topic of this essay. The essay is not therefore a history: it is but a method of appropriating history, of seizing the image of man fixed by our time or by another, out of the forms that convey it. The essay is not a practice of invention: it is an exploration of the terms of design which permit invention to be practiced. The essay affords no program for partisans: it traverses only the neutral ground upon which all partisanships at last are exercised. Its singular claim to virtue must be, to have provided for the visual arts the counterpart of theory which musicians command, and have long since learned to value rightly, for their art. To study music with any seriousness, it is essential to understand the conditions of musical expression—a musician's terms, the structure of his scales, the forms upon which he realizes his compositions. The same demand, as every master craftsman knows, presides over the conduct of any serious study of the visual arts. But that demand, though it is everywhere insistently felt, is nowhere met. This essay seeks to meet it. It is a simple beginning which addresses itself to a living need. Its success may therefore be plainly measured. For if it succeeds, it will have shown the identity of impulse in all art—in new art an old commonwealth, and even in old art the new one.

J. F. A. T.

East Lansing
June, 1963

The quotation on page 80 from Gerard Manley Hopkins' "God's Grandeur" is reprinted with the permission of the Oxford University Press. The quotation on page 128 from Wallace Stevens' "Peter Quince at the Clavier" is reprinted from *The Collected Poems of Wallace Stevens* with the permission of the publisher, Alfred A. Knopf, Inc.

Table of Contents

page

CHAPTER I. IN SEARCH OF HIS OWN IMAGE
1. The Nature of a Principle 1
2. The Production of Forms 6
3. The Image of Man: Art and Self-Knowledge 7

CHAPTER II. THE PICTORIAL FIELD
4. Of Titles and Enclosures 10
5. Transforming Contrasts and the Constancies of the Field 12
6. The Implication of the Spectator 13
7. The Shape of the Field: Regularity and Simplicity 17
8. The Shape of the Field: Visual Stability 19
9. Cognate Axes 22

CHAPTER III. ELEMENTS OF EQUILIBRIUM
10. Equilibrium 26
11. Axes 28
12. Positive and Negative Areas 30
13. The Vertical Axis 35
14. The Horizontal Axis 39
15. Static Equilibrium: Symmetry 40
16. Dynamic Equilibrium: Asymmetry 42
17. Asymmetry on a Static Axis: Perugino's *Mystical Crucifixion* 48
18. Directional Motives: Mondrian's *Composition in White, Black and Red* 50
19. Thrust and Counterthrust 58
20. Leonardo da Vinci's *Last Supper* 63

CHAPTER IV. PATTERN AND RHYTHM
21. Liberty under Law 68
22. Pattern 69
23. The Affinity of Forms 74
24. Quality and Quantity 78
25. Rhythm 80

26. Percussive and Continuous Forms 83
27. Frequency, Intensity, Inversion, Ambiguity: El Greco's *View of Toledo* 87
28. Emergent Qualities: Rembrandt's *Raising of Lazarus* 95
29. Cyclical and Intrinsic Rhythm 100
30. Objective Wholeness 106
31. "The Verticality of the Gothic": *Amiens Cathedral* 111
32. Progression and Regression: Bernini's *Apollo and Daphne* and the *Processional Frieze of the Parthenon* 119
33. Theme and Variation: Poussin's *Amalthea* and Seurat's *Sunday Afternoon on the Grande-Jatte* 128

CHAPTER V. COLOR
34. Physical Light and Sensed Light 139
35. White Light and the Spectral Colors 143
36. The Constancies of the Field 146
37. Hue, Saturation, and Value 150

CHAPTER VI. THE ORDERING OF SILENCE
38. Scale and Consonance: Toulouse-Lautrec's *At the Moulin Rouge* 159
39. Complementaries: Additive and Subtractive Effects 168
40. The Principle of Simultaneous Contrast 177
41. Color in Equilibrium: Goya's *Execution of the 3rd of May, 1808* 187
42. Abstraction and Representation in the Visual Arts: Degas' *Absinthe Drinkers* 192
43. Values 199
44. The Vision of Dignity and the Dignity of Vision: Rembrandt van Rijn 212

CHAPTER VII. THE CONTEMPORARY ENCOUNTER
45. The Image of the Mirrorer 219
46. The Illusion of Primitivism in Contemporary Art 227
47. The Primacy of the Mode of Encounter 230
48. The New Daedalus 238

INDEX 241

List of Plates

		page
1.	Perugino, *Christ Giving the Keys to Peter*	31
2.	Henri Matisse, *The Dance*	34
3.	Käthe Kollwitz, *Mother with Dead Child*	37
4.	Raphael, *School of Athens*	41
5.	Ernst Barlach, *Beggar*	43
6.	Perugino, *Mystical Crucifixion*	51
7.	Piet Mondrian, *Composition in White, Black and Red*	56
8.	Michelangelo Buonarroti, *The Temptation and the Fall of Man*	59
9.	John Marin, *Lower Manhattan*	62
10.	Leonardo da Vinci, *Last Supper*	64
11.	Iktinos and Kallikrates, *Parthenon*	73
12.	Pier Luigi Nervi, *Stadium*	75
13.	Harrison, Abramovitz, and Associates, *United Nations Secretariat Building*	85
14.	Tintoretto, *Last Supper*	86
15.	El Greco, *Resurrection*	88
16.	Georges Seurat, *The Circus*	89
17.	Peter Paul Rubens, *Rape of the Daughters of Leucippus*	91
18.	Pablo Picasso, *Ma Jolie*	92
19.	Alexander Archipenko, *Woman Combing Her Hair*	94
20.	Giotto di Bondone, *Lamentation*	96
21.	Takumi Shinagawa, *Yellow and Purple*	98
22.	El Greco, *View of Toledo*	99
23.	Rembrandt van Rijn, *Raising of Lazarus*	101
24.	*Lapith and Centaur*, Metopes, *Parthenon*	103
25.	*Amiens Cathedral*, Elevation, West Façade	112
26.	*Amiens Cathedral*, Elevation, Southwest	114
27.	*Amiens Cathedral*, Elevation, Interior	116
28.	George Howe and William Lescaze, *Philadelphia Savings Fund Society Building*	118
29.	Gian Lorenzo Bernini, *Apollo and Daphne*	122
30.	Constantin Brancusi, *Bird in Space*	124
31.	Pheidias, *Processional Frieze of the Parthenon*	126

32. Henry Moore, *Reclining Figure* (1935) 131
33. Frank Lloyd Wright, *Kaufmann House* 132
34. Nicolas Poussin, *The Infant Jupiter Nursed by Amalthea* 134
35. Henri de Toulouse-Lautrec, *Woman Fixing Her Stocking* 136
36. Georges Seurat, *Sunday Afternoon on the Grande-Jatte* 138
37. Paul Cézanne, *Mont Sainte-Victoire* (1885–1887) 148
38. Leonardo da Vinci, *Madonna and St. Anne* 155
39. Goya, *Saturn Devouring His Children* 156
40. Edvard Munch, *The Cry* 157
41. Pablo Picasso, *The Old Guitarist* 158
42. Henri de Toulouse-Lautrec, *At the Moulin Rouge* 166
43. Claude Monet, *Waterloo Bridge, Gray Day* 175
A. Simultaneous Contrast: Grays *following* 182
B. Simultaneous Contrast: Positive Hues *following* 182
44. Goya, *Execution of the 3rd of May, 1808* 188
45. Edgar Hilaire Degas, *Absinthe Drinkers* 198
46. Albrecht Dürer, *Erasmus of Rotterdam* 201
47. Pablo Picasso, *The Pipes of Pan* 202
48. Käthe Kollwitz, *The Widow, II* 203
49. Diego Velásquez, *The Weavers* 209
50. Jan Vermeer, *Young Woman with a Water Jug* 211
C. Simultaneous Contrast: Adjacent Hues *following* 214
D. Equilibrium of Color *following* 214
E. Equilibrium of Color *following* 214
51. Rembrandt van Rijn, *Hendrickje Stoffels* 215
52. Rembrandt van Rijn, *Self-Portrait* 217
53. Henry Moore, *Reclining Figure* (1938) 225
54. Vincent Van Gogh, *Starry Night* 226
55. Paul Gauguin, *The Yellow Calvary* 229
56. Paul Cézanne, *Self-Portrait* 234
57. Paul Cézanne, *Still-Life* 236
58. Paul Cézanne, *Mont Sainte-Victoire* (c. 1905) 237
59. Georges Mathieu, *Montjoie Saint Denis!* 239

I. In Search of His Own Image

1. The Nature of a Principle

In the plummeting of a pebble to the bottom of a pond, in the rising of a bubble to its surface, a scientific intelligence will find an illustration of one and the same principle. The visible phenomena are as unlike as can be—the upward movement of a bubble, the downward movement of a stone. They nevertheless exhibit the operation in nature of a common principle, the principle of displacement, that heavier bodies will in gravitating displace the lighter ones. In the one instance the pebble displaces the water, and the pebble sinks; in the other instance the water displaces the air, and the bubble rises.

A science of nature will interest itself in that principle, and will be interested in the visible phenomena only so far as they illustrate that principle. The appearances change; the principle which underlies the appearances remains one and constant. Therefore, if a man would gain knowledge of nature, he must look beyond the changes which riot on its surface. He must penetrate to the principle, which remains the same on all occasions.

That reflection is a very old one. It is as old as Socrates, and wherever men cultivate it, they resurrect his genius among themselves. For it is one of the few reflections which men in the Western tradition have found inexhaustibly rich. It is, I suppose, more than any other single insight, the profound source of that tradition, the thing that makes it Western. To meditate anything seriously, whether in nature or in human affairs, is to look for the principle of that thing, for unless the principle is understood, the thing cannot be understood.

Therefore, as men would gain understanding of themselves, there can be no avenue of human life or of the human enterprise in which

they can afford to leave principles unbared. The sense of the human enterprise is always precarious. Its precariousness is measured, as Socrates perceived, by men's ignorance, by their ignorance of what they want and of what at last they are about. Did not Socrates himself banish poets from the immaculate precinct of his ideal Republic? He crowned them with laurels and bade them farewell: an entirely American act of tolerance, except for this difference, that we leave them uncrowned and neglected in our presence. But, for the rest, the fault in him and in us is at root the same, that the function of art in the life of a people has been misconceived. The place of the arts in a Republic is equally imperilled whether they are unloved or are loved for wrong reasons, and I have never been persuaded that Socrates' poets would have been better off, or less vicitimized by circumstance, had he permitted them to remain and encouraged admiration of them on his terms.

Art can enact its function only on its own terms. To impose upon it terms which are alien to its performance is to kill it and to cancel its performance. That is why, in the modern predicament, the buried principles of art must be uncovered. Society alone is competent to decide the uses to which art shall be committed. But when society's decision has been taken, it must be content to be instructed concerning the terms of executing that commission. What society accepts and what it rejects, it accepts or rejects unashamedly as it sees its good, and this vision of its good is the severe condition of the practice of art in all societies, in all places and all seasons. The education of taste affords a palliative, but no remedy. For society, as it defines commissions, will always stipulate the conditions of service to itself. What society will treat as a solution cannot, therefore, be decided on the principles of art; but what constitutes an artistic solution can be decided only on the principles of art.

In art, as in all matters which affect the civilization of men, the timeliness of men's acts is determined by historical conditions. An act may answer to the demands of a historical situation, or it may not. If it answers, it shapes the character of men's lives, enlarges their purview, adds a new dimension to the experience they are capable of; if it does not, it leaves their lives untouched, as if it had been, and had been intended only to be, a simple revery. Men who labor as artists labor, solitarily, out of private surmise, discover an inhumane fatality in this. For it signifies that on occasion even the most flawless power of expression may find itself, in the irony of its

situation, unnoticed and unattended to, producing a meaning out of season, like a plant whose perfect bud has opened either too late or too soon, and therefore withers improvident, since the conditions of the season will not support it.

The art of Rembrandt may speak to our century, but never for it. Let Rembrandt paint those same portraits in the twentieth century, men would, I suspect, ignore his art, though its power were, now as then, unassailable. In the seventeenth-century artist they are prepared in humility to see the man in the Dutchman. In an artist of their own century they demand that he show them, prophetically, the man in themselves. Rembrandt's partisanship is wider than Holland. Holland's was nevertheless the first endorsement that he sought. The twentieth century would demand of him only as much, that it too count for something, that he work out of its special sufferance and first of all for its sake. The fault of the performance which should perfectly duplicate the portraits of Rembrandt in the twentieth century is not a fault of art, but of relevance. The act performed is not the relevant act, the act germane to this historical occasion, which commands spontaneous assent because men find in it a new and unimagined power in themselves, and share the illusion of having performed it, unassisted, out of the secrecy of their souls.

Art is always, in any epoch, thus prophetic, for men of its times an anticipation of what they experience inwardly and inarticulately in their dumb sense of being and rectitude. They greet it as the seventeenth century greeted Rembrandt, who produced for Holland the responsive echo of its own most intimate awareness of itself.

To strike that echo and reverberation is the labor of every artist in the life of any people, and where that echo has been struck, it is the one permanent value which immemorially has caused art to be prized. Men so value it for the reason that it supplies to them the terms of expression in which their own image may be identified.

It is a mistake to suppose that we now command, or shall ever command, principles which can assure that value to an artist's performance. He works, as the statesman, the philosopher and the saint work, at last as all creative men of whatever calling work, in finitude and separateness. He is competent to govern only his own act, that it shall bear the little truth he has. But he is powerless to arbitrate whether society beyond him shall prize that truth, or see in it the distillation of its own awareness, in which its thought and feeling are mirrored equally, so that it takes his image for its own.

Nor will the principles of art suffice to confer upon him that power. The historical conditions which call art forth are not the technical conditions of its coming forth, and to understand those technical conditions is to leave still unresolved the problem of relevance, the historical and profoundly creative problem which vexes, and must always vex, the solitude of every artist in civilizing the imagination of mankind.

Why do these technical conditions deserve nevertheless to be reflected on? Because, beneath all vicissitude, beneath all the transformations of thought and feeling among men, the fundamental conditions of expression in any art remain fixed and constant. An artist must speak in the terms of his art if he would speak at all, and must be understood in the terms of his art if he would be understood at all. The technical conditions of an art are simply the conditions of expression in it. To know them is not equivalent to understanding what makes art Classical or Byzantine, Gothic or Baroque; but to be ignorant of them is to be denied admission to any of these, to be ignorant of the foundations of all alike. A stream fed by no tributaries is a dry bed; yet only on a common bed does any tributary reach the sea.

In an old phrasing the arts of expression used to be described as "liberal arts," the arts which liberate, which draw forth and set free the powers that lie hidden in our buried lives. We preserve the same sense in considering them together as "humanities" (*studia humanitatis, studia humaniora*), marking by this description their educative virtue, which is permanent and ineffaceable, even when those who fashioned them are dead. They range before us all of the discovered possibilities of the human type, all of the resilient alternatives which waking men have freely embraced and thought sufficient to life and conduct. For one who has the eye to see it, the same transformations of thought and feeling may be read in codes of law and dispensations of religion, in systems of science and patterns of economy, but never with the same immediacy as in these free essays of expression. Once, in dejection, Coleridge wrote:

> I may not hope from outward forms to win
> The passion and the life, whose fountains are within.

Yet is not that what he and all like him equally have done, implanted into outward forms the passion and the life, whose fountains are within? "Dead things with inbreathed sense able to

pierce," John Milton called these arts, nor can the definition, though he spoke in a poem, be improved. For that, surely, is the essential humanity of the arts. Only the relic things, the sticks and stones of art, are dead; their sense is resurrected. These forms are capable of being reanimated in ourselves, and their sense resumed, in our living act, like those tongues of flame at Pentecost, which lick the spirit into life in a new creation. They pierce, their cognate sense is attended to, and there can be no question that they command respect because their sense is felt still to be in some measure relevant, humane, responsive to what we are, never like ordinary sticks and stones perfectly alien to us. One is therefore obliged to ask how it should ever come to pass that in these dead things a sense should be present, to ask how, in Milton's phrase, sense can be breathed into them or breathed out of them.

The conditions under which sense is made sharable are the one part of art, considered as an objective phenomenon, which men can profess to master in terms of principle.

When an artist works in visual terms, he constitutes a visual whole. The parts of that whole stand to each other in a relation of complementarity. They form not merely an aggregate, but an organization, in which the several members are mutually implicated in each other. All are necessary, none is dispensable, for the meaning of each is seen to reside in the relations which bind it to those others. That complementarity of parts is what men understand when they speak of the "inevitableness" of a work of art: to take from it any part or to add to it any part is to destroy the distinctive kind of equilibrium which it has.

Complementarity is a principle of art. It is but one such principle. But it is the sovereign one, the principle which underlies the essential integrity of any work of art. It is so perfectly fundamental that all other principles are but alternative ways of realizing it. Its singularity is, that it belongs to no one style, since it belongs to every style whatever. In any exclusive sense it is neither Classical nor Romantic, neither Renaissance nor Baroque nor Rococo, neither Greek nor Italian nor French nor American. For it will be found to hold for all of these alike. It is to works of art what displacement is, in the physical world, to bubbles and stones.

2. The Production of Forms

If out of nothing God created all things, that at all events is not the condition of man's creative activity. All that man does, all that he can ever do, is to bring together things which he finds already in nature.

In the making of a garden a man does but bring together soil and seed, and set each to a work which each was already fitted to perform before his act took place. The seed does not receive from him its capacity for growth; the soil does not receive from him its capacity to sustain growth. His act of gardening is simply an act of combination, drawing together capacities in things which are by nature fitted to complement each other. The combination alone is his; the elements combined are inevitably borrowed. They belonged to nature before his act, and belong still to nature after his act. The result of their combination would equally have ensued, had they been combined by an accidental gust of wind. They would have retained equally their fitness for combination, had their combination not in fact occurred—had seed remained still stored in pod, and soil unturned and fallow.

All human art is an art of combination. It is form-producing, not thing-producing. Its elements are given. It simply assembles, organizes these elements, introduces among them a pattern of its own, so that what actually art creates is not things, but only the forms of things.

In the measure that the elements of a constructive activity are given, in the measure that they have their own properties which render them fit for this combination and unfit for that, all art is an art of accommodation, an essay in finding those forms which are suited to the nature of materials.

The interest which attaches to forms evidently extends beyond those conditions which the nature of materials will dictate. But it can have no extension apart from those conditions. There is no art of combining snow and fire, or water and oil, for the materials resist the combination which an act of creation perfectly free might have assigned to them. Here nature sets the limits of human art, lays down the limits which no art of mere combination may transgress.

The first condition of art is thus nature's dispensation. A people obliged to build in stone will not fling poetically into space those

cantilevers which require the tensile strength of steel. They will not because they cannot: stone will so quickly fracture, under a stress of tension, as to mend their error and mar their art. So men's acts, in art as well as life, are limited by the conditions which nature sets. Such was the sense of Francis Bacon's insight, that nature, if she would be commanded, must be obeyed. In the prohibitions of nature art is silent; only in the silence of nature is art free to speak.

And art at last must speak. For within those limits which nature permits there remain still alternatives so numerous, possibilities so prodigal, that only the exercise of art may elect among them. A people which builds in stone may build either with posts and lintels or with arches and vaults. Why, given the means, the materials and the technique, to build with either, does it build with one rather than the other? The answer lies in the decisions which men make within the limits which nature indifferently allows. Those decisions are not negative conditions; they are positive conditions, positive acts of men in the face of nature.

The second condition of art is necessarily a positive dispensation of our own. For when men build, nature does not tell them what combinations they want; it tells them only that there are some combinations which they cannot have. Therefore, in nature's silence, unless art speaks, there shall be no speech, since speech is the art of setting limits on ourselves.

3. The Image of Man: Art and Self-Knowledge

What would be the image of man in a world of his own sovereign contrivance, of man unconstrained except as, by his own free act, he constrains himself?

We do not know. For his world is never thus purely subject to his sovereignty, and is governed at all, when he governs it, only in parcels. Yet those parcels, such as they are, limited as they are, will bear attending to, for in some of them which his hand has formed with the transparency of art, there may be found the most precious and intimate of all revelations of what he is.

The actor in a play does not see the play as a spectator sees it. He is forced by the practical demands of his role to respond to the scene in which he is immersed. The spectator is absolved of any such demand: unimplicated, he stands ideally apart, contemplative

and detached, himself unchallenged, privileged, as the actor himself can never be, to meditate a world, and the actions of men in a world, in which he has no part. That measure of contemplative detachment is never afforded to the actor who is party to the fiction. If Desdemona must die at Othello's hand, the actress still must live at his. Therefore he never sees the fiction as the spectator sees it, for whom, in that suspended world of imagination, Desdemona does actually die. Cancel her death, you have cancelled the play, for except by her death there can be no play. Which is to say, that actor and spectator stand related to the fiction in quite different ways. The spectator is morally disengaged; the actor is not. The spectator is not party to the pretense. Therefore he alone can afford to attend cleanly to the thing pretended. The action is severed, as by a separating veil, from his, the spectator's, moral world. Freed of any obligation to act, he may look in absolution upon a world seen but not shared, and he sees with a detached clarity of vision which he never otherwise achieves.

I call this detached vision of things, which the spectator exhibits, an *aesthetic detachment*. Aesthetic detachment describes the distinctive relation of a spectator to the image which he contemplates. It is his relation to the image when he views it with moral disengagement, without reference to any uses which it may have in relation to purposes of action or prediction.

Suppose one were to attempt, in an essay of self-knowledge, to attain an aesthetic detachment with respect to one's own role in the world. Suppose one were deliberately to produce a fiction in which the image seen was an image not of things, but of one's own act. Normally, that disengaged vision of ourselves eludes us. For not only are we too immersed in the business of acting to attend to the act itself. The act and the scene of the act are inextricably interfused, so that the part contributed by the scene and the part contributed by ourselves are not clearly distinguishable. The image is ambiguous, and it is with such ambiguous images that we usually put up in the rehearsal of our histories and biographies. The world changes and we change with it, and what is ours and what the world's, is to us opaque. How then shall one attend, and attend decisively, to one's own part, if one's own part is thus always tangled with accident, always a part in the world, never out of it?

The artist has a way. The condition necessary to his attending to his part is to hold a parcel of the world, for the interval of his attention,

constant. Let him frame off a segment of nature, and being for the time free of having to respond actively to changes in it or to changes beyond it, let him attend only to those changes which he himself has introduced into it.

That segment which he isolates and preserves constant for the purpose of his experiment I shall call his *field*. The field is a deliberate contraction of his world, a part of it which he as sovereign can profess to govern. All that falls beyond it he may renounce; what falls within it is an order which he disposes.

Then, since at least within that field which he has isolated the only changes to be observed are changes which he deliberately makes, he may regard those changes as the pure reflection of himself acting. He legislates the rule of order to which the field must conform. The field registers that order. The field becomes through that order the mirror of his act: he may study his image in it; he may read his image out of it. In that segment of nature which he has shaped he implants a humane deposit, an exhibition outwardly visible to himself of the role which inwardly he enacts.

That ordered field which he has instituted, exactly in the measure that he has succeeded in governing its order, will be said to *express* his role as actor. In the principle of its order is reflected the decision of him who ordered it.

The order is expressive not because the field resembles anything in nature, as the photograph of a landscape resembles the landscape photographed, or a portrait the person portrayed. The artist's order is expressive because it is principled, responsive to his government, estranged from nature in a dominion which he has visibly constituted. On rare occasions, a man's outward act may by its tenderness or stress become the perfect indication of what inwardly he is. So on occasion, with detached vision, in an ordered field one may see immaculate, as never otherwise he sees, his own spontaneity objectified, literally made into an object, for his contemplation.

The artist's field is not an imitation of nature; it is a parcel of nature which he has caused to imitate him.

Such is the problem of any theory of visual design, to discover the conditions under which a field may be thus appropriated to the uses of expression, that men may find in it, in the phrase of Longinus, the simple echo of a soul.

II. The Pictorial Field

4. Of Titles and Enclosures

To mark the division between what is *mine* and what is *thine*, I may build a wall. My plot is the part which lies on the hither side of the wall, your plot the part which lies beyond.

In a legal order the wall is simply the token of our titles. If I place it wrongly, you may require me to set it right. For the right setting of it is, like the wrong setting of it, not established by the setting, but by the titles which we hold. The wall, properly placed, is only a mark, making visible the ideal limit up to which my right extends and beyond which it lapses. The wall does not confer upon us our titles; it conforms to our titles and is limited by them. We may dispense with the wall, or let it crumble; the titles will remain the same.

So it is with the work of the artist: his field is not the space which he frames, but the space in which his title is established. His title is as valid as his capacity to govern the field which he has chosen to set apart. He owns only the order which he has implanted in it. Beyond its order he owns nothing.

For an ordinary spectator a pictorial field is the space within a frame. That manner of speaking will mislead only those who suppose that titles are distributed as walls are built, and that where there is no wall, there can be no title claimed. But for an artist the enclosing frame is a perfectly neutral incident. It has the narrow function of serving as the visible token of the limit which separates a pictorial field from the total residuum of the world that lies beyond it. In the making of his work the artist orders the elements of a pictorial field, physically shapes them according to the ideal order which he has established for that field. Considered simply as a physical object, his work is, like its frame and the wall on which it will hang, part of the stuff of nature, caught up inextricably in its universal web

and indivorcible from it. But within the web of nature a picture has this peculiar property, that for a contemplative awareness it will isolate itself. If it did not already, without its frame, isolate itself, no frame would suffice to isolate it. Place a frame about a painting, it reinforces the self-enclosedness of the pictorial field. Place the same frame, empty, on any random bit of wall, it isolates nothing, but will on the contrary be interpreted as an interruption of the wall surface which extends beyond it and under it as well.

A picture is not set apart; it sets itself apart. It is a self-contained and self-complete order, which has in fact normally been produced without a frame and could go still without it. Pictures are framed not because their limits could not be discovered in the absence of frames, but because the task of discovering those limits—of discovering where art leaves off and nature begins—is an unnecessary intrusion into the contemplative pause which comes with that discovery.

The painter Seurat sought with exquisite tact to mitigate the hardness of that demarcating line of frame which a carpenter's straightedge will produce (Plate 36). Beyond the surface of his painting, onto the inner edge of the frame itself, he extended that pointillist treatment of dots and touches, so that the frame was incorporated into his work, became its calculated adjunct, part of its artifice. That was an act of sensibility, not of dissimulation. He was not attempting to suspend the distinction between nature and art. He sought only to temper the abruptness of that contrast, to allow a measured transition through it, supplying gradations where, without gradations, the inner edge hardened unpacifically to his eye. Look to the outer edge of Seurat's frame: it is hard as life. Seurat, unacquisitive, chose to build his wall within his lot-line. His motive was to shelter his vineyard, not to gain a foot.

If then, for simplicity, in order to indicate the over-all shape of a picture, I sometimes speak of "the space within a frame," I do not intend to dignify the frame. I employ the frame as the token for that space and for the limits of that space. Properly, all that concerns me is that space, within whose circumference the artist's act begins and ends.

That space, whether or not it has a frame, I shall call the *pictorial field*, or alternatively, wherever the artist's operations upon it are specially in question, the *space for manipulation*.

A space for manipulation is that segment of space which an artist isolates for treatment: in its simplest state, it is the empty

sheet, the stretched canvas, or the plastered wall, as yet untouched, which his touch is destined to transform.

What new property shall come of his touching it? Untouched, it is he who must isolate it; touched, it will isolate itself. It becomes self-isolating, an ordered field, a field such that, once its order is made apparent, its limits are also apparent.

5. *Transforming Contrasts and the Constancies of the Field*

An artist isolates a field only in order to transform it. The transformation consists entirely of what he does within it.

No man makes a painting simply by isolating a field. In this sense a bare pictorial field is a pre-artistic fact, a piece of carving, not of painting, for temporally there is no art until the field has in fact been worked. But, logically, the isolation of a pictorial field represents a decision which bears consequences in all that art can do. It is an empty dramatic sense which does not see in the bare stage of a play both a limit and a resource of the playwright's craft. The properties of that bare stage will remain fixed even when the stage is peopled. What any actor does, what any actor can do, will be circumscribed by the limits which it sets. The action can take place only according to possibilities which it allows, and there will be invariably, on any stage, some possibilities which the stage itself forbids. A spectator may permit himself the freedom of viewing the drama as if it consisted simply of the comings and goings of actors: he may, in viewing the action, forget the stage. The playwright who permits himself that freedom cancels his art. For his art consists in realizing a play within the limits which the stage-space sets, and out of resources which the stage-space provides.

It is just so with the pictorial field. It is the artist's bare stage, a space carved out of the world, in which he would constitute a world, that so he might find in it a mirror of man.

The pictorial field is a *field for transformation*. Much is to be gained, and nothing is in fact lost, by postponing still a while the transformation of it. The field is empty. Only while it remains empty can one meditate the properties of the field itself, the properties of the field simply isolated and as yet untouched.

A pictorial field can be transformed only because, as an island in space, it has already a form. By the emptiness of the field is not

meant that it has no properties, that it is without any systematic feature. It is not elemental void, the chaos and old night over which the spirit brooded in the initial act of creation. On the contrary, by the emptiness of the field we in fact mean only that it is, for the artist's transforming act, visually homogeneous, bare of any contrast which shall be counted as a *transforming contrast*. Contrasts it may have, which belong to it in its physical estate, as grain to wood, or gradations of light to a ceiling-vault. It has its own color—white or black or gray, or one of the rainbow's hues. It has its own texture—rough or smooth, coarse or fine. It has its own determinate shape—flat or convex or concave, elliptical or polygonal.

The interest of these characteristics is their constancy. They remain fixed. They are conditions of any transformation of the pictorial space. It is only against them, as they initially appear, that any form which the painter would introduce can be registered. He marks his changes against their permanence, nor can he mark any change except as they will make it apparent. Thus there is no painting which works exclusively with identities: gray on white will do, or black on white; but white on white is, like black on black, simply the field again. In a visual art the only transformations which can count are *apparent* transformations, and it is the field which fixes the conditions of appearance.

The first principle of all art is, therefore, the principle of *contrast*. That is too simple to require stating? There is no understanding of the complicated things except in terms of such simples. To know the properties of a field is not sufficient to the making of a painting. But there never was a painting of any merit made—none at Altamira, none at Antibes—which did not respect the properties implicit in a field. The artist is, for better or worse, a worker in appearances, and he may not forget it. That is the difference between art and marketing. In the market-place to have the appearance of riches but not the thing is to have nothing. In art to have the thing but not the appearance is to have nothing.

6. *The Implication of the Spectator*

The delimiting shape of a pictorial field is a condition of all appearances that fall within it. It is so profoundly important that a painter ignorant of its stresses is ignorant of his craft. A painter may

select among such shapes. He governs then the selection. He is impotent to govern the consequences of having made that selection. The shape of the pictorial field having been delimited, all transformations of the field occur within it. It itself is not subject to transformation. The delimiting shape remains fixed, and the stresses peculiar to it remain fixed, for so long as the painter holds to that selection. Let him seek to diminish those stresses, he will be diminished by them. But on the contrary, if he be artist, he will know how to use them, to avail himself of them as essential resources of his art, which he may put to the service of his art.

What are these "stresses"? What shall be understood by "the stresses of the field"? It is easy to understand, among the forms introduced into a field, that some will have greater value than others. Thus, for example, other things being equal, a larger dot will have greater visual stress than a smaller. But what can be meant by the stresses inherent to the field itself? Simply this, that the value of any form which a painter introduces into a field will vary according to the placement which he gives to it. The value of the form will change as its position changes, though the form itself remains constant and the field on which it lies, considered simply as a surface, is perfectly homogeneous. Which is to say, that not all positions within the field are in point of visual stress equal. The same form in different positions will have a different value, and that variation in value is determined by the field, not by the form itself.

The geometrical shape of a circle has this peculiar property, that it remains visually stable, however one may rotate it in its plane (Fig. 1). That would appear still to be its property as a possible

Figure 1

pictorial field, that there is no rotation at which its stability as a simple symmetrical shape is greater or less than at any other.

But let a line be so drawn within it as to coincide with one of its radii. Which radius? Geometrically, it will matter not at all, for the same geometrical figure will be produced, whichever radius be chosen (Figs. 2, 3). Geometrically, Figure 2 and Figure 3 are

<center>*Figure 2* *Figure 3*</center>

identical. They are nevertheless, visually, very different: the one exhibits a qualitative equilibrium; the other does not.

The line which has been introduced is at once seen as upright or as tipped within the field, according as the radius which has been selected coincides, or fails to coincide, with what I shall call *the visual axis* of the field. The visual axis is the diameter which is felt as vertical by a spectator who confronts the field. It does not, like the drawn radius, appear as a transforming contrast within the field. It is not seen; it is nevertheless a condition of our seeing. That is its secrecy. The stress of the drawn radius is calculable only in relation to it.

The visual axis is what constitutes the difference between the circle as a bare geometrical shape and the circle as a pictorial field: a field implicates a spectator, a geometrical shape does not.

Evidently the visual axis is not a property of the circular shape considered by itself. Considered by itself, the circle gives no precedence to one diameter over any other. Any of its diameters may be taken as vertical; none requires to be. For that reason, since no diameter has a decisive pre-eminence over any other, the visual stress of any drawn radius is indeterminate. One may, by rotating Figures 2 and 3, see the radius in Figure 3 as upright and the radius in Figure 2 as tipped. Such ambivalence is inadmissible in a pictorial field. For it is the indispensable property of a pictorial field, that the value of any transforming contrast shall be determinately calculable within it.

To treat the circle as a pictorial field is already to have legislated what is the proper orientation to it. Let one orientation be fixed upon, and let the visual axis for that orientation be represented by a dotted line (Figs. 4, 5). Observe what is the consequence of that

<div align="center">

Figure 4 *Figure 5*

</div>

decision. All stresses become by the selection of that axis determinate. If the drawn radius coincides with the visual axis, it produces an equilibrium in the field; if it fails to coincide, it produces a disequilibrium. The positive form is in both instances the same—a drawn radius. But the value of that form has changed. The variation in its value depends not upon it, but upon the stress of the field.

That is no mean discovery. For we mark here a paradox, that the invisible axis establishes the stress of the visible form; it is not established by the stress of the visible form. The form, which is seen, has no calculable stress except in relation to an ideal axis, which is not seen.

The orientation of a field operates so secretly that men everywhere omit to reflect upon it. Its dominion is no less imperious for all that. The neglect of it is responsible for the common delusion which even painters sometimes allow themselves, that the proper orientation of a field is established solely by the forms within it. Cézanne's mountain rises, it does not droop; Manet's Olympia lies like a hussy, she does not float like an angel. We have lost our innocence in these representations. The demand for a right setting is as real and indispensable in a Kandinsky or a Mondrian (Plate 7) as in a Cézanne or a Manet, nor is the orientation in these less compelling because they show neither hillocks nor harlots.

7. *The Shape of the Field: Regularity and Simplicity*

So long as pictorial fields are determined by the demands of architecture, the shape of the field itself will be established by the shape of the space reserved for decoration. The painter has then to take what he gets where he gets it. He may have to accommodate the irregularities of a refractory space which another has isolated, and has isolated with sublime indifference to his pictorial problems. The stable arched-form of Raphael's *School of Athens* is interrupted by a door (Plate 4, Fig. 6*a*); Titian's rectangle for the *Presentation of the Virgin* is twice perforated by lintels (Fig. 6*b*).[1] The effect in each

a *b*

Figure 6

has been to disturb the initial symmetry of the space to be treated. Part of the interest in both paintings is the way the artist has found to compensate for these physical intrusions, constituting an equilibrium in spite of them. A regularity in appearance is made to neutralize an irregularity in fact, but to accomplish this the design of art has had to respond to stresses in the field which fact has dictated. Painting may after this fashion accommodate itself to the necessities of architecture. But that is precisely the interest of such instances: they make evident what otherwise must have passed unperceived, that the shape of a pictorial field is never for an artist a matter of indifference.

In the moment that painting is freed from the external demands of decoration, the pictorial field will invariably assume a contour which has predictable visual properties: it will be *regular*; it will be *simple*; it will be *stable*. Where these properties of regularity, of simplicity, of stability are wanting, or are not visually appreciable, there exactly is where an act of accommodation is necessary in design.

[1] Accademia, Venice, 1534–1538.

The shapes of paintings are after all very few: rectangles and ovals and circles, triangles and semicircles, arched and gabled forms. Why just these? Why these in preference to others, wherever preference may be exercised?

Complicate those forms and you may see. Let them take on the capricious irregularity and complexity of the form of an amoeba. One's whole essay in form must then become an act of accommodation like Raphael's or Titian's, a poor bondage committed to achieving that measure of perspicuous constancy against which any free essay in visual order can be securely seen.

Irregularity, complexity, instability multiply the stresses of the field itself. If these stresses be so far multiplied that their perspicuous constancy is lost, they baffle the uses which the field has been set aside to serve.

By the regularity of a pictorial field I intend its *visual* regularity, a regularity in it which is appreciable to the eye. A shape is regular if it conforms to a rule. It has visual regularity if that property is visually appreciable, if its regularity is apparent in the seeing of it. Thus, a circle is a visually regular shape, a shape governed by a rule, whose rulefulness is apparent. If need were, that rule could be stated. But it is not necessary to state the rule in order to see the regularity of the form. I see the form as a regular form already before its rule is stated, and even if its rule remains unstated.

Those who live by words are, like all peddlers who have a commodity to exchange, typically disposed to overvalue their product. The most insufferably tedious of the tribe are those who suppose intuition to wait upon their capacity to render into language the findings of intuition. Poor learned dust, they have forgot that astonished vision of their innocence, when, through a windowpane in winter, a child's eye first fell upon the regularity of a snowflake. The child saw regularity. In the midst of all that multitudinous complexity which was a flake of snow the child intuited an order, and a rule of order, which an intellect less filled with the wonder of it could essay to state, but which a child filled only with the wonder of it was content to love.

Well, let me set down a few such regular forms, forms more complicated than a circle, less complicated than a snowflake, forms whose regularity is immediately apparent, visually appreciable (Fig. 7). Each of these forms is regular. Each is visually stable. They differ with respect to the property of simplicity.

By simplicity I intend, as before, *visual* simplicity, the number of units of which a visual account must be taken in order to apprehend the form. I do not mean that you actually count them—that you see in a triangle three angles and three sides, and in a six-pointed star twelve angles and twelve sides. That is not what you see; that is only what an analysis will disclose. What you see is a triangle and a star. You see each as a whole, and you see one of these wholes as simpler, as containing fewer parts *for* analysis, than the other. That visual simplicity is the property which is intended.

Figure 7

Analytically, an equilateral triangle is simpler than a square. The square is nevertheless of the two forms less constricting and generally more usable. That is not to say that the property of simplicity is without importance, but only that, within certain ranges of simplicity, other considerations (in this instance, capaciousness) take precedence.

But regularity without simplicity will not suffice. The star is regular; the shape of a snowflake is regular. Their complexity gives nevertheless a field so fractured, itself so manifold, so demanding of attention, that what takes place within the field—the artist's transformation of it—must compete with it. The value of simplicity in a pictorial field is precisely this neutrality, this uncompetitiveness, which permits attention to rest where the artist intends that it should rest.

For a free art, where is it fitting that it should rest? Not on the resolution of a problem which the field has set for the artist, but on the resolution of the problem which the artist has set for himself.

8. *The Shape of the Field: Visual Stability*

Regularity and simplicity have only a negative justification: their presence settles nothing; their absence unsettles everything. They have the same kind of value which peace has in the conduct of human affairs. Men who aspire after peace as if it were itself a substantive good betray only the disturbance of their lives. It is not the tranquillity of men's lives, but the content of men's lives, which

makes life worthy and peace necessary. Peace *is* necessary in the lives of men. Yet in itself it has no value: it is valued, wherever its value is understood, only for the sake of those activities which its presence permits and its absence forbids. It is an emancipative condition of other values. In itself it is perfectly empty: a sleeping man has it in greater measure than any man waking; a dead man has it in greater measure than either.

In the same way, regularity and simplicity have no virtue in themselves. Their value is in their tolerance, in their permissiveness of effects which they do not themselves afford and which they cannot themselves guarantee.

The visual stability of a pictorial field is a value of a different order. It is a profoundly important positive resource of the painter's art, so perfectly fundamental to all that he essays to do that to be ignorant of it is to be ignorant of what he does. Within a pictorial field he produces a visual order. The order which he undertakes to achieve is in all cases describable as a kind of equilibrium. That equilibrium may be static; it may be dynamic. It can be seen as one or the other only in relation to some stably fixed and visually appreciable axes. Deny those axes to an artist, deny them to the spectator of his art, you disorient them both. A painter can tip a form, the spectator can see that form as tipped, on the one condition that the field in which the form is placed is itself presumed *not* to be tipped.

The field establishes the conditions of any proper orientation to a picture. It cannot therefore be permitted to raise questions as to what is a proper orientation to itself.

In a field deliberately impoverished, as in Figures 4 and 5, it was found necessary to stipulate that one diameter, the diameter represented by the dotted line, was to be interpreted as the vertical axis of the field. Until that stipulation had been made, the stress of any accent within the circle was radically ambiguous. Its value was simply indeterminate, for the reason that the circle itself made no selection among its own diameters. Therefore, arbitrarily, I selected one. That arbitrariness is, before a picture, precisely excluded. A picture has its own immanent axes which a spectator is obliged to discover and, having discovered, to respect.[2]

[2] If anyone wonders at this, let him contemplate the animal forms of Altamira or Lascaux, where no frame betokens the limits of the field: the shape of the field being undeclared, the spectator supplies it, as every photograph by careful cropping innocently declares.

To the spectator who confronts a painting the painting speaks not a word. It announces itself only to the eye. It works in silence. So that what is vertical and what horizontal, as the painter conceived verticality and horizontality, can be gathered only as the ordered field enables it out of silence to be gathered. What then is its *right* orientation? An arbitrary stipulation will not in this case suffice, for the spectator's interest is not to dignify the orientation in which accident has placed him, but to re-establish the orientation proper to the picture as the painter envisaged it. The immanent orientation of a field, the orientation which is obligatory for any spectator who would grasp the painter's field, is therefore a problem. Men seldom formulate this problem, for there are normally external indications—the evidence of representational elements and picture-wire—that a given setting was intended. But that is to have missed the point: we speak of pictures, not of representations or of picture-wire. The circular field of Raphael's *Alba Madonna* has a discoverable right setting even if one recognized no Madonna and found no picture-wire. Such external indications do not constitute the rightness of a setting; they *follow* it. Unless there were indications immanent in the field which validated that setting, that setting would not, despite those external indications, be respected.

The painter is not at hand. It is a consolatory reflection concerning the painter's art that if he needed to be, he would be no artist.

Let a Mondrian be hung askew on the wall of a gallery (Plate 7). A person entering the gallery will do either of two things: if he has the courage, he will set it right; if he has it not, he will cock his head so as to establish, at least for his relation to it, a right setting. Who has told him that this relation which he establishes is right, and that that hanging askew is wrong? No one. Then how does he know that the hanging askew is not the intended hanging, but requires correction, and requires in fact the correction which he gives it? It would be convenient if he could cite a covenant commonly agreed upon by all artists and by all spectators of their art, that a work of art should be composed within a stable pictorial field. But there is no such covenant, nor is there any need of one. Such a covenant would be superfluous, since it would require what men found already necessary independently of its requirement. You do not legislate that men should breathe, or that they should gravitate. Why do you not? Because, simply, men do both of these things independently of any piece of legislation that they should do them.

To be a man is to breathe; to be a man is to gravitate. In the same way, to be a work of pictorial design is to exhibit an order of visual equilibrium. Any condition indispensable to rendering that order an apparent order, an order visually appreciable, will be obligatory. A stable pictorial field is such a condition.

That is why the behavior of Mondrian's spectator is so fundamental a revelation, whether he rights the picture or rights himself in relation to the picture. The interest of either of his acts is the same. It is simply this, that he knows at once, even before the painting has been identified, that his orientation to it is wrong. How does he know that? On this sufficient ground, that no orientation can be right if it forbids having the declarative axes by reference to which alone the work's immanent equilibrium can be judged.[3]

9. Cognate Axes

I propose to speak of the kind of order which is realized by transforming contrasts within a field as its *visual equilibrium*. The kind of order—the formal character—which belongs to the field itself, considered simply as a field for manipulation, isolated but not yet worked, I shall refer to as its *visual stability*.

The two are distinct, and it is indispensable for our present purpose that they be so understood. A field for manipulation can exhibit a visual equilibrium only as a consequence of having been manipulated. A field for manipulation may have the property of visual

[3] Painters know that one of the readiest ways of identifying a dead spot in a picture is to invert it. That deliberate estrangement of the work from its intended position in relation to a spectator enables him to see aspects of it, especially in its negative areas, which eluded his awareness in its right setting.

Why, given a rectangular frame, does he invariably rotate it in its plane through 180 degrees? Why not through, say, 45 or 60 degrees only? The reason is clear. A 45- or 60-degree rotation is not merely not right; it is just dead wrong. A rotation through 180 degrees is wrong because it inverts the subject; but it does not forbid, on the contrary it permits, and is valuable because it permits, a judgment of the surface in relation to the same stable stresses of the field which belonged to it in its upright position. Cocked at 45 degrees or at 60 degrees, unless the spectator cocks his head to cancel the difference, the surface becomes literally incalculable, incalculable not because the same forms within the field do not play against each other, but because that play of forms is not graspable as a visual equilibrium except as the stresses employed by the painter are re-established.

stability even before it has been touched: any manipulation of the
field addresses itself to this property of the field as to a given con-
dition which it does not profess to alter. Visual equilibrium is what
the artist sets out to achieve within a field. Visual stability does not,
under normal circumstances,[4] require to be achieved. It is, on the
contrary, a condition of any artistic achievement; without it there
could be no achievement.

Consider the isosceles triangles in the following figure (Fig. 8):

Figure 8

Actually, the three forms are identical. They are the same in shape
and the same in size. Figure 8*a* and Figure 8*b* differ in one respect
only, that in Figure 8*b* the form has been tipped so as to rest upon
one of its equal sides. The instability of the form in that position, or,
to state what is the same thing, the instability of the form when we
stand in this orientation to it, is immediately apparent. I do not
mean that it offends my sensitivity to physical equilibrium. If it
were an architectural phenomenon, a matter of gravitating masses
whose thrusts were visually appreciable, it would. But the fact is,
I do not expect it imminently to tip over. I am content to regard it
simply as a visual shape. I nevertheless pronounce it an instable field.
Why? Because I am unable spontaneously and with assurance to
determine where, if I were to treat it as the field for a pictorial
design, its axis must be presumed to fall. The tipped axis, cognate to
the triangle itself, drawn from its apex and represented by the dotted
line in Figure 8*b*, I do not interpret as a visual axis at all. For what
is required of a stabilizing visual axis is, that it be vertical with
respect to my field of vision and that it distribute the area within the
triangle into two visually equal parts. If, in Figure 8*c*, I essay to
draw an axis, it will not be an axis cognate to the triangle itself:

[4] The abnormal circumstances are those referred to in connection with Raphael's
School of Athens and Titian's *Presentation of the Virgin*: see p. 17.

it will pass neither through the point at any angle nor through the midpoint of any side. I can have therefore no assurance, in the moment that I delete the dotted line, leaving only the visual equilibrium which I have contrived in relation to it, that you will place it where I have placed it, or even that I would place it securely there again. The consequence is, that any visual equilibrium which I may contrive in relation to that axis will be found as precarious and as insecure as the axis itself.

An axis which coincides with the cognate geometrical properties of the shape of the field itself will be said to have *perspicuous constancy*. A field is stable if its axis has that property. Thus, Figure 8*a* is stable; Figure 8*c* is not.

To describe a pictorial field as stable is simply to say that a pictorial field implicates an ideal spectator.

A pictorial field is never a mere shape; it is that shape plus a determinate orientation.

To know the shape without knowing the orientation which is proper to it is to see still a physical object: it is to be lost within a picture. For the picture requires what the mere shape is indifferent to, namely, a stabilizing axis decisively felt and spontaneously grasped, in relation to which a pictorial equilibrium can be felt and grasped. It is this felt axis which establishes the meaning of verticality, and implicitly the meaning of horizontality, for that field. In a given painting, a form may or may not fall upon that axis so as to coincide with it: a Classical artist will employ that coincidence; a Baroque artist will, except for reasons of special emphasis, avoid it. Yet for the one or the other the stress of a form can be determined only by reference to that axis. The value of any form as a factor in equilibrium can be felt only as that axis permits it to be felt. The forms alone are visible; the axis is invisible. Yet unless the axis be known, the equilibrium cannot be known.

The forms which occur within a pictorial field retain still their positions relatively to one another, even when the field is rotated in its plane. They are not changed; their relations to each other are not changed. The field itself has still the same geometrical shape which it ever had; they are related to its shape as they ever were. But the adventure of rotation has, despite these constancies, deranged the picture, rendered it impenetrable. Inherently, it has the same immaculate equilibrium which formerly it had. But the equilibrium which it has is no longer an *apparent* equilibrium, an

equilibrium which it can be *seen* to have. The equilibrium is there to be seen, but it is not seen; and, in a picture, not to be seen is the same as not to be.

III. Elements of Equilibrium

10. Equilibrium

When I was a child, there used to be hung above the dining-room table in the Christmas season, as the festive token that its celebrations were in progress, an ingenious device which would nowadays be described as a mobile. It was to me then, and shall always seem, the strangest and most curious of fabrics, made of thread, of a few tenuous wire rods, and of pieces of colored glass and ceramic angels, all delicately strung together in a sequence of suspensions, which floated the rods in space and produced, by deviations from the horizontal, a splendid series of apparent imbalances, angels soaring and sinking as rods rose and fell. Collapsed in the box in which it was stored, it was an insensate tangle of débris. Suspended aloft, lighted, touched, it was a little universe in miniature, which would move with an eerie majestical precariousness for an hour long before regaining its static equilibrium again. Its motion had the intellectuality of music, a music of pure silence, whose tones were shapes, whose melody was change, whose intricate harmony was enough to addict a childish heart, if it had known Pythagoras, to affirm devoutly the harmony of the spheres of heaven.

The hanging of the mobile aloft was annually performed with a solemnity and care suited to so important a matter. For each year, as it was resurrected from its storage place, it hung foolishly askew, demoralized by vicissitude, like a drunkard's hat crushed out of shape. Not that it had not still an equilibrium, a static balance, which it would assume and, if disturbed, would assume again, as if to declare idiocy alone immortal. It did not wait, in order to have an equilibrium, for an artful hand to give it one. Such equilibrium as it had, from the accidental concert of its parts, it had with the

26

indifferent equanimity of all things merely physical. Beauty was its accident, as idiocy also was its accident. It was as innocent of virtue as it was innocent of sin: it knew no propriety, therefore deserted none. I admired in it only what I demanded of it, a virtue of which it knew nothing. Yet, for my part, I permitted myself no such egotist reflection. I regarded it all as the contrivance of the hand which adjusted it. In my child's world, that was the secret of my mother's hand, which no other sought to compete with, much less to penetrate. She knew, at least her hand knew, that of all of the possible equilibria which were available equally for choice, there was one special equilibrium needed, one only one which was alive, resonant, essential to the production of that effect to which it intricately ministered. That equilibrium was indispensable to the music which the mobile gave forth, its beginning and its end, the poise from which its movement issued, the cadence in which it came with perfect finality to rest.

The indispensableness of that equilibrium I learned when at last, the usual hand grown quiet, I tried to hang the mobile unassisted. There it was, the same mobile, the same in all its elements. No element was wanting. The effect only was wanting. It was an offense to the eye, crippled, disproportioned, grotesque, the dead corpse of what it was capable of, and I took it down. Who was demoted, it or I? I, surely, for the partisanship, the predilection, was, like the disappointment, in me, not in it. The demand which conferred rightness on it, like the incapacity which could not set it right, was mine. Therefore I was desolate, not because of what it was, but because of what it failed to be, because of what I wanted of it and had not the craft to produce in it.

In such simple incident lies the image of all art. Let that equilibrium which was needed in order that the mobile should work its desired effect be described as the *normative equilibrium*. That equilibrium will be the rightness of that structure, that which is sought after whenever any adjustment is made of it. By reference to the normative equilibrium I may then mark a distinction between a right adjustment of it and a wrong adjustment of it, between a valid essay and an invalid one.

The normative equilibrium may never in fact be struck, as I was never able to strike it, so that, unstruck, it is never available in perception for experience. It is therefore nothing? On the contrary, I who have failed to strike it know, in my dumb despair, that I have

failed to strike it, just as, if by accident I had struck it, I should know
that too. My activity is regulated by the idea of it: I am aware of
its absence when it is unrealized, I am able to acknowledge its
presence if it were to be realized, I remain dissatisfied until it is
realized. Its positive function in experience is confirmed not by the
circumstance that it is on any occasion actual, but by the circum-
stance that it is on all occasions demanded. A normative equilibrium
is that which every artistic imagination is committed to producing;
that which, once produced, it is committed to preserving; that
which, being lost, it is committed to restoring.

The idea of a normative equilibrium is the most general category
of formal analysis. The value of any artistic form will be found to
depend upon it. The value of the form is measured exactly by its
contribution to that normative effect. A work of art is more than an
artistic equilibrium; but it is always committed to being at least
that. A work which achieves less is artistically incomplete. A work
which is committed to achieving less has not the status of art at all.[1]

11. Axes

I begin with an empty rectangular field, simple, regular, visually
stable (Fig. 9). Its visual stability consists in the declarative sym-

Figure 9

metry which it has as its areas distribute themselves about an ideal
axis, the *vertical axis*, which runs between the midpoints of its upper
and lower edges. The vertical axis is the major axis of any field.

[1] I have treated the concept of normative equilibrium at length in an article,
"The Foundations of Artistic Community," in *The Review of Metaphysics*, XIII,
2 (December, 1959), pp. 235–258. Paragraphs drawn from that essay are here
used by permission of the *Review*.

Bisecting it, there is a second axis, the *horizontal axis*, which runs between the midpoints of the right and left edges. These two axes I shall refer to as the *perpendicular axes*.

The opposite angles of the field generate two additional lines, the *diagonals*, which are, like the perpendicular axes, cognate to the form of the field itself.

Why do we not treat lines other than these as cognate to the field? I confess that I do not know. It is simply a fact that in our perception we do not. In theory I am able to conceive alternatives which are without question, for a geometer, equally valid, alternatives which take account of properties as cognate as those which I have here distinguished. For example, I am able to conceive two vertical axes for the field, axes which serve to divide the field into three equal vertical panels (Fig. 10). But though that alternative is

Figure 10

perfectly conceivable, I do never in fact *see* the field's stability in the first instance by reference to those lines. If they figure as axes at all, their verticality is quite clearly derivative and dependent, invariably affirmed by reference to the undrawn vertical axis of the central panel.

Medieval triptychs divide themselves into separate panels, each with its proper central axis. The central panel then appears as the dominant panel of the three. Why? The unperceptive answer is, that the most important subject will invariably be placed there. That in fact is true. But that is the burden of the question, not an answer to it. Why does that subject which is in point of sanctity or dogma the most important come invariably to occupy that place? Because that same subject, in fact the most important, would not appear to be the most important, were it displaced to either side. The artist's problem is precisely to make the appearance of the

matter and the fact of the matter coincide. The central panel of a triptych is not dominant because its subject appears to us as more important; its subject appears as more important because it occupies the axis by which the field as a whole is judged.

The central and lateral subjects of a triptych can never appear as equal. If you want equality to be seen, you are obliged to relate equal terms equally to that central axis: they must be equally upon it, or equally apart from it. Therefore, if you demand equality of appearances, or church or state demands it, paint diptychs. Either that, or do simply as we began by doing: settle for a symmetrical division of a single field.

Painters know the uses of this circumstance in establishing degrees of emphasis among appearances. Any element which is permitted to occupy a position on the vertical axis will acquire a conspicuousness entirely disproportionate to its size. In Perugino's fresco in the Sistine Chapel, *Christ Giving the Keys to Peter* (Plate 1), the figures are distributed symmetrically at either side of the vertical axis. Perugino's problem was to focus attention, in a densely populated foreground, on Christ and Peter and on the key to heaven which is the motive of the action itself. Christ and Peter are the figures nearest to the axis; the key lies exactly on it. Thereby the key acquires, in so huge a field, an emphasis entirely out of proportion to its minuscule size: it holds attention to itself even in competition with forms of a hundred times its mass.

12. Positive and Negative Areas

The field is empty. Let a mark be made upon it. For the moment the character of the mark itself is not in question. All that is required of it is that it should be apparent, that it should appear as a visual contrast in the field.

The transformation is most remarkable. For this field, while it remained empty, solicited attention in its own behalf. It was the dominant fact for my awareness, an immaculate presence, homogeneous in its character, which had its own color and its own texture and its own distinctive shape. By the introduction of this simple contrast into it its function in my experience undergoes a mutation. Formerly, I attended to *it*. Now I attend to the transfiguration of it. I do not see it, as formerly I saw the world beyond it, as a mere

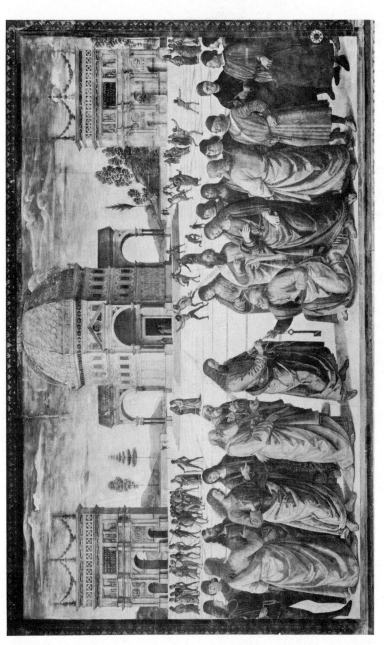

PLATE 1. Perugino (*1446–1523*), *"Christ Giving the Keys to Peter"* (*c. 1481*), *Fresco, Sistine Chapel, Vatican* (*Anderson*).

ground, penumbral and out of focus. The contrasting mark is discriminated as part of a whole: it is one part; the residuum of the field is its active complement. The field, formerly itself an appearance, has become simply a condition of appearances.

In this transformation the mark achieves an eminence, a visual compulsiveness, which the field itself could never claim. The condition under which the mark appears is a *controlled* condition. The properties of the field remain fixed and calculable. Therefore, once noted, they may be permanently allowed for, and only the germinal properties of the mark itself need be attended to.

Well, attend to it. I have touched the field but once, made but a single mark upon it. It matters not what the shape of the mark has been, I have produced *two* shapes. I do not mean that I have produced the shape of the field and the shape of the mark within it. I have produced two shapes *within* the field. The mark which has been introduced is one shape; the field less that mark is another. The field is a containing shape; within that containing shape two shapes are contained. Each contained shape is the complement of the other within the field; together they make up the whole which is the containing shape of the field.

When a master artist distinguishes between the *positive* and *negative areas* of a painting, this is the curious circumstance which he reflects upon, that for any shape which he introduces into a pictorial field there will appear, in addition to that shape, a shape which is its complement. The first is the shape which he has introduced; the second is the part of the field which he has left untouched.

Figure 11

Figure 12

Assume a rectangular field, and let the problem be, to make a circular dot appear within it.

Either of two alternatives presents itself: you may color the dot and

leave the residual part of the field untouched; or you may color the residual part of the field and leave the dot untouched (Figs. 11, 12).

In either alternative the dot will appear as the positive form. Evidently, it is not the color that determines which form shall be construed as positive. In Figure 12 the area which appears as the dot is the area from which color has been withheld; in Figure 11 the area which appears as the dot is the area to which color has been applied. Both figures are interpreted equally as a dot within a rectangular pictorial field. That precisely is the point: whether the mark which you make in the field is the mark which appears as black in Figure 11 or the mark which appears as black in Figure 12, in either case that mark generates a complementary shape which is an active stress within the field.

Visually, the untouched area in both figures is an active stress. That is why it is so very difficult for an uncultivated eye to see as the eye of the master artist sees. The master artist has disciplined himself to see the negative forms as well as the positive forms, and the negative forms no less than the positive forms. The beginner sees only the poor dot which is the subject of the picture. But the picture is not to be seen in the dot. The picture is to be seen only in the *complementarity* of the forms by which the dot is presented. Therefore, if only the dot, which is the positive form, is attended to, and the residual area, which is the negative form, functions only as penumbra, as a shape used but not seen, a picture is not seen.

The positive and negative spaces of a pictorial field are invariably complementary. To produce the one is inevitably to produce also the other. Any design which attends only to the value of the one and lets the value of the other go by default is in that measure not governing the pictorial field but governed by it.

Negative spaces are not waste space. They are part of the total space which an artist professes to control. If they are themselves without interest, if they have no formal justification except the empty one that they fill out the unused areas between figures or between figures and the frame, the artist has defaulted. I see his subject; I see no art. For the subject I have no reason to commend *him*, for I was capable of seeing that subject quite apart from his offices. The subject existed before him and will exist after him and without him. A picture can exist only by and through the order which he has conceived. An artist does not inherit his world; he constitutes it (Plate 2).

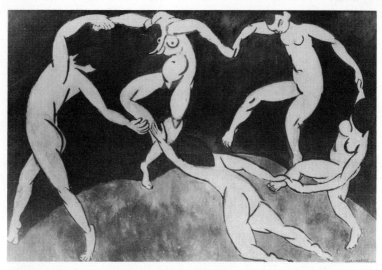

PLATE 2. Henri Matisse (1869–1954), "The Dance" (1910), Museum of Modern Western Art, Moscow.

Matisse's "Dance" is the purest illustration of the presentation of a theme by the complementary impact of negative as well as positive areas. The negative space is not waste space. Its interest, simply as shape, is as assured as the interest of the shapes of the dancers, whose movement would be indiscriminable without it. Suppose the figures to remain the same, but let the field be expanded. The negative area beyond the figures will alone have altered. But by that single transformation the intensity of that vortex of movement in which the figures are immersed will have been diminished.

13. The Vertical Axis

Let now a single round dot occupy that position in the field at which the perpendicular axes intersect, it will have an absolute visual compulsiveness for any eye which contemplates the field (Fig. 13). In its uncontested possession of the field, it has a dominion

Figure 13

as absolute as its solitude is perfect. It rivets attention. The attention which it gets it is not fitted to hold for long at a time, for neither it nor the field in which it appears is various enough or diverting enough to bear exploration. A field so poverty-stricken is exhausted in the moment in which it is seen. It dies in the eye which it refuses to nourish. But the magnetism of the field is not what is here in question; the only thing in question is the magnetism of the dot within the field. So long as an eye confronts the field actively, it is drawn irresistibly to that accent, and will dwell focally on it, exhibiting no tendency to move from it.

The effect is an absolutely static visual equilibrium, next to the bull's eye of a marksman the most completely static of all visual effects. There is no change in that whole which will give an equilibrium superior to the equilibrium already found.

If, deliberately, I transfer my attention to an edge or to an angle of the field, my attention will inevitably gravitate again to that imperious focus, and will rest there, obedient, for so long as I am content to treat that field as a whole for my attention.

In that position the accent exercises the same kind of attraction upon vision which a "home tone" exercises upon hearing in a musical cadence. The same unease, the same sense of incompleteness, the same want of finality, which is experienced in music until that home tone be struck, is experienced here until that focus is assumed and tension is resolved.

Such is the secret of the insistency of that clutching hand in Käthe Kollwitz's *Mother with Dead Child* (Plate 3). The eye can leave it only to return to it. It is the prime motive, of which the figures are but the echo and reverberation.

Preserve the same visually stable round dot on the horizontal axis; but let it be displaced to one side of the vertical axis (Fig. 14).

Figure 14

The visual equilibrium of the field has been deranged. The field remains as it ever was; the dot retains the same stability which it ever had. But the change has unsettled the visual economy of the field. The eye focusses on the dot, but is not content to remain where the dot holds it in precarious embrace. It is disturbed and inquiet by being thus drawn, despite itself, away from that intersection of axes toward which it would gravitate if the dot did not forbid it.

The dot is identically what it was, only its position has been changed, but by that change it comes to be grasped as a rebel thing, a thing uncivilized, in tension with the stability of the field. Has the field been changed? It has not: it is the self-same rectangle as before. Then what is the secret of this visual transformation, that a simple shift of the position of a dot should produce such disarray? The secret lies in that residual part of the field, the negative area, the unobtrusive efficacy of whose shape is everywhere felt though it is nowhere attended to. The change of position for the dot has affected the symmetry of the negative shape beyond the dot: as the negative shape wants equilibrium, so now the field as a whole is found to want it.

In short, the solitude of the dot within the field has been all along a delusion. It has been at no time alone. Neither has its dominion

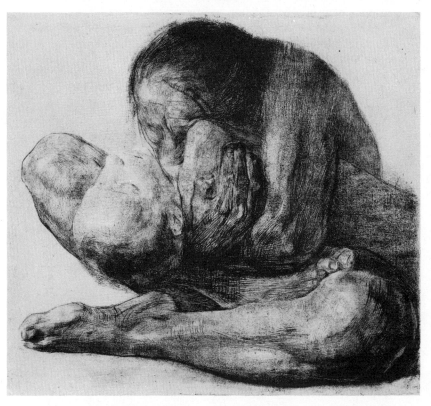

PLATE 3. Käthe Kollwitz (1867–1945), "Mother with Dead Child" (1903), Etching.

been at any time more real than the dominion of that negative
space which lies inconspicuous beyond it, the quiet and inevitable
complement of any of its adventures.

The field as a whole can exhibit a visual equilibrium only as the
negative as well as the positive space permits it. Equilibrium is their
joint effect, and can be afforded by neither one of them alone.
When the negative form is instable, the positive form is felt, despite
the tame symmetry of its motive, to have disturbed the visual
economy. A complement is required which will serve to compensate
for it, and to neutralize it, in the field.

Let that neutralizing element be added. Produce in an equal size
a second dot upon the horizontal axis, as far removed on the yonder
side of the vertical axis as the first dot is removed on this
side (Fig. 15).

Figure 15

The equilibrium of the field has been restored. The field is as
statically balanced as in Figure 13, but the balance is more com-
plex. It has become a matter of counterpoise.

The new positive form perforates the negative space. As the posi-
tive forms have been increased, the negative form has been in the
same measure diminished. That diminution is exactly the correction
that was needed, for the disbalance in Figure 14 was occasioned not
by the instability of the positive form, but by the instability of the
negative space which was its complement. The result is again a
visual equilibrium, in which the negative as well as the positive
form is stable about the vertical axis. That is what is intended by
a visual equilibrium: there is no tendency on the part of any spec-
tator of the field to redistribute the factors within the field; no other
distribution will produce an equilibrium superior to that which the
field already has.

There may be more than one possible equilibrium which may be obtained by distributing the factors within a pictorial field. But always the thing sought after, in the making of a picture, will be an equilibrium of that field. The things an artist civilizes may be more interesting than dots; the equilibrium he produces may be more eloquent than this poor equilibrium which I have deliberately impoverished. But that is the plain interest, as it is also the exclusive interest, of this field, that in it one may see already, in separation from the manifold other interests which normally accompany it, and enrich it, and complicate it, the simple condition of an artist's simplest act.

14. The Horizontal Axis

The vertical axis is the dominant axis of any pictorial field.

The horizontal axis is visually subordinate. A dot occupying the vertical axis above or below its intersection with the horizontal axis will as before derange the symmetry of the negative area (Fig. 16).

Figure 16 *Figure 17*

But a disturbance which affects only the symmetry about the horizontal axis is by no means so decisively felt as a derangement of the field. The introduction of a second dot, as in Figure 17, represents a theoretical, and even a sensible, gain in equilibrium, but as the loss of equilibrium was less acutely felt, so the gain is less appreciated.

Visually, equilibrium is in the first instance a matter of quantities in counterpoise about a vertical axis. A disequilibrium about the vertical axis will be rejected as visually unsatisfactory. A disequilibrium of quantities about the horizontal axis is, on the contrary, experienced as a qualitative contrast. Figure 16 satisfies the

primary demand for equilibrium. It will continue to satisfy that demand if the field be inverted. All quantities within the field remain then the same. But the inversion of the field, which causes the dot to appear below the horizontal axis rather than above it, has transformed the quality of the field as a visual whole. Causally, that transformation depends not at all on any difference of quantity. It depends solely on the inversion of the negative shape. In that inversion a perceptive reader will have seen the secret of the placidity of a Dutch landscape painting.

15. Static Equilibrium: Symmetry

A field is in symmetrical equilibrium if the parts lying opposite to each other about the perpendicular axes correspond in size, shape, and relative position as a mirror image corresponds to the thing mirrored.

Wherever a symmetrical equilibrium is strictly realized, the parts of the field are in such perfect counterpoise that an inversion of the whole will produce that whole again (Figs. 13, 15, 17).

So rigid a symmetry is never in fact encountered, as a principle of visual design, except in ornament. What men commonly mean by symmetry in the visual arts is *bilateral symmetry*, symmetry about the vertical axis only (Fig. 16).

A visual equilibrium will appear *static* exactly in the measure that a principle of symmetry governs it.

That is a general truth of the most fundamental importance, for it enables us to know of any field, irrespective of the particular forms which may be introduced into it, that an absolutely symmetrical distribution of those forms will give an absolutely static equilibrium, that a bilaterally symmetrical distribution of those forms will give a bilaterally static equilibrium, that where there is no symmetry, there can be no rest.

For some purposes symmetry may be the effect which is wanted; it can never, for an artistic purpose, be the whole of the effect which is wanted. Its importance is as real as it is limited; but it is real only in the measure that it is limited. Produce a perfectly symmetrical order in a field, the field congeals, becomes visually frozen, an order of the dead. That is the hoarfrost effect of symmetry, its negative value, wherever the limits of its use are not understood and observed.

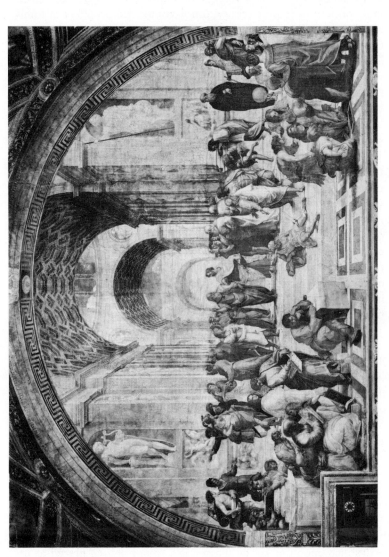

PLATE 4. Raphael (1483–1520), "School of Athens" (1509), Fresco, Camera della Segnatura, Vatican (Anderson).

Nevertheless, where the limits of its uses are known, symmetry can become one of the sovereign resources of art, a primary principle of design. It produces within a visual field an effect of luminously intelligible order, uncomplicated and serene, in which the center of gravity is so lucidly apparent, and the balance about it so formally assured, that in all this measured world there is no detail whose importance relatively to any other is not calculable, nor any detail whose counterpart anticipation cannot predict. Such has been the basic effect which Classical art has always wanted. A symmetrical structure answers to its predilection. Perugino is its severest exemplar (Plates 1, 6), Raphael its purest master (Plate 4), Poussin its symphonist. The art of Raphael is too unproblematic, too composed, too settled and unvexed an affair to command in the contemporary scene the assent which other men, in other times, who had, or deluded themselves into believing that they had, his measure of certitude, have given to it. The fault, dear Brutus, is in ourselves; at least, if it is in him too, it is not only in him. At all events, that is the effect which he wanted with assurance, and symmetry is the principle he used with assurance to get it. If among the cultural indecisions of living men that kind of order has become an irrelevance, yet still men must know it as they would know the measure of what they reject, or repine at having lost (Plate 5).

But even for those who, like Raphael, have employed the principle of symmetry with least constraint, it has imposed too austere a limitation. The *School of Athens* is, in its basic design, bilaterally symmetrical; in its detail, it is asymmetrical. We have now to see that asymmetry is compatible with equilibrium. For that we must look to the diagonals.

16. *Dynamic Equilibrium: Asymmetry*

The diagonals have until this juncture been unemployed. Therefore, the only kind of equilibrium which could be noted was an equilibrium consequent upon a symmetry of the field.

The possibilities of visual equilibrium are not, however, exhausted by the possibilities of symmetry.

Produce upon one of the diagonals a round dot, so placed as to fall clear of the point at which the diagonals intersect (Fig. 18).

A most unpropitious beginning, for if ever depravity were total, it is total here. Judas to a tittle, this stray intrusion into the empty

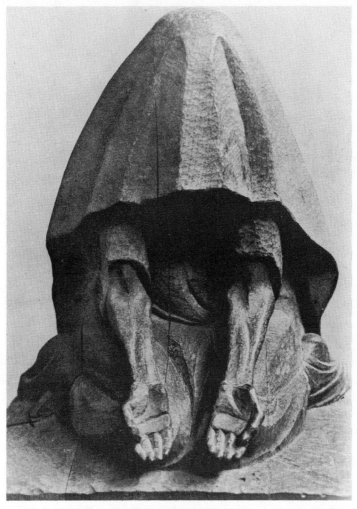

PLATE 5. Ernst Barlach (1870–1938), "Beggar" (1919), Wood, Collection unknown.

Figure 18

field has doubly deranged its stability. Not only is the field in disequilibrium about the vertical axis; it is in disequilibrium about the horizontal axis as well.

A dot which restores the quantitative equilibrium between the upper and lower registers serves only to aggravate the disequilibrium about the vertical axis (Fig. 19).

Figure 19 *Figure 20*

A dot which neutralizes the disequilibrium about the vertical axis gives a result of bilateral symmetry, but leaves still the qualitative contrast between the negative area when the field is upright and the same area when the field is inverted (Fig. 20).

But let a second dot of equal size be placed on the same diagonal, so situated as to fall beyond the point at which the two diagonals intersect, and as far removed from that point as the demented first dot is removed from it (Fig. 21).

Considered by itself, that second dot is as depraved as the first, and for the same reasons. But if the dot is seen as party to the complex which includes that other stray, its depravity is exactly the remedy needed. I suffer misgivings concerning this principle as a

Figure 21

principle of morals. That is a strange homeopathy which requires depravity as an antidote to itself. But as a principle of visual equilibrium it is beyond suspicion: it affords the one satisfactory resolution in which a wholly dynamic field can be established and preserved.

The field is poised in an entirely new kind of equilibrium. Its factors are distributed in such perfect counterpoise about the vertical and horizontal axes that an inversion of the whole will produce that whole again. Yet the new equilibrium has this peculiarity, that neither side of the vertical axis is a mirror image of the other, and neither side of the horizontal axis is a mirror image of the other. The field wants symmetry. It is nevertheless in equilibrium. Its equilibrium is *asymmetrical*.

The principle of asymmetrical equilibrium is capable of inexhaustible elaboration, and elaborations upon it constitute in fact, except for the simplest ornamental designs, the visual experience of mankind, wherever the experience of mankind has been subject to artistic controls. Asymmetrical equilibrium is the veritable key to Baroque painting. In Classical art it is the relaxing grace which teases geometry into life, tempering its order with freedom, its justice with mercy, its eternity with time.

A visual equilibrium will appear *dynamic* exactly in the measure that a principle of asymmetry governs it.

That is a general truth of the most fundamental importance, an emancipative truth which, as we shall see, is more pregnant of consequence than that truth concerning symmetry noted above.[2] It enables us to know of any field, irrespective of the particular forms which may be introduced into it, that where there is no asymmetry,

[2] See p. 40.

there can be no movement, that where asymmetry is present, the field, if it appears to be in equilibrium, is in dynamic equilibrium, that this dynamic character increases as the diagonals are approximated.

When painters speak of a pictorial field as being "active" or "at rest," they speak metaphorically and elliptically. For if to be at rest is simply not to move, then, in a literal sense, every pictorial field must be described as being at rest in relation to the ideal spectator whom it implicates.[3] And if to be active is to move, then, in a literal sense, no pictorial field is active. But evidently a literal sense is not what is intended. Among pictorial fields, all of which are in a literal sense at rest, the painter intends by the terms "activity" and "rest" to discriminate qualitative differences, differences which are visually so positive and demonstrable that any eye which cannot mark them is, like an eye grown blind, permanently forbidden from penetrating into the conditions of his art.

The painter's language is ambiguous; the contrast he intends to refer to is a simple datum of visual awareness. What then is this fact, which he discriminates as activity or rest, and which we discriminate as the dynamic or static character, of a pictorial field?

Well, to begin, he is talking about appearances. Matters of physical fact, of actual movement or rest, are not in question. The only matters properly in question are matters of visual stress.

Consider Figures 15 and 21. The one field is at rest; the other is active. Both are in perfect equilibrium: no transformation of either field will give an equilibrium superior to the one which the field already has.

Shall one impute the activity of the one field to a movement in the eye of the spectator? One shall not. In both cases the eye of the spectator remains, like the field itself, stationary, moveless, once the image has been focalized.

In what then does the qualitative difference of these fields consist? In one thing: degree of tension with the perpendicular axes. Both are in visual equilibrium. But the equilibrium seen is seen as a tension which relaxes as the horizontal and vertical axes are dominant, and grows taut as the diagonal axes are dominant.

[3] The cinematic art of the film is a revelatory exception. It shares the actualities of movement of the living drama and the dance. Pictorially it is powerful only as it works by cadences, resolving actualities of movement into moments of poise or suspension. These moments of poise or suspension, from which movement issues, toward which it gravitates, are the pictorial equilibria here under analysis.

The diagonals are *axes of dynamic stress*; the perpendicular axes are *axes of static stress.*

The axes are thus characterizable by their relation to the stability of the field, that visually stable whole which the spectator confronts. An axis of static stress is an axis by reference to which the stability of the field itself is judged. The proper orientation of field to spectator is established by it: it is an axis of zero-stress when the proper orientation has been found. An axis of dynamic stress is a line of maximum deviation from the static axes.[4]

[4] It is convenient for theoretical purposes to gain some conception of the range of static and dynamic possibilities: they are without number.

Compose about a rectangular field a circle whose center is the intersection of the axes, and whose diameter is equal to a diagonal (Fig. 22). Then *a–i* will

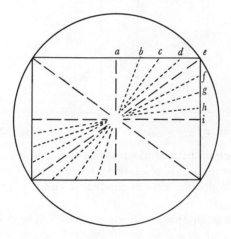

Figure 22

represent a selection of diameters, of which *a* and *i* are the perpendicular axes, and *e* is a diagonal.

The dynamic effect of any accent is the product of two factors: the distance of that accent from the vertical axis and its distance from the horizontal axis.

The point of intersection of the perpendicular axes is the cemetery of all dynamic effects: it is the point of no tension, absolute zero for that field, as perfectly static and immobile as it is singular and compulsive (Fig. 13).

But since any accent which lies apart from that point on one of the perpendicular axes will have with respect to that axis a distance-value of zero, its dynamic stress, at whatever distance it lies from the other axis, will be zero.

The diagonal *e* will be the locus of maximum dynamic stresses for this selection of diameters.

17. Asymmetry on a Static Axis: Perugino's "Mystical Crucifixion"

I propose now to complicate the equilibrium of the field by per-
mitting one additional factor to vary.

Heretofore, the resolution of a disequilibrium in the field has
been obtained by the simple repetition of a form in some other
position in the field.

There, as its shape was the same, and its size remained fixed, an
equilibrium was possible on one condition only, that the two forms
be distributed to positions equidistant from the point of intersection
of the axes. Thus, Figure 23 is in equilibrium; Figure 24 is not.

Figure 23 Figure 24

So long as equilibrium was identified with the symmetry of the
field, that was the single resolution of any disequilibrium. For by
that resolution alone could one produce a visible symmetry in the
negative area.

But in the moment that equilibrium is found to be independent of
symmetry, as in those visual equilibria which detach the forms from
the static axes, a whole new range of possibilities arises. There
emerge possibilities which permit even the static axes to be dynam-
ically employed.

Suppose a balance-arm to be physically placed upon a fulcrum,
and weights distributed upon it (Fig. 25).

Without a load the balance-arm rests in equilibrium on its ful-
crum (*a*). A load placed directly above the fulcrum leaves that
initial equilibrium undisturbed (*b*). If the load be displaced in any
degree from that position in which its gravitating stress is translated
directly downward through the vertical axis of the fulcrum, the
equilibrium is cancelled (*c*).

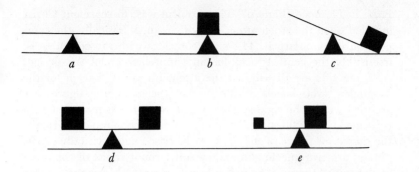

Figure 25

If a load equal to the first be placed beyond the fulcrum and at an equal distance from the fulcrum, it will provide a civilizing counterpoise which exactly compensates for the first load: the balance-arm returns to the horizontal, and equilibrium is restored (*d*).

There remains still a possibility. A lesser weight placed at a greater distance from the fulcrum will serve to compensate for a greater weight placed at a lesser distance on the opposite side. The balance-arm is again horizontal: the loads are distributed in equilibrium. The equilibrium is asymmetrical (*e*).

But the asymmetry has in this instance nothing to do with the tilting of the balance-arm. It is entirely a matter of the size and distribution of the weights.

In the same way, in a visual field, an asymmetrical equilibrium may be contrived on the static axes (Fig. 26). That precisely is the

Figure 26

kind of equilibrium employed in the most celebrated of Perugino's frescoes, the *Mystical Crucifixion* at Santa Maria Maddalena dei

Pazzi in Florence (Plate 6). The problem was, to represent Christ impaled upon the cross, attended by five saints. Basically, the composition is symmetrical. The cross coincides with the central axis, irresistibly the central focus for any apprehension of the design. At either side are distributed the attendant saints. Except for the Magdalen, who kneels at the foot of the cross, the figures are grouped within the rigid symmetry of a triangle. At its apex Christ is imaged, beautiful nude Apollo for nuns to contemplate, visually the dominant figure of the field. At its base angles, visually subordinate, are two kneeling saints, each the counterpoise of the other in the static scheme. The major saintly figures—Mary the Mother and John—stand nearer to the axis, and gain importance by their proximity to it. Each provides a compensating stress for the other in the despotic balance which presides, thus far unrelieved, over the design. Among these four figures, for each tilt of a head or advance of a foot on one side of the cross there appears a neutralizing counterthrust on the other. The whole design is suffused with this lucidly intelligible order, whose balance is so austerely calculated, whose placidity is so pure, so serenely free of accident, as to immobilize the mystery. But the Magdalen has still to be included in it. She kneels at the right of the cross, and for the mass of her figure there remains no other figure to provide the necessary counterpoise, lest the equilibrium be shattered. It is not shattered. On the contrary, it is preserved, but so preserved as to relax the symmetry which had otherwise been regarded as a work of the dead. The counterweight is found in the landscape, in three tenuous trees which silhouette their foliage against the sky above thin stems that repeat the vertical of the cross. They are too light a counterweight? No, they are exactly the counterweight needed. At their distance from the fulcrum, which is the cross, they have a visual stress equal to the stress of the Magdalen who kneels next to Christ and is, in her convent, next only to him in importance.

18. Directional Motives: Mondrian's "Composition in White, Black and Red"

A round dot is the most inflexibly stable of all visual motives. In such unerrant stability lie both its interest and its limitation. However it be rotated in its plane, it gives always the same stable

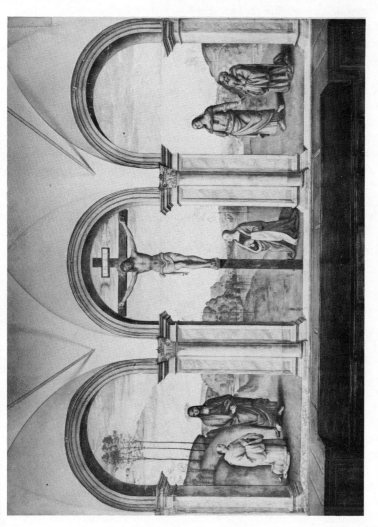

PLATE 6. Perugino (1446–1523), "Mystical Crucifxion" (c. 1496), Fresco, Santa Maria Maddalena dei Pazzi, Florence (Brogi).

aspect: it is never out of orientation, since its axes are all indifferently alike.

One cannot therefore speak of tilting a dot, unless by a gradation of tones one makes it appear to tip forward or backward out of the actual plane on which it is inscribed. But if those gradations be withheld from it, so that it lies flat and equable within its plane, it will exhibit the peculiar property, that no one of its internal axes has precedence over any other.

A round dot is the same in any placement, and will itself appear stable in every placement. A variation of the dot's position in a visual field will affect the equilibrium of the field; it does not affect the stability of the dot. The transformation of the visual field is attributable not to any difference in the dot, but, as we have seen, to a difference in the negative area that surrounds it. The positive form of the dot retains an undiminished stability through all of its vicissitudes.

A straight line has not this inevitable innocence. Its most declarative feature is its directionality. It marks a direction, it *points*, according to its orientation in the field (Figs. 27, 28). It is capable,

<div align="center">

Figure 27 *Figure 28*

</div>

if I let it move within the field, of pointing in any direction. But it has this peculiarity, that it never points in more than two directions at once. In this respect it differs significantly from a dot. The axes of a round dot point in all directions at once; therefore a dot is never felt to point at all. It is the visible illustration of Lord Acton's dictum, that power corrupts, and absolute power corrupts absolutely. But the line affords a very different kind of stress. Its power is very limited. Its stress is nevertheless intense in the measure of its limits.

Initially, the difference of motive causes no difference in the field which we are not already prepared to describe.

So long as the line is isolated, so long as it remains the single positive form in the field, no matter of any special theoretical interest arises.

The same equilibria which before were admissible are admissible here (Figs. 27–30). They have simply been increased in number, a

Figure 29 Figure 30

distinct equilibrium appearing as the motive lies parallel with the vertical axis, or with the horizontal axis, or is unambiguously tilted in relation to those axes.

The same possibilities of disequilibrium appear. A line that falls free of the vertical axis of the field, or of the vertical and horizontal axes together, will have to be compensated for, and neutralized, if the visual equilibrium of the field is to be restored (Figs. 31, 32).

Figure 31 Figure 32

The real novelty of the new motive shows itself when it is repeated in an attempt to constitute an equilibrium which has been thus deranged. For it immediately appears that the thing required, in order to neutralize a directional accent, is not merely a repetition of that accent, the repetition of an equal pulsation of dark on light, but a proper direction of it as well (Figs. 33–36). The orientation of the second motive makes a difference. Where dots were used, it

made none, so long only as the right position, the right location of it in the field, was struck. But with a directional motive an equal accent, even an equal accent properly located, will no longer suffice.

Figure 33

Figure 34

Figure 35

Figure 36

The equilibrium of the field now depends not merely on the equality of the accent and on the location of it, but on the direction of it. In Figures 33 and 34 the equilibrium fails. The motives are neither unequal nor improperly located; they are simply improperly oriented. In consequence, their actual equivalence is not visually affirmed. Visually, the direction of the motive is part of its value; differently directed, it has not the same value.

How shall the contrast of the two fields in Figures 35 and 36 be described? The one is static, the other dynamic? So it would seem. Yet both are realized upon a static axis of the field.

The same question arises, but arises conversely, with respect to Figures 37 and 38. How shall they be described? The one is dynamic, the other static? Yet both are realized upon a dynamic axis of the field.

Evidently a more precise characterization is needed. For, visually, the differences among the four fields are remarkable enough. But if

Figure 37 Figure 38

the terms "static" and "dynamic" are reserved to describe only the character of the field as a whole, then terms are wanting to describe these differences.

I shall therefore extend the use of these terms so that it shall be possible to speak both of a static or dynamic *field* and of a static or dynamic *motive*. Basically, the sense is the same, since ultimately the reference is in all cases to those static axes, the perpendiculars, by relation to which the orientation of the field is judged. Yet by this extension I am able to state the respects in which these fields differ. Figure 35 is a static field composed out of static motives; Figure 36 a static field composed out of dynamic motives.[5] Figure 37 is a dynamic field composed out of dynamic motives; Figure 38 a dynamic field composed out of static motives.

A viewer of Mondrian's *Composition in White, Black and Red* (Plate 7) will find himself spontaneously attending not merely to the lines, which are Mondrian's positive forms, but to the interior expanses within them, to the whites and to the frank colors, whose shapes they have generated. One hardly thinks to notice, in meditating those shrewd and empty spaces, that the linear rectangles are for the most part open, closed only by the frame, which is no part of the ensemble. Whether as expanse of color or as linear contour, one sees the same shape constantly recurring. Neither line nor shape is permitted to vary: therefore one attends, and attends singularly, to differences of measure, to contrasts of color, and to ratios. The color and proportions of these simple shapes are

[5] Strictly, Figure 36, considered as a field, is not symmetrical, since the right and left side are not each the mirror image of the other. The counterthrust of motives which is wanting to the field, too greatly complicates it to introduce a strictly static symmetry here: see Section 19.

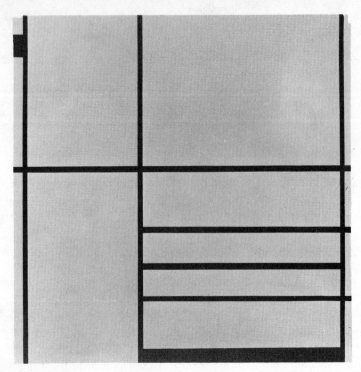

PLATE 7. Piet Mondrian (1872–1944), "Composition in White, Black and Red" (1936), Oil on canvas, 40¼ × 41". Collection, The Museum of Modern Art, New York. Gift of the Advisory Committee.

The narrow upright rectangles at the extreme left (adjacent to the frame) exhibit in their heights two measures (1 and 2). Immediately above them, in two small rectangles (3 and 4) identical in size as well as in shape, a single contrast of hue is stated.

The rectangular shape, those two measures, and that single hue contrast are Mondrian's simple terms.

The two measures reappear in the large rectangle (three linear sides) at the lower left (5). It is an illustration of the most famous of all simple proportions, the proportion known as the "Golden Section," a rectangle such that the shorter side a is to the longer b as the longer is to the sum of the two sides:

$$a : b :: b : (a+b).$$

That is Mondrian's theme. The remainder of the painting may be explored as variations rung upon it.

Mondrian's simple values. Out of them, out of their orderly relations to each other, the economy of the field has been realized. The forms are all static, their sides all rigidly parallel to the perpendicular axes of the field. The merciless severity is relaxed only by an asymmetry of the field itself.

Shall this be accounted art, this simple study of proportions which Mondrian was content to frame? The poise of the array is literally incontestable. Men who debate the authenticity of this art should be aware that the matter in dispute is not the sensitiveness of the performance, but its sufficiency only. Its sensitiveness is beyond suspicion. It is, in visual terms, what men are accustomed in music to describe as a theme and variation. Men blind to its virtue are incompetent to comment on its limits. But it is one of the characteristic timidities of the temper of the times that when its positive virtue has been noted, its limits go unnoted. It is art without risk, and it is a commentary on ourselves that men should ever have thought to admire it for its audacity. The audacity is not in it, but in its frame. Mondrian is the frankest Academician of the twentieth century, and men who take the twentieth century seriously, because it is their world, will discover in this simple array of lines and shapes the most pathetic document of a world in which the fragmentation of life has been carried to its farthest extreme, a document infinitely more pathetic than the *Guernica*, whose artist knew at least to despair of the world that begot it. Plato would have loved Mondrian. He would have loved him for the reason that Mondrian claimed for art no function beyond the one which Plato would permit, who desired of flute-players that they play the flute and desist from matters more consequent than melody. But I surmise that a dedicated artist ought to hesitate before the approbation of one who loves him as a geometer without a head. It is a confusion of thought to suppose that the fulfillment of art must lie solely in the demonstration of its capacity for independence. For if that were so, art would be proved superfluous in the moment that its independence was admitted.

19. Thrust and Counterthrust

By the *thrust* of a motive is intended simply the value which it acquires, by virtue of its directionality, when it is set in concert with other motives. The thrust of a motive is a contextual value, a value

which can appear only as the motive figures as an element in composition. Out of sensitivity for it an artist selects his motives; out of sensitivity for it his motives are combined. It lies at the foundation of all composition of shapes. It will show itself in the simplest Greek fret; it will show itself equally, with variations rung upon it, in a Michelangelo.

When, in the frescoes of the Sistine Chapel, Michelangelo represented *The Temptation and the Fall of Man* (Plate 8), he chose to include within one and the same pictorial field two successive episodes, both the temptation of the serpent and the banishment from the garden. Dramatically, the two scenes are sequent: they follow one another in time. Pictorially, they are simultaneous: they appear one beside the other. The artist's problem was to assure, in spite of the simultaneity of his art, that in the reading of the picture the dramatic order should be observed—that is, that the picture should be read from left to right and not, in opposition to the dramatic sequence, from right to left. Every viewer will discover that he has in fact, without reflection, read it in that order, nor has the order of the reading been dictated, as one might suppose, by any habit imparted by a literary convention. The design would compel a Chinese, whose literary habits are the reverse of ours. Even in ignorance of the Bible story he reads as we do, in spontaneous compliance with the order which Michelangelo intended. The order is governed by the immanent thrust of the forms out of which the picture has been composed. That superb Eve set against a desert Eden turns in *contrapposto* upon her own axis to receive the fruit. The form of Adam is the visual obverse of her form, the same form seen from the opposite side. Both are spirals, like coiled springs suffused with tensions, and in both the tension is released in the outward thrust of a reaching gesture which extends itself toward the serpent and the forbidden fruit. You may see the same directional thrust, already twice announced, announced still a third time in the somber shape of the dead tree-stump, whose leafless branch simply repeats the direction in an echo of the dead. That thrust thrice stated is translated over the outspread arms of the serpent. It is taken up and struck again, as in a final trump of doom, in the flaming sword of Gabriel on the yonder side of the tree. Beneath it, abased in their lost innocence, move the banished pair, afflicted Adam whose backward gesture contains the movement by opposing it, Eve cowering in a physical degradation which, though outwardly

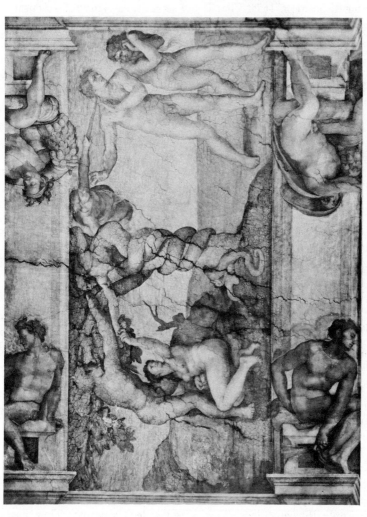

PLATE 8. Michelangelo Buonarroti (1475–1564), "The Temptation and the Fall of Man" (1508–1512), Fresco, Sistine Chapel, Vatican (Alinari).

greater, shall be sooner remedied. If there be any doubt of the
government of that design, attempt to read it in the reverse order.
The eye suffers an arrest, as if it were offending against its own
better disposition. It is. That is the secret sovereignty of a design,
that we take its disposition to be our own.

Leonardo wrote: "Two weaknesses leaning against one another
add up to one strength." I propose at this juncture to exhibit this
characteristic in its simplest estate.

Let three directional motives be placed together within a field as
in Figure 39. The lines are of equal length; they share a single

Figure 39

direction. Nevertheless, if it be asked, which *pair* of lines, of the
three possible pairings, is visually dominant, there will be no dis-
agreement that the upper two, considered as a pair, have the
firmest unity, and this consent will be sensibly confirmed if the
field is inverted.

The interest here is not in the fact of the matter but in the why
of the matter. Why do we apprehend this pair as dominant, as most
unitary, despite the fact that in each of the three pairs the lines are
parallel, and in one of the three pairs both members fall on the
vertical axis?

The reason is clear, that the dominant pair are seen as segments
of one and the same line, and therefore reinforce each other, con-
ferring upon each other a value which neither has as a member of
the other pairs. The dominant pair are not merely parallel; they
are implicitly coincident. They stand indeed separate. They are
nevertheless seen as the termini of a single line, and though the line
is undrawn except as they draw it, their implicit relation to each
other, as parts of that simple whole which would include them, is an
enhancement of their relative value as a pair.

We reflect here upon a predisposition in ourselves, to see selectively and to see by spontaneous preference those combinations in which the greatest number of complementarities may be found. Gestalt psychology is an extended reflection upon the perception of this phenomenon. But the psychology of the matter is for our purposes not in question. The phenomenon alone, not the perception of it, is in question. The phenomenon contains, implicitly, one of the profoundest principles of all art.

Let two lines be placed upon the vertical axis as in Figure 40.

Figure 40

It would seem that if the tilt of the lower motive were to be reversed, so as to neutralize the obliquity of the upper motive, a more assured equilibrium might be had. The visual effect of that transformation is just the opposite of what was expected (Fig. 41). Both motives

Figure 41

fall on what is in fact the vertical axis of the field. But the field is in visual disarray. The active center of the field no longer coincides with the vertical axis: it has been displaced somewhat to the left of the position where the equilibrium of the field would require it. Why? Because the motives seen together are not the same as the

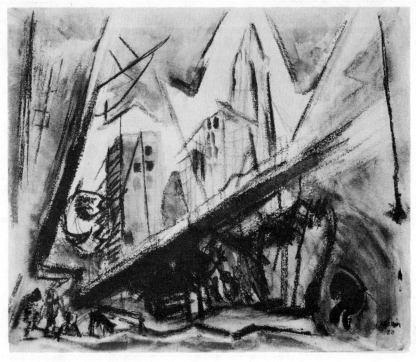

PLATE 9. John Marin (1870–1953), "Lower Manhattan" (1920), Water-color, 21⅞ × 26¾". Collection, The Museum of Modern Art, New York. The Philip L. Goodwin Collection.

The medium is watercolor. The effect is symphonic. Unerringly, John Marin commands the most monumental effects out of the simplest possible means. It is an art of suggestion, never of statement. His space is invariably thus contracted, jagged, suffused with explosive thrusts and angularities. The value of any form is always beyond itself, never in itself. The forms are unharnessed except as they harness each other. As the composition is dense, its frequency is increased; as the positive forms bulk large in relation to the empty intervals, their amplitude is exaggerated to a degree beyond all expectation in so delicate a technique.

motives seen apart. They thrust at each other, as was intended. But the thrusts converge at a place distinct from the place of the motives in which they have originated. The motives have their place on the vertical axis. The center of stress falls at a place midway between that axis and the point at which the thrusts converge.

When directional motives play against each other, they activate parts of the field beyond themselves, parts of the field which they do not themselves occupy (Plate 9).

Therefore, if the thing wanted in Figure 41 was not merely a neutralization of thrusts, but an equilibrium of the field in which thrusts are neutralized, Figure 41 is a failure. An equilibrium can be gained only by a displacement of the motives themselves, so that not they, but the center of stress, shall coincide with the vertical axis (Fig. 42).

Figure 42

20. *Leonardo da Vinci's "Last Supper"*

Leonardo's *Last Supper* is a study in the uses of such thrusts (Plate 10). Christ sits attended by his twelve disciples at the sacramental feast. How, out of this complicated assembly of thirteen figures, do we know which figure is Christ, and which is Judas? That we know, there can be no question. But how we know, how in visual terms we succeed in discriminating the major personages, is worth attending to. It is the clearest possible illustration of the general truth, that art and despotism are intimately allied. An artist's controls are never merely permissive; they are invariably tyrannous.

In the season of the Counter-Reformation, Baroque artists— a Tintoretto, for example—will find the significance of the Last Supper in the institution of the Eucharist, in the sacramental act,

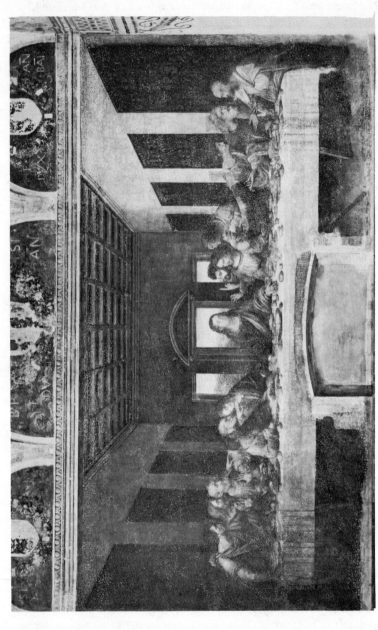

PLATE 10. Leonardo da Vinci (1452–1519), "Last Supper" (1495–1498), Santa Maria delle Grazie, Milan (Alinari).

the breaking of the bread and the pouring of the wine, so that Christ, however else he be identified, is at last distinguished by the act he performs, and singularly performs (Plate 14). But here it is not so. A Classical artist discovers no incitement in the ritual observance. Leonardo chose to represent a human scene, not the divine mystery but the human drama, the essentially human trage- dy, in which, if indeed a god was sacrificed, yet still a master was deserted, and a loyalty was spoiled. Leonardo chose for represen- tation, as a dramatist would choose, the "pregnant moment," the moment freighted with moral consequence, serious and appalling, in which Jesus announces that one of the twelve will betray him. The shock of the revelation runs through the stunned and stricken group, as each of the disciples registers his characteristic agitation. Each is a study in singularity. Each reacts individually according to the idiom of a temperament, so that in the heightened tenor of the scene the emotion is refracted twelve times over, and twelve times differently. That is the perspicuous power of this design, that out of responses so various and so diffuse there should never- theless emerge an effect so unitary, so stable, and so concentrated.

Christ is the center, visually as well as dramatically. His figure falls directly on axis, so that the basically symmetrical design hinges itself upon him. But more than that, the head appears at that rivet- ing position at which all of the ideal axes—the diagonals as well as the perpendiculars—intersect. Such is its prime distinction: it is the only element in perfect poise, the one element at perfect rest within the field. It is the already familiar motive which was seen, in the extremity of abstraction, in Figure 13. It is, simply, Figure 13 put to use.

Christ's position in the field would of itself suffice to isolate him. But if such isolation will declare that he is not of the world, it will not establish unequivocally that he is nevertheless in it. His impli- cation in the scene which includes that tumultuous world about him Leonardo has contrived out of simple thrusts, directional motives multiplied and insistent, which converge upon him. Project the lines established by the upper edge of the tapestries on the wall, by the beams of the ceiling, by the tiles on the floor: they irradiate from the head of Christ as from a common center. They not merely irradiate from it; they point toward it. Directional motives, they generate visual thrusts, systematically relating the surrounding space to a center beyond themselves, upon which ideally they

converge. Those lines are, in fact, the perspective lines of recession, which structure the space in depth. Christ's head is at their vanishing point.

In short, the point of zero stress for the field and the vanishing point of these lines of recession virtually coincide, and Christ's head appears, an irresistible cynosure, limned solitary dark on light, at the point of their coincidence.

The movements of the disciples are individually violent, surcharged with excitement. Yet, though each figure except Christ reacts with intense outward gesture, the general impression of this pictorial drama is, by a visual paradox, very placid. The parts are many and agitated, the whole is one and serene. Observe Tintoretto's version if you doubt its serenity. But you will not doubt it. Despite all the diffuse intensity of its details, the picture remains concentrated, lucid, orderly. How has this effect been achieved? By thrusts. By thrusts methodically counteracted, by thrusts imperiously tamed. "Two weaknesses that lean against one another add up to one strength." For every thrust there is a neutralizing counterthrust, so that out of a concert of elements, all of which are individually instable, comes this stability and perfect poise.

The twelve disciples have been distributed into four groups and ranged at either side of Christ. Within each of these sub-groups the individuating gestures have been carefully worked. Was it not Leonardo's advice to painters to observe the movements and gestures of men, since movement, gesture, was the dumb image of the soul? James's figure (at Christ's left) flares back with the pained repugnance of a man lashed across the face. The thrust of his form is immediately met, counteracted, and neutralized by the forward movement of Philip: "Lord, is it I?" Each of the thrusts is instable; together they form a stable group. Therefore, in the third member of the group, Leonardo can afford a vertical: it is Thomas, Doubting Thomas, identified by the vertical upraised finger with which, later, he shall ask to probe the wound of a resurrected Christ.

The same balance of thrust and counterthrust is realized again at Christ's right. John, half-swooning, leans away from Christ; his movement is met and immediately neutralized by Peter, who juts forth his fierce aggressive chin and resolutely draws a knife. Each thrust compensates for the other. Together, the figures are stable. Who then is he, the third member of the group, whose shape sinks sinister into shadow? Judas would be known, even if he grasped no

money-bag. Not only does a shadow cover him. He leans, he produces a thrust, instable and nowhere neutralized within his group, so that his figure as a member of that group obtrudes itself, a dissonant rebel thing, at peace neither with others nor with itself. The visual form answers to a dramatic demand.

Louis Sullivan enunciated the dictum: "Form follows function." It is so in architecture. It is so here. It is so in all art, wherever form is artistically employed. Art may detach itself from religious subjects. It may detach itself from drama or from story. It can never detach itself from the demand which calls it forth. A form in art has a functional justification, or it has no justification. No form is self-justifying. That is why the art of Leonardo is so permanent a revelation of the artist's task, even for those who no longer share his purposes. For he knew that art and use are not opposed. There are no purposes which are inartistic. There are only purposes which men pursue inartistically.

IV. Pattern and Rhythm

21. Liberty under Law

Tell a painter that there are rules of his art, he will in the name of freedom deny it. Tell the same painter that his art is unprincipled, he will be offended.

Here, evidently, as in other connections where fundamental matters are at stake, men's acts are more trustworthy than their protestations. In what they do you may see principles at work which are on the whole consistent and coherent. In what they profess you must be content to hear them affirm principles which in practice they renounce, and deny principles which in practice they affirm. Their acts are honorable, at least they are no worse than those of their forebears, as certainly they are no better, so that if to be honorable is to be only as good as their forebears, they are honorable. But their professions are nevertheless confused, and if there is any respect in which the present generation of men excels the generations of its ancestors, it is in the degree of confusion which it permits itself.

A principle of art is a rule of art. Any artist who claims for his art that it is principled asserts in effect that there is a rule which governs it, a rule implicit in his activity of construction, which must be grasped, and firmly grasped, if the art of his construction is to be grasped at all. The art of his work is at last the lawfulness of his work, and not to see its lawfulness is precisely not to see its art. For the art of his work lies in the responsiveness of his forms to the rule which he has laid down.

The making of rules for art is the task neither of philosophy nor of criticism. It, is, on the contrary, the artist's task. He is his own legislator. The rule which obliges him he has given to himself, and except as he gives it to himself the role of artist is denied to him.

In this lies the freedom of every artist in every generation of men. The artist can find authority in precedent only because he treats precedent as authoritative. He can find authority in nature only because he has constituted it there. He may place authority in neither. He is in his role as artist free to legislate as he chooses, to make whatever rules of art he chooses. Only one thing is forbidden to him, which circumscribes his freedom, because it is the condition of his freedom: he is not free *not* to choose. He is not free to work without a rule. That is the paradox of the artist's freedom: there is no rule which governs all art; yet there is no art without rule, and can be none.

Once, when I had still the innocence of a child, I flew aloft a kite and watched it soar like a snared gull, impatient of its leash, in its wild element against the sky. Proud untamed thing, pulsing in glorious insecurity in the wind at its dizzy altitudes, it struggled against the bond which denied to it its freedom. Out of love of it, to set it free, to give it freedom, I loosed its string. It fell tragically dead upon the soil. Broken, torn, irreparable, it would not fly again, and I, too suddenly grown wiser, wept above it. The restraint which held it to the earth was the condition of its mounting to the sky. Its freedom was in its bond, not beyond it. Without its bond it had no freedom, but only brokenness and cessation.

Just so, though every artist is free to choose his rule, there is no art without rule, and can be none. The freedom of the artist is in the rule which his activity respects. Lawless freedom, freedom beyond rule, he neither has nor ever in fact wants. For the only authentic freedom which men do ever seek, in art or elsewhere, is a freedom under law, whose sanctity lies in the fact that they have sanctified it, that the law is theirs because they have constituted it theirs, and stand committed to preserving it, and themselves in it.

22. *Pattern*

The primary datum for all visual analysis is *pattern*. By pattern I understand an order among elements whose relations to each other are governed by a discerned principle.

Wherever pattern is, there also a principle must be. To apprehend a pattern is to discern the principle on which its elements are ordered. To see the elements only will not suffice, for the pattern

does not reside in the elements. It resides in the rule which governs
their relations to each other. To see only the elements is to leave the
pattern undiscerned, for the pattern which emerges from those
elements consists in the regularity of their order, and in nothing
else.

Thus, there may be a pattern where no pattern is seen. The
obtuseness of ordinary vision encounters patterns on every side, and
passes them impenitently by, patterns whose principle of order,
though discernible, is undiscerned. Men have eyes, and see not,
and the spirit famishes amid plenty, eating out of itself, on stale
crust. The reason is, not that the patterns are too subtle, but that
the vision is too dull, dulled by habit, closed by stereotypes which
have been formed exclusively in the interests of action. This is the
only destitution for which the poor of the earth are themselves
responsible, and for which the practical of the earth can busy no
remedy. Stereotyped vision sees only those patterns which its
stereotypes have permitted it to anticipate. To other patterns,
which its stereotypes exclude, it is blind with the fatigue of old
habit, blind as Samson was blind in the living tomb of his own
body, whose eyes Philistines had put out. Habit is the Philistine
part of us. The patterns are there to be seen; they are not seen.
And for any expansion of experience which they might have en-
gendered it is as if they were not. Of habit we can never be free.
The education of men is grounded in it; but also, and no less, the
miseducation of men is grounded in it. That is why, especially in
America, where miseducation of the eye has gone farthest, the cul-
tivation of vision is so profound a challenge, serious in the measure
of our poverty. For experience can never be wider than man's capac-
ity for apprehension. In that limitation no man need ever find
occasion for lamentation. We are what we are, we have the capac-
ities we have, and that is enough. The demoralization of spirit,
which men can in reasonableness regret, comes from elsewhere,
from the circumstance that they allow themselves to be less than
they are, to range abroad less far than they are capable of, self-
paupered, victims of no dullness save dullness which they have
wrought.

To discern the principle of a pattern is not necessarily to articulate
it—to put it into words. That a man may or may not succeed in
doing, or even aspire to do. It is unnecessary, except as it cultivates
discernment, that it should be done, and putting things into words

is at all events an art as narrowly diffused as any other art. "The creatures of painting," said Socrates, "stand like living beings, but if one asks them a question, they preserve a solemn silence."[1]

The principle discerned in all ornamental patterns is *simple repetition*. Let a round spot of color be repeated at regular intervals over a plain surface, preserving in a simple iteration the same shape, and size, and color-contrast. There results a simple pattern, the common polka-dot, which pulsates in an even distribution over the surface (Fig. 43).

Figure 43

The principle of repetition underlies all ornament whatever. That, basically, is what one means by ornament: a motive being fixed upon, the motive is simply repeated, and repeated regularly, throughout the area reserved for it.

What is the effect? It is identically the effect which is produced wherever a standard unit is applied to any space: it *measures* the space. The dots are of a size, and the intervals between them are fixed. Therefore, once the size of the dot and the interval are known, all distances become calculable. The point is not that one counts the dots and intervals: one could, but does not. The actual number is without interest. The matter of importance is the visual transformation of the field itself. The field has been sensibly scaled, quantified. It has been rendered, by the regularity of the contrasts over its surface, visually appreciable as an area. One of the profoundest metamorphoses which a space can undergo is this investiture with an implicit scale, which permits it to be seen as measurable, though its measure be never taken.

In general, for our perception, what is seen as measurable is more easily grasped than what is not. Stand in the midst of a field of

[1] *Phaedrus*, 275 c-d.

wheat, so that the surface of the wheat-ears extends uninterruptedly in all directions from your waist-height: all distances will lose their definiteness. The surface is homogeneous, without contrast, therefore without scale or measure which makes distances graspable. Stand beside the fence that hedges a field on any of its sides: the fence-posts, themselves of equal height and spaced at equal intervals, enable the distances to be grasped, and grasped visually, in a single act. In fact, physically, both expanses are indifferently measurable: a surveyor can plot a distance from the middle of the field as well as along its edge. But that indifference is not the phenomenal fact which you experience. It is exactly what you do not see, but have had to learn. Both expanses are in fact measurable; only the one is *seen* as measurable. The latter alone affords, as a visual appearance, the scale necessary to make distances appreciable.

Appreciable scale is at last the simple basis of those descriptions of Greek architecture which characterize it as a thing of "clarity," of "definition," of "intelligibleness" (Plate 11). A classical order is a system of proportions, and this system, once settled on, provides an intelligible unit which is known and repeatable. Each column with its piece of entablature and the bay which separates it from its neighbor is a visually appreciable quantity. Therefore, in the peristyle of the building, the unit being fixed, the repetition of it scales the space of the building, renders it systematically intelligible in terms of the measure which the unit has declared.

It is one of the paradoxes of musical experience that one is as much aware of the absence of sound as of its presence. A listener identifies in music, besides the value of its sounds, the value of its silences. Which is to say, that music is an art of time, only derivatively and incidentally an art of tones. For if in music the tones alone have value, a musical silence should have none. Is it not strange that sound withheld can be at times more pregnant of urgency than sound rendered? The reason is at hand. A musical silence is never a mere void; it is invariably a suspense, a suspense which gathers increase as its interval is extended. Time is not here wasted; it is used. And the awareness of it is, if anything, made more acute as expectancy is postponed. That, I say, is a paradoxical phenomenon, though familiarity has dulled the intellect from perceiving it. Beneath the structure of a musical composition, representing the measured flow of time, there is a recurrent pulse, stable, even, equable, against which the melodic line unfolds. Were it not for this basic structure, the

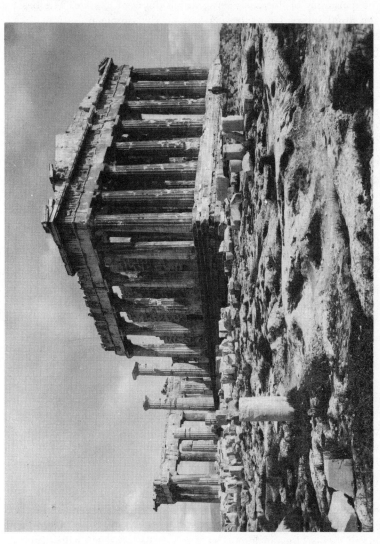

PLATE 11. Iktinos and Kallikrates, Parthenon (447–432 B.C.), Elevation, West, Acropolis, Athens (Alinari).

declarative temporal character of the melodic line could never be
felt. The line quickens or slows: its change is apprehended against
the constancy of this basic flow, which does not change. The basic
accentual interval may be marked by the simple pulsations of a
drum-beat. The drum-beat is then a pulse regularly recurring at
fixed intervals. It has introduced a bare regularity into the experi-
ence of time, and time is apprehended as a measured flow. What is
the interest of a musical silence? The measure having been estab-
lished, let one beat fail to strike before its pulsation is again regularly
resumed. The interval is still felt, though no beat has been struck to
announce it. The thing repeated is in fact the interval, which is
silent, not the beat, which is heard. The beat is needed to establish
the quantity, and afterwards to maintain it. But the rule of quantity
continues to operate even in its absence.

The polka-dot produces with respect to space the same effect
which the recurrent drum-beat produces with respect to time. The
regularity of the repetitions enables spatial intervals to be judged.
Omit one of the dots where its occurrence was anticipated, you will
experience the effect of a visual hiatus, a "silence," a *felt* omission.
Which is to say, that the visual area over which the pattern is spread
is experienced as a system of intervals whose rule is known. The
space is no mere void. It is a structured lattice, whose structure
qualifies the effects producible within it (Plate 12).

23. *The Affinity of Forms*

Every apprehension of pattern is grounded on what I shall call
the *affinity of forms*. Visual forms are never neutral; they are never
merely juxtaposed. They stand to each other in varying degrees of
affinity. They mutually attract, or mutually repel, each other.
Where there is no affinity, there can be no pattern. Where affinity is
not seen, no pattern can be seen.

Of all the senses sight is the most meticulous economist. A set
of elements distributed within a field will be apprehended in the
simplest geometrical form which is consistent with a decisive order-
ing of them. Thus, in Figure 44, I grasp the forms as ideally distrib-
uted within a lozenge. Why do I not see them, as very well I could,
as having their centers distributed on a circle (Fig. 45)? It is the case
that I do not. The reason is, that an ideal circle gives no decisive

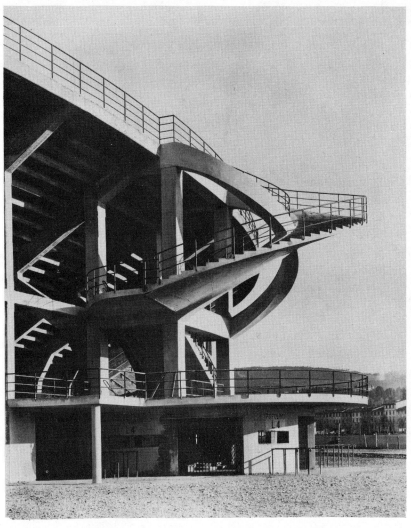

PLATE 12. Pier Luigi Nervi (1891–), Stadium (1932), Florence.
Nervi's Stadium is a lyric in steel and concrete. The essential clarity of the design resides in the single circumstance that every element is the declaration of a module by which the space may be scaled. The space is seen in terms of repeated quantities; it is therefore itself a calculable quantity. All distances in all directions are capable of being mastered in terms of the visual measures which pulse through the work.

Figure 44

selection among its own diameters: it will not suffice to discriminate the vertical and horizontal diameters as the relevant ones. The circle is therefore indecisive as a simplifying form in terms of which the arrangement can be grasped and held. In my spontaneous act of

Figure 45

vision I adopt the lozenge, the simplest form whose axes will declare decisively the position of the dots in relation to each other.

But now let the upper and lowermost circles be replaced by squares (Fig. 46). I see the group immediately in the first instance

Figure 46

as lying on a cross. The vertical between the squares and the horizontal between the circles are visually more emphatic than the lozenge, though, subordinately, the lozenge is still felt. This relative attraction of like forms to each other is what I call their affinity.

The affinity of forms for each other is a phenomenal fact, a fact about motives, not a fact about the perception of motives. It consists in this, that a relation of similars has a value which preponderates over a relation of dissimilars. The relation of circle to circle, or of rectangle to rectangle, has a value which is not shared by the relation of circle to rectangle or of rectangle to circle. No actual line is spread between the like forms in Figure 46: I see them nevertheless bound to each other as by a real ligature. Nor will that bond of affinity be made less powerful by a different distribution of the

Figure 47

shapes, as in Figure 47. The bond between the forms is a function of their similarity, not of their position.[2] It should, moreover, be

[2] A special case should be attended to. If diagram *b* in Figure 47 be placed on its side, I see two parallel verticals, each composed of a circle and a square. That should come as no surprise. For here the things held to be alike are complex, neither the circle nor the square taken simply, but the two taken together. The symmetry of the group determines what I shall construe as unit in the group.

noted that the similarity in question is not restricted to similarity of shape. Let the shapes remain constant, and introduce among them a contrast of color, the similarity in color will suffice to establish felt affinities, to which the eye will spontaneously respond.

When Fra Angelico would crown the Virgin amid an angels' choir, he gives a garland of heads: the affinity of shapes will make a choir of a crowd. When Michelangelo would isolate the panels of the Sistine ceiling, he disposes a sequence of nude youths: the affinity of forms will generate even for Omnipotence a sufficient frame (Plate 8).

24. Quality and Quantity

The thing repeated in ornament, the unit out of whose repetitions the pattern emerges, is entitled a *visual motive*.

All visual motives will have at least this degree of complexity, that they depend upon the contrast of a positive form with the ground on which it lies. Upon the ground the positive form recurs at fixed intervals. The interval is constant, just as the positive form is constant. What I call a visual motive includes the interval as well as the positive form.[3]

The same positive forms repeated at a different interval will therefore be understood to constitute a distinct motive (Fig. 48).

a b

Figure 48

The mathematician Birkhoff claimed in a table of seven ornaments to have exhausted the species of ornament expandable in one dimension, and in a table of seventeen the species of ornament expandable in two.[4] For the purpose of cataloguing ornament that information, if it be true, is not unimportant. It is not, however,

[3] The interval may be zero, as in all continuous or tangential forms (Figs. 48*b*, 50*b*).

[4] George D. Birkhoff, *Aesthetic Measure* (Harvard University Press: Cambridge, Mass., 1933), p. 55: Plates VIII-XII.

the information which is practically wanted for any purpose of visual analysis or of visual design. The information wanted lies not in the species of ornament, but in the principles by which those species are differentiated. For in these principles, exhibited in the sheer transparency of a use which isolates them, will be found the modes of transformation belonging to the painter's art in its most majestic and sophisticated no less than in its simplest and most guileless essays.

I set down three strokes, vertical lines regularly spaced and each equal to the others (Fig. 49*a*). The visual motive is engagingly

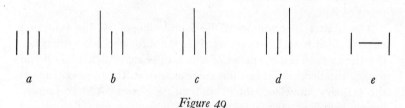

Figure 49

simple, a single vertical line with its interval. Thrice repeated, it produces a pattern. By lengthening one stroke, I introduce a most remarkable transformation (Fig. 49 *b, c, d*). Only the quantity has been altered, but that single alteration has imported in its train an accentual contrast, a dominance of one element over the other two, and as the position of that accent varies, the quality of the sequence varies. What before was a pattern has become, in any one of these alternatives, a single complex motive, capable itself of generating a pattern and of producing a distinctive rhythm as its accent cyclically recurs. The *sequence* (as distinct from the elements which compose it) has acquired a positive value, since it will exhibit a different rhythm as the position of the accent varies.

The contrast which distinguishes Figure 49*a* on the one side from *b, c*, and *d* on the other I shall describe as a *quantitative contrast*: it depends entirely on quantity, on the length of the lines.

The contrast which distinguishes Figures 49*b, c*, and *d* from each other I shall describe as a *qualitative contrast*: the quantity remaining constant, the difference depends on the characteristic rhythmic contrasts of the several sequences—on dactyls and anapests, and on that tamed Ohio which will never overflow. In the same way *a* and *e* are qualitatively distinct.

25. Rhythm

Quantitative and qualitative contrasts lie at the basis of what is described as *rhythm* in the visual arts. By rhythm I intend an emergent property of sequences. Every pattern has it. Ornament is the redundancy of it. In the simplest visual motive it is already implicit in the alternation of positive form and interval, though only repetition will disclose it in that, its simplest estate.

The root of the word rhythm is the Greek *rhein*, "to flow," whence the noun *rhythmos*. A stream flows: in a dry season its rhythm is placid; in a season of flood its rhythm is turbulent, fierce, savage, all ruthless drive and angry tumult. Rhythmic contrasts are contrasts of flow.

The matter in question is the foundation of all the sublimest effects which man knows in art. It is the most pervasive, therefore it is the most secret, character of a human being's world of sight and sound. Intellect can at last but countenance it. It can never impart the primary knowledge of it, and unless already it were known, known simply as men know warmth or passion or pain, there could be no knowing.

I set lines down side by side. The matter in question is for the moment not their sense, but the manner in which their sense is borne.

> Music that softlier on the spirit lies
> Than tired eyelids on tired eyes....

> Thou still unravish'd bride of quietness
> Thou foster-child of silence and slow time....

> The world is charged with the grandeur of God.
> It will flame out, like shining from shook foil;
> It gathers to a greatness, like the ooze of oil
> Crushed.

> Rumble thy bellyful! Spit, fire! spout, rain!
> Nor rain, wind, thunder, fire, are my daughters....

> Not poppy, nor mandragora,
> Nor all the drowsy syrups of the world
> Shall ever medicine thee to that sweet sleep
> Which thou ow'dst yesterday.

> Him the Almighty Power
> Hurled headlong flaming from the ethereal sky,
> With hideous ruin and combustion, down
> To bottomless perdition....

And you O my soul where you stand,
Surrounded, detached, in measureless oceans of space,
Ceaselessly musing, venturing, throwing, seeking the spheres to
 connect them.
Till the bridge you will need be form'd, till the ductile anchor hold,
Till the gossamer thread you fling catch somewhere, O my soul.

The contrasts of rhythm are as broad as the contrasts of sense. That is their artfulness, that they reverberate so responsively to the demands of sense that sense and sound are interfused, the one the inevitable and indivorcible complement of the other. That fitness is the sole object of any serious concern with form. Divorce form from the use to which it has been committed, you have suspended its proper virtue. The value of a work of art never lies in the circumstance that it has form, but in the circumstance that the forms it has are the forms required.

Therefore, if now I invite you to contemplate rhythmic contrasts estranged from any use, I must for a little time rob them of their virtue. Nothing is lost by that. The keenness of a knife-blade may be observed even if I do not know its use for cutting. But I shall understand its value in that use only by understanding first the objective properties which fit it to serve uses.

Shall it be said that a painting "flows"? With the same propriety, neither more nor less, with which it may be said that a piece of music "flows." In both cases, in music as well as in painting, and in music no less than in painting, we employ a metaphor, but habit of language debars us from acknowledging metaphor in the one case as we freely acknowledge it in the other.

The parts of a painting appear side by side: painting is a spatial art. The parts of a musical composition appear one after the other: music is a temporal art. That difference is ineradicable. Whatever may be said of rhythm in painting or in music, that difference will remain. Therefore, if in describing music as rhythmic you mean simply that music is temporal, no one can gainsay you. But that is *not*, even in music, what you mean in describing it as rhythmic. Time does not vary in music; rhythm does. If you permit yourself to speak of "slow" and "fast" time, you refer in fact to differences of rhythm: you do never mean that music, as its tempo varies, is more or less temporal.

We are victimized in this matter by a metaphor which language institutes and dumb habit forgets. A stream flows, flows not

metaphorically but in fact. What is meant by the flow of a stream? Only one thing, that its waters *move*. They move in space as well as in time. There are two discriminable sequences, the sequence of moments and the sequence of positions. From this concrete movement of the stream I may therefore abstract in either of two ways: I may abstract to the sequence of moments, or I may abstract to the sequence of positions. Neither by itself is what literally we mean by flow, which is the concrete movement of the stream's waters. But both may equally, being marked off, be taken as representatives of that flow. They can represent flow because each, and each alike, exhibits a sequence, though the sequence of the one is temporal and the sequence of the other is spatial. Rhythm, as we employ it, is a property of sequential order, whether that order be temporal, or spatial, or both.

If you would represent the rhythm of a poetic line, you hold it fixed in a spatial image.

> Season of mists and mellow fruitfulness!
> Close bosom-friend of the maturing sun

So Keats spoke. You would hold the rhythm of his line? You represent it thus:

$$— \cup\cup — \cup — \cup — \cup —$$
$$— — \cup — \cup\cup\cup — \cup —$$

Has not the rhythm, in being held, been also frozen? And if it is frozen, has it not ceased to flow? The parts of the image are simultaneous; the parts of the line, as the line is heard, are successive. How then should the one be thought to represent the other? Very simply: it fixes on the structure of the sequence, and omits its temporality. Though time and space differ, the order of the sequence is in both the same. Well, if A is like B, then also B is like A. That is admitted? That is all that needs to be admitted, for that is all that is at stake when one affirms the rhythm of a visual pattern. To hear the line is to hear that pulse; to see the image is to see it. The poetry has no doubt the greater interest. That is nothing to be wondered at. If you would make comparisons of things professing to be equal, you do not compare a living man with a skeleton. You compare skeleton with skeleton, or living man with living man. The image will bear comparison with a drum-beat. If you would find the other term of comparison for Keats, look to Constable.

26. Percussive and Continuous Forms

I propose then to observe the possibilities of rhythmic variation among visual patterns. I am aware that in ornament I confront poor skeletons, terse scaffoldings only, in which the factor of expression has been reduced to the barest minimum. That precisely is the value of ornament for an expository act, that it enables us to see the factor of rhythm in the extremity of isolation. In a work of art it is never thus isolated. Implicated in its uses, it is never separately seen. I not merely confess, I insist, that its sole value consists in those uses, and that apart from its uses it has no interest whatever. It is valuable only for the sake of expression. But in attending to the expression for whose sake it is valued, I attend only to the value of its result; I omit to acknowledge how it has contributed to the production of that result. In the end it is right that I should attend to the expression alone. The artist who permits me to do otherwise has so far failed. For it must be assumed, of an artist who parades his resources, that economy is not one of them. The only artist who can afford superfluity is an empty one.

If you would train a sculptor to represent the nude human figure, you direct his attention to the anatomy of the figure. Which is not to say that the nude human figure is nothing but anatomy. That is not true. But the sculptor may learn the structural means of expression by reflecting, forgetful of his block, on the structural values he works with in his block. For that reason, Michelangelo exercised himself in the dissection of corpses. The real challenge of anatomy is not in naming parts of the body, but in seeing how the functions of the body are realized out of parts. That is the challenge of the anatomy of visual design. An artist may forget the names. He may forget the functional values of the things named only on peril of impoverishing the expression he seeks after.

The simple alternation of vertical lines and intervals will produce a pattern (Fig. 50a). By the iteration of the motive the space is scaled. By the alternation of the positive form and the interval the

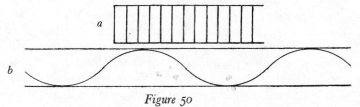

Figure 50

sequence has acquired a visually appreciable rhythm, a special character which is as distinctive as it is implacably redundant. Set that pattern beside the sinuous fluency of a meander (Fig. 50*b*), the comparison will exhibit the same qualitative contrast which is drawn forth from a violin string as it is bowed or plucked to an alternating pitch. In both cases there is a pulsation of sound, but the flow is in the one case continuous, serpentine, in the other interrupted, percussive, detached. So, here, the visual alternation of the vertical line and interval is, like the sound of the plucked string, *pizzicato*; the pattern is discontinuous.

That is so small a thing? It is. But observe the eloquence of its results in use. In the *United Nations Secretariat Building*, in the rhythmic vertical alternation of ribbon window and spandrel, men have celebrated an aspiration in terms of it (Plate 13). In architecture, where it exhibits itself in a use as abstract as ornament, no one fails to mark it. The difficult thing is to see it at work where it works in secret, unnoticed, in order that notice may fall elsewhere than on itself. "It is the greatest perfection of art," said Dryden, "to keep itself undiscovered." To represent a sphere in space, an artist will reproduce an effect of gradient lighting. The part of the sphere nearest to the source of light will carry the highest light, and from that part, in continuous gradations, the light will diminish in an ordered series of grays. Such is the effect observed in Leonardo's *Mona Lisa*, in the Christ child of the *Virgin of the Rocks* (Paris), or in the *Madonna and St. Anne* in the National Gallery, London (Plate 38). That studied and controlled series of gradations was in its own day the technical marvel of all painters. It was once the smooth *legato* effect which belonged to the *Last Supper*, though the physical deterioration of that surface has made it less observable (Plate 10). Yet, even in its melancholy ruin, if one asks why, simply as a lighted surface, the *Last Supper* appears so tranquil, the reason is at hand. Between a point of highest light and a point of deepest dark there is a perfectly even gradation of lights, which measures the transition and controls it. Set beside Leonardo's *Last Supper* that magnificent version which Tintoretto fashioned at San Giorgio Maggiore in Venice (Plate 14). It is like heat lightning that blasts the sky, and mottles it: it coruscates. The surface pulsates with the abrupt irreality of a blinding vision. Why is this vibrating surface so starkly arresting, this surface with its strange image of worlds intermixed, fusion of homeliest still life and angel choirs, which denounces doubt by shock? There

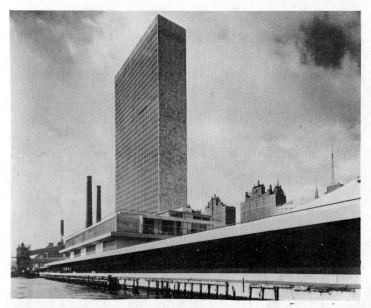

PLATE 13. Wallace K. Harrison, Max Abramovitz, and Associates, United Nations Secretariat Building (1950), New York.

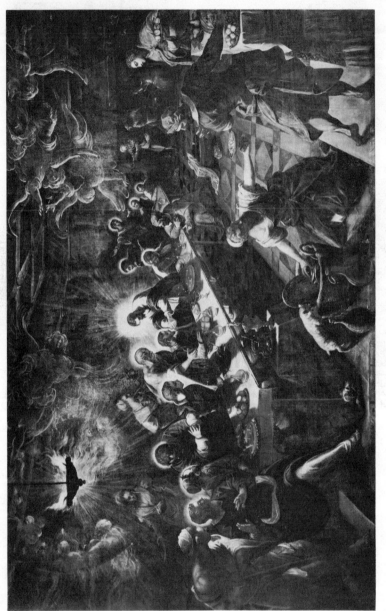

PLATE 14. Tintoretto (1518–1594), "Last Supper" (1594), San Giorgio Maggiore, Venice (Alinari).

are a number of reasons. A major one is, that the highest lights and the deepest darks have been starkly juxtaposed. The transitions between them have been expunged, so that the light values appear *staccato*, disconnected, percussive, estranged from their physical habit. Rhythmically, Leonardo's work and Tintoretto's belong to different worlds. So indeed did they.

Part of the singularity of the manner of El Greco is grounded in the competition of the continuous rhythm of his figures and the percussive rhythm of his lights: the forms flow into one another; the lights pulsate detached (Plate 15). Suspend the percussiveness of those lights, you would have in El Greco the sinuous arabesque of Seurat's *Circus* (Plate 16).

I have paused over this initial rhythmic contrast not in order to magnify it, but in order to make plain the larger sense of our enterprise. The rhythmic motives which are thus simply isolated in grill and meander (Fig. 50) may be illustrated out of the total range of the visual arts, in a cathedral as in a vase, in a dome-mosaic as in an etching or a watercolor sketch. In the arts of expression such principles of rhythm are always present. They are not always superficially declared. Where they work covertly in the latent structure, the discovery of them is an exercise in discernment. There can be no exercise which sensitizes perception in equal measure. For to discern them is to lay bare and to meditate the controls of the artist in his positive and authentic craft.

27. *Frequency, Intensity, Inversion, Ambiguity: El Greco's "View of Toledo"*

Upon the grill motive in Figure 50a a number of quantitative variations may be rung. The interval may be increased or diminished (Fig. 51). The positive form may be increased so as to be equated

 a *b* *c*

Figure 51

with the interval, or even to exceed it, as in a stripe or checker pattern (Fig. 52). The positive form may be fractioned, vertically

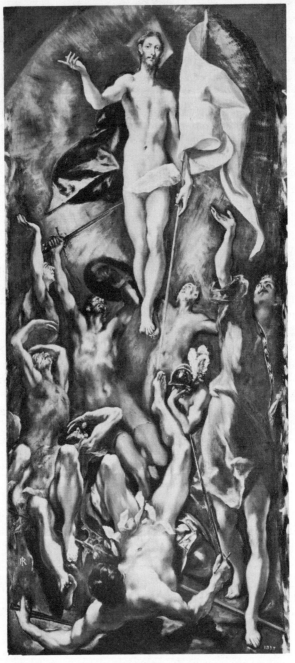

PLATE *15*. El Greco (*c. 1545–1614*), "*Resurrection*" (*c. 1608*), Prado, Madrid (*Anderson*).

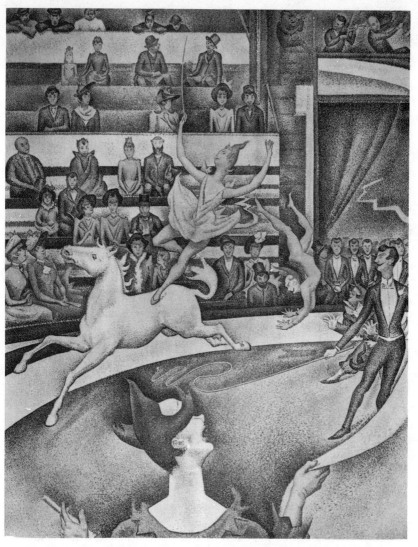

PLATE *16*. Georges Seurat (*1859–1891*), "*The Circus*" (*1890–1891*), Louvre,
Paris (*Archives Photographiques—Paris*).

Seurat's "*Circus*" is an arabesque, formally a sequence of variations played
upon a single theme. A figure skater will spontaneously respond to the rhythm of
it as to the visual complement of his own act. Every involution of forms will be
found somewhere in the visual field to be resumed in some other, which imitates it
and strikes a variation out of it. The design expands itself in large arcs and diminishes
in small ones. El Greco's forms have the same fluency, but they are overlaid with
percussive light-contrasts (Plate *15*).

a b c

Figure 52

diminished as in Figure 53, or so complicated, by multiplying the strokes within it, that it contains a subordinate interval as one of its elements (Fig. 54).

a b

Figure 53

a b

Figure 54

The actual rhythm remains, for each of these quantitative variations, discontinuous, always like the pluck of a string or the beat of a drum. The changes produce nevertheless a most remarkable set of felt contrasts.

An increase or diminution of interval produces a distinction of *frequency*—the effect which in music is identified as tempo, as the variation of slow and fast (Fig. 51).

An increase or diminution of the positive form produces a distinction of *intensity*—the effect of amplitude which in music is identified as volume, as the variation of loud and soft (Figs. 51*b*, 52*a*, *b*).

The charged quickness of a Rubens composition depends always in part on the density of its elements; its decisive monumentality depends on their amplitude, on the size of the positive forms in relation to the field (Plate 17).

Picasso's *Ma Jolie* is like a jewel whose adjacent facets have been multiplied (Plate 18): the pattern of lights quickens within it. Its frequency is, in the manner of all Cubist art, accelerated. The

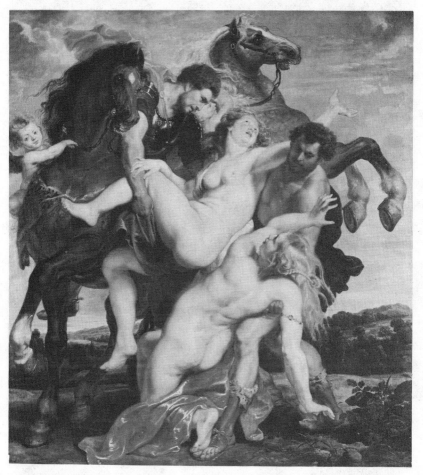

PLATE 17. Peter Paul Rubens (1577–1640), "Rape of the Daughters of Leucippus" (c. 1618), Alte Pinakothek, Munich (Alinari).

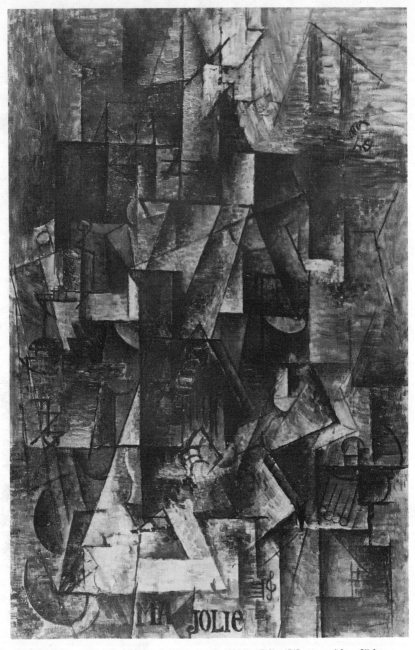

PLATE *18. Pablo Picasso (1881–), "Ma Jolie (Woman with a Zither or Guitar)" (1911–1912), Collection, The Museum of Modern Art, New York. Acquired through the Lillie P. Bliss Bequest.*

special genius of the work lies in the circumstance that the business of its surface has been so imperiously muted: its order remains transparent, monumental in effect, in spite of the flaky density of its manifold elements. Business is the cardinal sin of Cubism. It is what makes good Cubist works as rare as Christians (Plate 19).

There are unanticipated qualitative transformations which accompany these changes in quantity. All of them are emergents, which, apart from the acquired craft of experience in these matters, could not have been predicted.

Increase the interval, you have retarded the frequency. Increase the interval still further, you not merely retard the frequency; you produce an emergent transformation known as *inversion*. Figure 51*b* is apprehended as a series of black verticals on a white ground: the dominant element is the vertical stroke, the subordinate element the interval. Figure 51*c* is apprehended as a series of white squares: the dominant element is the shape of the interval, the subordinate element the separating line. The relative importance of interval and positive form has been inverted.

Diminish the interval, the rhythm accelerates (Fig. 51*c*, *b*). Diminish it still further, the pattern will be apprehended as a fluent gray, textured but continuous, continuous in effect though not in fact (Fig. 51*a*). The effect is *fusion*.

Increase the positive form, it gathers insistency and amplitude (Figs. 51*b*, 52*a*, *b*). Increase it still further, and let the interval be diminished (Fig. 52*c*), you produce an absolute inversion of Figure 51*c*.

When, in the *Lamentation* of the Arena Chapel (Plate 20), Giotto groups his figures densely, so that though they are separate, they are seen together as a stable mass, he has transposed in just these terms. The intervals have been contracted, the group itself acquires a shape from the negative area which surrounds it. You apprehend at the left a square which holds, and contains within the field, the impetuous downward thrust of that diagonal formed by the Hill of Golgotha, by which Christ, Mary and John are indicated.

When the interval and the positive form are equated, as in Figure 52*a* or in an ordinary checkerboard, the pattern acquires an emergent quality of *ambiguity*. The equality of the elements forbids a decisive interpretation of what is to be construed as positive form and as interval. The motive is interpretable indifferently in either of two ways, as a white form on a black ground, or as a black form on a

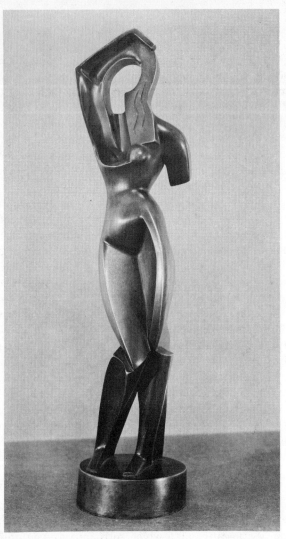

PLATE *19*. *Alexander Archipenko (1887–1964), "Woman Combing Her Hair" (1915), Bronze, 13¾" high. Collection, The Museum of Modern Art, New York. Acquired through the Lillie P. Bliss Bequest.*

Master of some of the most elegant effects of modern sculpture, Archipenko super-poses the angularity of a Cubist reduction of the figure to planes upon the sinuousness of his fundamental motive. The planes are set at angles in opposition to each other; the edges where planes meet form lines which interlace themselves in the vertical meanders. Every interrupted line suggests a form which is resumed in some line or contour beyond itself. So perfect is the freedom from the natural form, so compelling the assurance of the idiom, that no eye falters at that piquant inversion by which, for the head, a void has been substituted. It is celebration of the female nude in the image of the musical clefs.

white ground. It is both; decisively, it is neither. Such ambiguity is in scientific discourse a stultifying defect. It may be that in art. But on occasion, in the art of painting, it may become a positive and usable value, which an artist has deliberately employed (Plate 21). The sense of physical estrangement which one experiences before El Greco's *View of Toledo* depends on it (Plate 22). The shock of irreality of that landscape, over which a spirit broods, is realized by a transposition of values, which vision at once denounces and affirms. Edges appear as lights, planes as darks, upon those buildings limned ghostly against the blasted sky. The buildings are visually equivocal. They are masses; yet they do not behave as masses certifiably behave. They wear the disturbing and ambiguous aspect of a photographic negative, in which all values are transposed. The result is, that all our habits of visual construction, by which visual indications are normally interpreted, suffer an arrest. The clues to physical reality which experience has taught us to decipher with assurance have been intentionally aborted, yet are so far preserved as to enlist into activity those habits which they can only demoralize. The ambiguity is deliberate; the indecisiveness of the image, which suspends our certitude, has become a positive resource of expression, the ground in nature of a vision beyond nature that El Greco wanted.

28. Emergent Qualities: Rembrandt's "Raising of Lazarus"

Chemists speak of certain properties as "emergent." Two elements in combination may have properties which neither had separately. Sodium will kill life. Chlorine will kill life. Together they form salt, which is essential to life. The property of the combination, as distinct from the properties of the elements, is an *emergence*.

The special interest of fractioned forms is found in such emergent properties, in qualitative differences which appear unpredicted on a quantitative change.

We began with a simple vertical stroke (Fig. 51). Let the stroke be parcelled, and one of its segments omitted, so that it runs only part of the distance between the upper and lower edges of the ornamental field (Fig. 53).

Basically, this is a quantitative variant: the positive form has been contracted, the negative form expanded. The registered visual

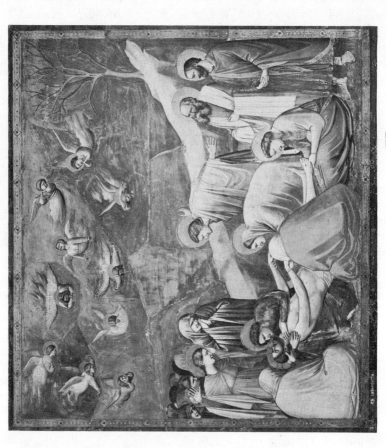

PLATE 20. Giotto di Bondone (c. 1266–1336), "Lamentation" (1306), Fresco, Arena Chapel, Padua (Alinari).

effect is nevertheless a qualitative transformation. The fractioning of the positive form has produced an emergent continuity in the negative area. It flows unbroken through the interspaces, as the water of a lagoon flows into low places, taking its pattern from the visible topography of the land. An artist's eye is exquisitely sensitized to that transformation. Seurat's *Sunday Afternoon on the Grande-Jatte* is, for one thing, a very subtle and complicated essay in it (Plate 36). It is the principle which operates declaratively in all silhouettes. It is the secret of that transfigured dignity which is found on occasion in a cityscape, seen in the diminished light of dusk, before lights go on and rediscover in positive forms the detail which darkness has obliterated.

> The river glideth at his own sweet will:
> Dear God! the very houses seem asleep;
> And all that mighty heart is lying still!

In just the same way and on the same principle, if the fractioned forms are made to alternate as in Figure 53*a*, so that each next stroke is the inverse of the last, the negative area acquires the somber rhythm which belongs to an angular meander, or Greek fret. It flows, a grave *basso continuo*, which underlies, and supports, and supplies the uninterrupted foil for the alternating percussive forms.

In Figure 53*b* the emergent continuity is even more pronounced. The parcelling of the vertical strokes is evidently governed by a rule: the order is climactic, recurrently rising and falling in a horizontal alternation of crest and trough. The fluency of this result is hardly what should have been expected, given the rudimentary elements out of which the expanded motive has been realized. The positive pattern is constructed out of percussive elements: it consists, in fact, of the iteration of vertical lines set apart at a constant interval. No one in fact sees that as its dominant aspect. The dominant pattern moves horizontally, not vertically—sinuously, not percussively. The effective impact of the verticals is their conjoint impact: they work by *fusion*. The visual effect is a diffuse intensification of the lower part of the field, which appears as a single grayed area, textured, but continuous as the upper range of the field is continuous. It is as if a continuous line had been drawn, joining the upper extremities of the upright elements. There is no line: the grayed area has in fact no edge. You nevertheless project a continuity among the positive forms even where there is none. You

PLATE 21. Takumi Shinagawa, "Yellow and Purple," Print, Collection of James A. Michener.

Ambiguity in art is an effect of premeditation, not of oversight. Takumi Shinagawa's ground color is yellow. Upon it textured black forms have been disposed. The darks are then, presumably, his positive forms, the lights his negative ones. It must be so, since the yellow ground is continuous at the frame's edge. Yet wherever the positive forms are perforated, an inversion occurs. The yellow ground, in the moment that it is enclosed or partially isolated, is inevitably construed as itself a positive form, the shape seen as light on dark. The inversion is pronounced in the key-shaped form which appears light on dark exactly at the intersection of the axes of the field. The handle of the key appears to extend itself across a yellow interspace and into the separated neighboring dark area at the left. If that be negative space, it is a very egotistic one: it sings itself. Ambivalences such as this activate awareness throughout that total surface. Any of its forms may be read either as positive or as negative. They are equally diverting in either way. But since neither way of reading can be consistently maintained, we in desperation practice virtue by reading all forms in both ways. Such is the substance of that essay: the vision of complementarity is, for an art of vision, the source of all virtue.

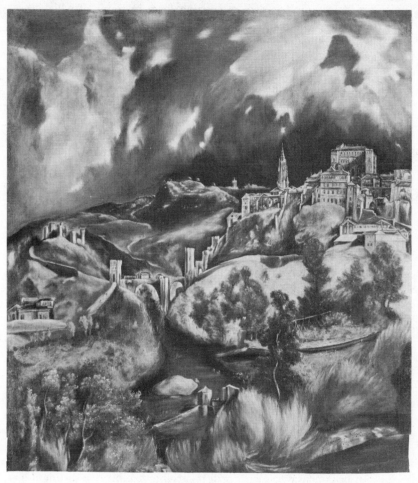

PLATE 22. El Greco (c. 1545–1614), "View of Toledo" (c. 1610), The Metro-politan Museum of Art, New York. Bequest of Mrs. H. O. Havemeyer, 1929. The H. O. Havemeyer Collection.

project the simplest ideal organizing form in terms of which the
whole may be clearly grasped,[5] and having projected that form,
you complete it, even where, in the image itself, its components
leave it incomplete. What you see, in short, is not those components,
but the complementarity of those components. That is their objec-
tive property for your perception, the way of the phenomenon, not
merely the way of your vision of the phenomenon. An analysis of
the psychology of vision may tell us why we see the phenomenon in
this fashion as a total *gestalt*. But the *gestalt* appeared before the
explanation, and continues after it. The visual gravity of those ele-
ments, their complementarity in a total pattern, is the proper topic
of visual analysis.

Isolate any square half-inch of a Rembrandt etching. The lines
will appear insensate, a poor gnarled tangle of blacks, mere noise,
nondescript and unmeaning. Line of beauty there is none, for the
function of Rembrandt's lines never resides in their isolated ele-
gance. It resides in their fused impact. Out of their concert emerges
a vision, a vision of light, an apparition conveyed not by line at all,
but by gradations of gray, which range between the darks (the
densest nodes, where the intervals are compressed) and the pure
uncontaminated white of the paper, reserved from any line, owned
without a touch. From such unlikely elements, in one of the
strangest transformations which appears in all art, emerges, on a
tissue of paper not six inches square, the sublimely monumental
effect, preternatural and majestic, of the *Raising of Lazarus* (Plate 23).

29. Cyclical and Intrinsic Rhythm

An ornamental sequence will invariably exhibit two distinguish-
able rhythmic patterns. The first is the rhythm of its cycle; the
second is the rhythm within its cycle. The one depends on the repe-
tition of a motive; the other depends on the character of the motive
repeated.

For ornament is in this respect like music or poetry. Beneath all
the emergent rhythms which diversify its surface there flows the
equable pulse of a recurrent rhythm, simply repeated, which pre-
serves its constant measure.

[5] See Section 23.

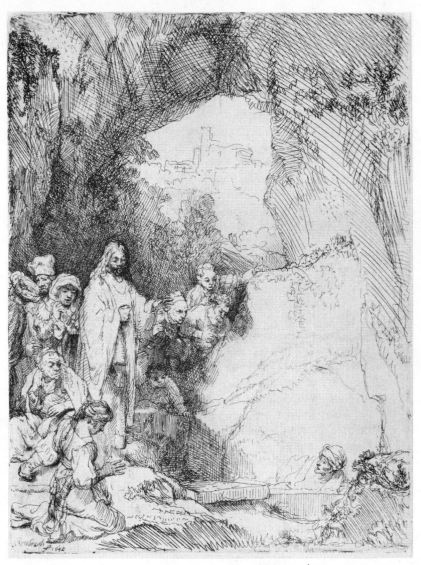

PLATE 23. Rembrandt van Rijn (1606–1669), "Raising of Lazarus" (1642),
Etching, B. 72, The Metropolitan Museum of Art, Gift of Henry Walters (1917).

The metric foot in poetry is a unit of cyclical rhythm: the unit of the cycle declares itself by a repetition, in which the cycle is renewed.

> The wrink/led sea/ beneath/ him crawls;
> He watch/es from/ his moun/tain walls,
> And like/ a thun/derbolt/ he falls.

Against this cyclical rhythm, which redundantly recurs in measured stresses, a poem unfolds a second rhythmic pattern, which varies according to the character of the measure used. The character of the foot—its intrinsic rhythm as dactyl or anapest, as spondee or iamb or trochee—waits on no repetition to declare itself. It is felt emergent in a single instance. That is why it can be permitted, in a musical art, to vary: the failure to renew it leaves its internal character undisturbed.

> Ōut ŏf thĕ/ crādlĕ/ eñdlĕsslў/ rōckĭng,
> Ōut ŏf thĕ/ mōckĭng-bĭrd's/ thrōat, thĕ/ mūsĭcăl/ shūttlĕ

So, in storm at sea, over the mighty undulations of the ocean's surface the wind sweeps patterns in caprice, whitecaps and spray flung wild. The ocean, terrible and impassive, keeps still in silence its stupendous pattern of heave and surge and fall.

The *cyclical rhythm* of an ornamental sequence is the measure which is generated by the recurrence of the visual motive as a whole. The quality of the cycle depends upon the internal character of the motive itself—upon what I shall call its *intrinsic rhythm.*

If ornament had the freedom of a poem, men would find no difficulty in marking that these two rhythms are distinct. But the free rhythm of a poem is never encountered in pure ornament. The cycle remains fixed; the character of the motive remains also fixed. Both alike are redundant, so that the cyclical rhythm and the intrinsic rhythm appear to be identical. The distinction between them is nevertheless essential. For in the visual arts, in all visual arts which have freed themselves of the principle of bare repetition, the two kinds of rhythm will be found to vary independently. In a theme and variation the cycle may be preserved while the motive changes; or the motive may be preserved while the cycle changes.

On the outer frieze of the *Parthenon* that battle of Lapith and Centaur shall never end (Plate 24): it can never develop, it can only recur, as everlastingly another stroke is dealt. The cycle is frozen in the span of a metope, the motive alone can alter, and it alters only to imitate itself.

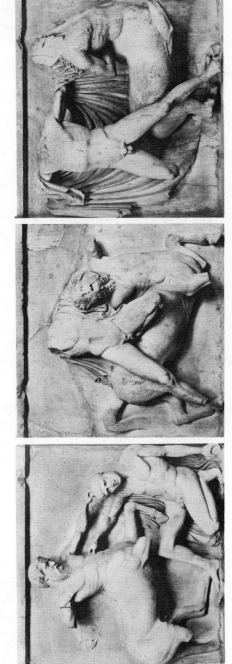

PLATE 24. "Lapith and Centaur," Metopes, Parthenon (447–432 B.C.), Athens

It is otherwise in that stately procession on the inner frieze (Plate 31). There, all is development. The forms recur, the cycle contracts; therefore, the tension gathers increase, the tempo quickens, and the procession moves.

In some free essays the cycle may be suspended. There is no cycle. A rhythm remains. That rhythm is intrinsic.

If cyclical rhythm—the rhythm that comes with repetition—were the only rhythm, then, rhythmically, the variation of a motive should make no difference, so long as the length of the cycle remained the same. But it is not so. The variation of motives enormously extends the range of rhythmic possibilities which we are heir to.

Suppose upon the rim of a wheel I paint a white dot, and set the wheel in a slow rotation, at a regular speed, upon its axle. Then, in any turn of the wheel, the dot will traverse a constant distance in a constant time before appearing again at the position from which it started.

The dot's return to that position is cyclical, and therefore rhythmic, a sheer measure which repeats itself redundantly. It will measure time, it will measure space; it will measure either indifferently, according as I attend to the duration of the temporal interval, or to the length of the spatial distance, between its recurrences. Both are constant, the duration and the length: therefore, both are units of measure. If I forget the distance and mark only the time, I have a clock; if I forget the time and mark only the distance, I have a ruler. Length and duration are simply different aspects of the same phenomenon, and I may attend specially to one, forgetting the other. What I am not permitted to forget, since it is implicit in both, is the cycle, the measured rhythm of the dot's return as the wheel spins.

Well, let that rhythm which is redundant, which goes on repeating itself, be called the *cyclical* rhythm of the wheel's rotation.

But now, holding the cyclical rhythm constant, suppose I introduce a further contrast on the rim of the wheel. I do not care what in particular the contrast may be: its special character is a matter of perfect indifference. The matter of importance is the circumstance that an accent has been intruded between any two recurrences of the white dot. The character of the rhythm will have been transformed, though the cycle has remained the same. The rhythm quickens, not because the wheel moves faster, but simply because the frequency

of contrasts has been multiplied. The rhythm is more intense, not because the white dot has been enlarged, but because the emptiness of the interval has been diminished. Let this difference of rhythm—the rhythmic character which thus appears within a cycle—be described as the *intrinsic* rhythm of the wheel's rotation.

Evidently, there are two patterns discernible in the rotation: the first the cyclical one, the second the intrinsic one.

In just the same way, in an ornamental sequence, two rhythms are distinguishable, the extrinsic rhythm of its cycle and the intrinsic rhythm of its motive.

Any one of the motives in Figure 55 is fitted, in an ornamental sequence, to establish a cycle: it corresponds, in the sequence which

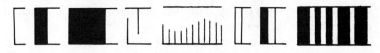

Figure 55

is generated out of it, to the measure in music. The rhythmic differences among these motives—their differences from each other —are differences of intrinsic rhythm.

Out of such sorry virtues shall one aspire to sing oneself, to honor nature, or to celebrate the love of God? Icarus, out of charity I hope that you cannot. Whether from such elements as these one shall succeed in these things depends not only on the virtue of the elements but on the virtue of the self to be sung, of the nature to be honored, and of the God to be loved. And it is a poor self, a poor nature, and a poor God, which could be sung with these alone. But it is not in the singularity of these elements that their interest lies. Their interest resides in the principles which they enable us to isolate. And, as anyone can see, in the rhythmic *principle* of one of them a theme from Beethoven's *Symphony No. 7* has been embodied. From these principles, if not from these motives, one shall indeed sing oneself, and honor nature, and celebrate the love of God. In a blade of grass I discern the same principle which I see in life everywhere. Life is not therefore grass. It is necessary in these matters to be clear what we are about. The greatness of a soul to be sung is not guaranteed by the principles of art. But without those principles there can be no song. For the song is guaranteed only by the principles of art.

"I sound my barbaric yawp over the roofs of the world," said Whitman. The man who knows his barbarism is no barbarian. That capacity for self-knowledge which is in him is the God in him, all in nature that is honorable, and in himself all that is worthy of being sung.

30. Objective Wholeness

Not all cycles are extrinsic. Some are internal to the wholes in which they occur. In the great part of the music which one hears a recurrent cyclical rhythm is identifiable. This rhythm is the prime constancy of the musical "field," so that, whatever else music may become, it has always at its base, like ornament, the fundamental pulse, which is its measure.

Within the compass of a painting or of a sculpture or of a work of architecture it is possible on occasion to discover such internal cycles. In the repetition of the orders of the *Parthenon* there is a cycle visually declared; in the nave arcade of *Amiens Cathedral* there is another; in the vertical alternation of ribbon window and spandrel of the *United Nations Secretariat Building* there is another still (Plates 11, 27, 13). Such cycles belong to the internal composition of the architectural work: they declare its scale; they govern the meter of its intrinsic rhythm.

The work itself is unrepeated. There is but one *Parthenon*, but one *Amiens*, but one *United Nations Secretariat Building*. The singularity of each consists in its *wholeness* and *sufficiency*. Each of these works is, if you please to view it as such, one brave motive, the total interest of which is, in terms of form, its intrinsic rhythm. Once stated, it is a sufficient statement. A restatement of it would be a distracting superfluity. Its interest can only be diminished by repetition, since its interest lies entirely in the articulation of its parts, in the system of proportions by which they stand related to each other.

A polka-dot, it must be admitted, has a wholeness equal to the *Parthenon's*. What is wanting to it (which disparages the comparison) is not wholeness, but sufficiency. With respect to wholeness the polka-dot is a motive without a flaw. But its wholeness is so mute, so stolid and unimperilled, as to command no interest. *Integer vitae scelerisque purus*, it is, in one word, a demure and untousled bore, virgin without innocence, innocence without passion, passion

without ardor, ardor without selflessness. Its fault is its vacuity. It challenges scrutiny, but is incapable of rewarding it. It wants inner articulation, that measure of apparent order and apparent complexity, in which the relations of its parts are visually declared and sensibly appreciable. Therefore, to repeat a polka-dot is, despite its wholeness, to enhance its virtue. But to repeat the *Parthenon* is to denounce its sufficiency.

The perfect sufficiency which belongs to a work of art is never found in ornament; the wholeness is. Nor is that wholeness which is found in ornament always so inarticulate as in the vacancy of a polka-dot. We are meditating one of the profoundly important conditions of art, wherever art is found. For without *articulate wholeness* there can be no sufficiency. If the *Parthenon* were not regarded as an isolable design, the total interest of which, formally, was its intrinsic rhythm, it would not have the status of architecture. Therefore, to understand what makes it isolable is necessary to understanding what makes it art.

I begin with an unarticulated whole, an isolated dot (Fig. 56*a*).

Figure 56

It has already its distinctive intrinsic rhythm, the rhythm which distinguishes it, considered as a whole, from a simple vertical stroke, or from a triangle or a square.

Let it be repeated identically at a fixed interval (Fig. 56*b*), it has acquired the extrinsic function of a unit of measure in a cycle.

But now, suppose I treat that threesome as itself a complex motive, as a recurrent "phrase," which includes that former cycle as an ingredient character of its intrinsic rhythm (Fig. 56*c*). I have

now a second measure, a more extended cycle, which has super-
seded the first, as a yardstick supersedes a foot, or a poetic line a
dactyl. In that containing motive the former cycle is contained as
an *intrinsic* rhythm.

You observe that the rhythm in Figure 56*b*, which is extrinsic to
the dot, is intrinsic to the phrase. What is described as an intrinsic
rhythm or as an extrinsic rhythm depends entirely on what I choose
to treat as the containing motive, on what I choose to regard as a
whole. The ornament does not divulge its own limits, and what I
choose to regard as its limits may vary arbitrarily, so long as the
ornamental strip remains open-ended.

That open-endedness of ornament forbids its completeness, and
will continue to forbid it, so long as it is governed by the principle of
bare repetition. It is forbidden by that principle from achieving, as
an objective phenomenon, the character of a whole. The principle
commits it to being, in its objective estate, systematically incom-
plete: for any motive struck, there remains always an illimitable
beyond, in which it could be struck again. So that its wholeness,
such wholeness as it has, depends not on any objective property in
it, but on the accident of my choice or forbearance or fatigue. It is
not closed; I close it. Its closure is imposed on it, not announced by
it.

The question therefore arises: Is there any complex motive or
composition of motives which can on formal grounds alone be con-
sidered an *objective whole*, an organization which is self-enclosed,
which circumscribes itself, whose wholeness depends not on the
caprice of a spectator's judgment, but on its own intrinsic order?

Let it be said, let it be said despite all modern shibboleths, despite
all the indolence of intellect by which we have deliberately emptied
our inheritance, that no work of art is ever a matter of pure form.
Yet, nevertheless, this remains true, that every work of art has its
formal character, and if men ask what, formally, a work of art is,
the answer in formal terms must be, that a work of art is a self-
isolating order of elements, an order such that, once its principle of
order is discerned, its limits are also discerned.

The problem is, to find such an order. There is a specious solution
which I am confident the judicious reader has not only seen, but seen
to set aside. It consists of introducing a variation not into the motive,
but into the field on which it lies. Let the strip be bent in such a way
that its two open ends are brought together, as in Figure 57. Then,

though the principle of repetition operates as formerly, the result is nevertheless a self-enclosed whole.

Artistically, that solution is trivial. For that solution has been made in total independence of the motive, and remains still available even in the absence of any motive. In the production of that whole the motive is superfluous: it contributes nothing, and counts for nothing. It is so perfectly inessential that it could be dropped without offense to the integrity of the field.

Figure 57

That is not the kind of whole, neither is it the kind of articulation, which art considers. The thing wanted is an articulated order of elements, the principle of whose order will serve objectively to isolate it, as the order of elements in the *Parthenon* serves to isolate the building, even in an open field.

Essentially, the problem is one of complementarities. The difficulty is to find an example which shall appear as simple as it is clearly isolable. Complex illustrations are familiar already: they are known wherever art is known. But that is the disability which we suffer before art, even before the *Parthenon*, whose simplicity is so disarming, yet so unimaginably calculated, a thing: a work of art does not everywhere betray its principle, and there are some works the secret of whose power not even a dissection has disclosed. The effect is known; the principle of the effect is unknown. Like those streams which flow in silence in the depths of the ocean, it works in secrecy, unhurried, known only by its effects, beneath the visible riot of the surface. I choose therefore the simplest illustration that I know, a visual whole as indubitable as it is immemorially old, so

simple that a child can take it in, so purely intelligible that grave
philosophers have found in it a symbol, an image of "the Way"
(Fig. 58).

Figure 58

That is a polka-dot? It is nothing of the sort. It is an
articulated pattern, a whole of interrelated parts, which one may
repeat only on pain of diminishing its value. It contains a single
contrast, only one, but by virtue of that one it has parts. Its parts
have immediately discernible relations to each other. They are
the same in shape. They are equal in size. They differ only as black
and white. But their difference is such that the one is immediately
perceived as the inverse of the other. It is not merely its inverse, it is
its implicit complement, so that, if one part is deleted, it continues
by the other to be implied. Their fluency is a matter of most delicate
balance, of systematic order: as the one increases, the other de-
creases, so that the ratio of white to black has on any diameter an
appreciable constancy. The measure of each is on any diameter pre-
cisely equal. Yet from these parts the whole emerges, the systematic
product of their relations to each other. The circle is as
essentially and inevitably related to them as they to it. The
image is the cleanest extrusion of all accident, a sheer perspicuous
economy in which whole and part are indissolubly allied. Change
an element, you cancel the system; change the system, you
cancel the element. Such is the inevitableness of that image.
It has not the sufficiency of art. But that naked inevitableness
is what men intend when they say of a sufficient work of art—
of a painting, a sculpture, or a work of architecture—that it is
an artistic whole.

Works of sufficient art have been grounded on this shape. The most famous of them is Rubens' *Rape of the Daughters of Leucippus* (Plate 17). The meaning of "sufficiency" is available visually in the difference between the two.

31. "*The Verticality of the Gothic*": Amiens Cathedral

There is no description in the history of art which has enjoyed so uninterrupted, or so sterile, a currency as the verticality of the Gothic mode of construction. That description, "the verticality of the Gothic," gives expression to a half-truth. It is like all half-truths, true only as men know how to construe it. But it is demonstrably false when it is taken to be the whole truth. True without qualification it is not. Men who permit themselves to live by such half-truths have closed their eyes and murdered sleep, for they have closed their eyes, as only a man can do, before the spirit has earned its rest.

From quarried stones medieval men had learned to raise aloft an intricate web of masonry, so delicately poised in its system, so daring in its conception, as to make of the sky its element. Nothing in the world is more astonishing in its visible artifice than a Gothic cathedral. Seen from the outside, it rises in solitary gray eminence above the town, the dominant structure of the townscape, towering over the private buildings that lie huddled at its base (Plate 25). Of that community it alone is large enough, and complex enough, and eloquent enough, to announce the affirmation in which the common life was led. In the cathedral at Chartres, at Paris, at Soissons, at Reims, at Amiens, the primary impression on the exterior is an impression of multitudinousness, of a manifold of elements—sculptured embrasures, turrets and pinnacles, multiplied buttresses and crockets, finials and crestings, which have been combined in one embracing scheme, comprehending infinite detail, so that nothing is either too large or too small, too sublime or too indifferent, to fall significantly within its compass. It is in principle like the arch which it uses. For is not that subordination, which one sees upon its surface frankly and honestly declared, the essential secret of the arch? If, out of elements no one of which is equal to the spanning of a space between supports, you would nevertheless build, you lay the elements together in one concert, which enables these

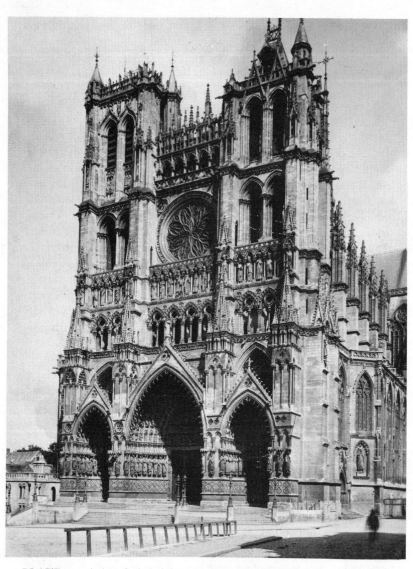

PLATE 25. *Amiens Cathedral (1220–1288), Elevation, West Façade (Archives Photographiques—Paris).*

many elements to do together what no one of them could do sepa-
rately. You would span that space? Bring then together those trivial
wedges of stone, those voussoirs from which the arch is formed,
compose them to its shape and place a keystone at their crown, but-
tress them with a mass of stone so that none can move, they will hold
there in midair in an eerie balance of their own, and will support a
load as well. The power is in the scheme, not in the part. Yet no
part is dispensable, each is needed, each is subordinated to that
common function by which the whole is held thus, in airy suspense,
aloft. The keystone, the voussoir at the crown, is but the loftiest
in its place. But there is no element which has not its place, nor is
the element in any place, whether at the springing or in the founda-
tions beneath the soil, capable of being eliminated without de-
stroying the integrity of the system in which all are held. An arch is
composed, like medieval society, upon a principle of systematic sub-
ordination: the significance of any element, its admissible individ-
uality, is found in its membership in a system that falls beyond it.
Apart from that system, which orders the functions of its elements,
there is no function, neither function nor authentic individuality at
all, but only the looseness of débris, the empty freedom of stones
that lie in fields where hawks prey and mice run. Authentic indi-
viduality, so those medieval builders believed, is in membership, in
alliance with others of one's kind, in a common order in which
freedom is real because functions are necessary.

The Arabs have a proverb: "The arch never sleeps." Those
massy stones raised aloft produce a constant physical stress, the
stress of literal tons of gravitating stone, which, if the system per-
mitted it, would destroy the system. That is the technical marvel
of the arch: it harnesses precisely those factors which would de-
stroy it into the action of holding it together. A Gothic groined vault
is simply an elaborated extension of that principle. It channels those
eruptive stresses, those gross physical stresses of compression, and
concentrates them at the points where the groins converge. There, at
those points of convergence, one may see on the exterior of the ca-
thedral half-arches soaring above the side-aisles, the visible links
between the nave-vault and the turreted masses of stone which
buttress it, absorbing its outward thrusts and transmitting them
downward beyond the side-aisles to the ground (Plate 26). The
flying buttress is the exposed frank feature which you see in the
engineering system of a Gothic cathedral, the most characteristic

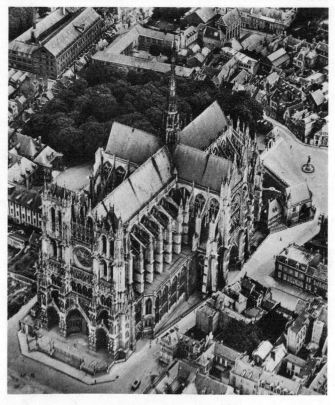

PLATE 26. *Amiens Cathedral (1220–1288), Elevation, Southwest, Flying Buttresses of Nave Vault.*

structural element on its exterior. *St. Patrick's* in New York shows none. Which is to say, that it is possible to cheat, even in a house of God. A Gothic cathedral, whatever else it is or may become, is a building at work, unashamedly at work, in celebration of the task which it performs, the one task of all in which all things—man and stone, history and nature—can be significantly allied.

In ordinary construction a wall performs a dual function: it supports a load, each course of stone carrying those which are above it; it provides a screen, a shield which separates the interior from the exterior space. In a Gothic cathedral these two functions have been divorced. Since the gravitating thrusts of the vaults have been concentrated, buttresses are needed only at the separated intervals at which the groins converge. Between these points of concentration the wall is no longer required as a support. It carries nothing. It functions merely as a screen. Therefore, the Gothic builders omitted it, and into its place between the buttresses, at the level of the clearstory, introduced leaded screens of glass, glass screens through which the light of day was filtered, shimmered various in stained patterns, into the transformed space of the cathedral's nave.

Enter that space, what shall you see? A space removed from anything on earth, set apart in plenitude and large peace (Plate 27). The spirit of man, the spirit even of infidels, is hushed before it. The grand solemnity of it is perfectly irresistible, as it is perfectly assured. For it rises, a huge vertical volume that engulfs and diminishes all things, that subordinates all things to the one thing which it exalts. A Protestant church, as befits the universal priesthood of all believers, is always essentially, where its program is understood, an auditorium: the large orientation of its space is diffuse, directed neither upon an altar nor even upon a pulpit, but upon the members of the congregation. The focus of the space on the interior of a Gothic cathedral is just the reverse. It is compulsive and unrelievedly concentrated. It falls, and falls exclusively, upon the sacrifice that is re-enacted by the mediating act of priest before the altar-table. So therefore, by design, the first light that strikes the eye, as one enters the cathedral, is the jewelled glow of the lancets in the apse, before which the altar-table stands. The pulsating rhythm of the arches in the nave arcade moves toward it; the string-course moldings converge in perspective recession upon it. Above, the groins of the apse radiate from it; the ribshafts which receive them and descend to the floor below return the eye inevitably to it.

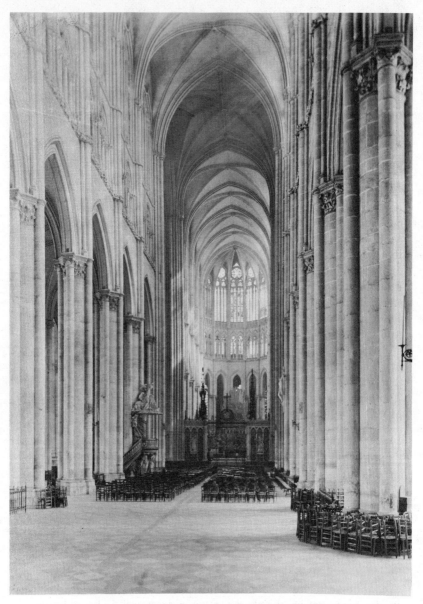

PLATE 27. *Amiens Cathedral (1220–1288), Elevation, Interior (looking East) (Archives Photographiques—Paris).*

It is the single part of a Gothic space in which definiteness is certified. In any other place, for any part which the eye may reach, there is always an indefinite beyond, which remains to be explored. Here there is none. The altar-table is the common center in which all movement comes voluntarily to rest.

The vertical proportions of this volume in the Gothic nave remain nevertheless at the root of the sense of amplitude which it excites. Verticality is the character which, of all features of the Gothic, has been always most frequently noted, nor has one to go further than to its immediate predecessors, those sturdy old churches of the Romanesque, to discover how materially at last that system of proportions counts in the production of this singular effect. Outside as inside, the Gothic soars: it is felt always as volume, not as mass; but always as volume which rises out of mass. It dematerializes as it soars. It is compounded out of grossest stone. Physically, it is a skeleton of stone, shielded by glass screens. Yet by some secret of design it transcends its gross physical estate, so that it gives the appearance neither of a gardener's hothouse nor of a modern skyscraper. The space of a gardener's hothouse remains, despite its transparent voluminousness, a physical space; the space of a skyscraper remains, despite its accentuated verticality, an earth-rooted thing. Therefore, the space which dematerializes itself in a Gothic nave is not to be accounted for either by its transparency or by its verticality. What is the principle of design on which its difference rests? I submit that the difference lies in a principle of *progression*.

A skyscraper is, like a Gothic cathedral, essentially a screened volume. It is a vertical slab of space ordered, basically, on a principle of simple repetition. Each floor reduplicates the floor beneath it, so that, at least wherever the exterior design honestly reflects the disposition of the interior space, it is seen as a series of horizontal tiers (Plate 28). Yet even where, as in the old *Woolworth Building* in New York, a Gothic revêtement has falsified it, permitting the eye to sweep vertically aloft forgetful of the intrinsic percussiveness of its stages, the skyscraper remains earth-born and earth-bound. I do not deprecate the earth. But I mark here a difference from the Gothic which those who adore the earth must mark as well. For consider what is the phenomenal fact for any man who stands in the Gothic cathedral at the entrance to its nave. At either side, lithic, huge, and massive, are the piers of the nave, things of stone,

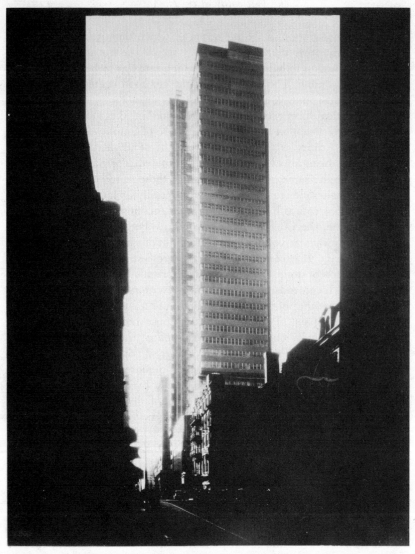

PLATE 28. *George Howe and William Lescaze, Philadelphia Savings Fund Society Building (1931–1932), Philadelphia.*

which carry, with the physical muteness of stone, the vertical compression of the superstructure. The materiality of these is declarative, emphatic by assault, that, whatever else this space may be, the means of contriving it are physical, physically garnered from the soil as you and I are physically garnered from the soil. Yet from these massive piers, on the ribshafts which are clustered at their base, the eye moves upward, through the level of the triforium gallery, in which the masses begin to be perforated and lightened, to the clearstory range in which, in the transparency of lights that stain the nave, the materiality of all things is dissolved; until at last, by strange transformation, those darkling vaults, those literal tons of gravitating stone, appear to float there weightless and not to gravitate at all.

That transformation is the effect not of the verticality of the Gothic, but of the principle of progression which governs it.

32. Progression and Regression: Bernini's "Apollo and Daphne" and the Processional Frieze of the Parthenon

Let the interval between all blacks remain constant, and import into the sequence of the blacks a graduation of intensities, such that each next black has a constant increase of value over the last, until the motive begins again (Fig. 59).

Figure 59

The motive exhibits a *progression*, a graduated variation of ascending intensities which in each instance culminates climactically in a peak-intensity before it subsides and begins anew. If the percussiveness of that motive were to be suspended, if it were to become fluent and continuous, it would be described not merely as a progression, but as a growth, a development.

The pattern is cyclical and therefore redundant. But the intrinsic rhythm of the repeated motive discloses in germ a principle of the greatest possible interest. Considered as a unit, the motive has an implicit direction which none of its elements, considered separately,

can claim. The direction of the motive is an emergent property of
the sequence within it, which is to be found in no one of its parts.
The sequence *leans*; the elements within it are without exception
static. Thus the pattern presents a series of crescendoes, of expan-
sions out of germ. It develops, like the generations of men, each
generation transmitting in its seed, not the growth of the last, but
only the principle of its growth. Do not underestimate the power of
that principle. It is for the time restricted to cycles, held in a tether
which commits it to redundancy, to the bare repetition of itself,
at every third pulse a recurrent monotone. But let it be freed of
that restriction, it shall, like the generations of men, beget a giant
brood, prolific of consequence exactly in the measure that its own
history accumulates unforgotten on itself, so that none of its gener-
ations is the last, and the sequence of its generations moves, without
duplicate, each big with what it is yet capable of, inexhaustible,
and forever incomplete.

So at least, set free, it is capable of becoming, that progression of
silly dots which must at last, given an increase unlimited and illim-
itable, enshroud all the world in black. I do not recommend for
it this use. But unless you can see, see even in that sequence of silly
dots, a principle profoundly serious, a principle of control, a prin-
ciple conferring power in proportion as the uses implicit in it
are governed, you do not see as an artist sees. I shall look to
its uses presently. For the moment its direction requires to be
attended to.

For, it must be admitted, that instrument of power is, like a sword,
two-edged. The same motive which, read from left to right, exhibits
a progression, exhibits, read from right to left, a *regression*. The
direction of the motive itself is ambivalent. In either reading it has
a direction; in the two readings the directions are contrary. It is all
in the course of the reading which you take, whether you shall en-
counter a series of crescendoes, all ascending, or a series of dimin-
uendoes, all descending; all in the course of the reading which
you take, whether, when the principle is set free, you shall encounter
a sequence which must at last in a universal deluge engulf the world,
or one which must at last in a universal desiccation empty it. That
is why, as a device of composition, the principle of progression can
never operate singly; that is why the principle of regression
can never operate singly. The artist who would use either for purposes
of expression is obliged to dictate the course of the reading. Neither

is usable except as it is disciplined, and the discipline must come from beyond it, not from itself.

The discipline may be imported in either of two ways. A principle of recurrence may govern the progression or the regression as in ornament, so that the sequence returns forever and again upon itself (Fig. 59). Or the two principles—progression and regression—may be combined, so that each is by the other tamed and counteracted (Fig. 60). Both of these modes of discipline have their uses

Figure 60

in free art. The space of a Gothic nave is the grandest, as it is also the simplest, of all illustrations: the vertical progression of its voids is governed by a principle of recurrence. But illustrations abound on every hand. For my immediate purposes two will suffice. Recurrence controls the progression in Bernini's *Apollo and Daphne*; in the *Processional Frieze of the Parthenon* progression and regression control each other. The one recurs upon itself; the other develops and recedes.

Women are the only predatories who gain their quarry by running away from it. There is but one instance recorded in which escape was actually intended. Its singularity caused it to become a legend. The story of Daphne and Apollo is, I am confident, only a legend, though a very beautiful one. It is, after all, the myth men live by, and I hope, for everybody's sake, that they will preserve it always. In the Villa Borghese, in Rome, Bernini has represented the legend, Apollo in pursuit of the nymph Daphne, who, as she is overtaken, is metamorphosed into a laurel (Plate 29). That is the moment which the sculptor chose to represent, the moment of the metamorphosis, which is the climax of the pursuit—neither the pursuit merely, nor the metamorphosis, but the two together, each impregnated by the sense of the other, implicating in a single visual apparition all that has preceded it and all that shall succeed upon it. The capturing of that dramatic moment is an act of virtuosity, an extraordinary feat of expression in purely visual terms. Save for the eruptive effect of Daphne's arms, the whole of the composition falls within an ideal oval, its right side one fluent continuous sweeping

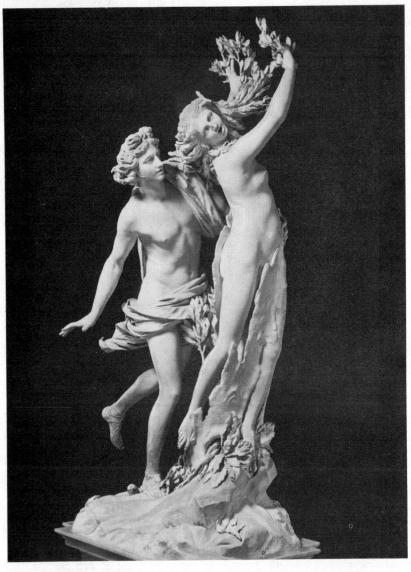

PLATE 29. *Gian Lorenzo Bernini (1598–1680), "Apollo and Daphne" (1622–1625), Villa Borghese, Rome (Alinari).*

curve, which is flung back in Daphne's head, and transmitted jagged, in an agitated *staccato* pulse, through the trailing extremities —head, hand, and foot—of the form of Apollo. That ideal oval, stable and vertical, the foil against which the changes are to be rung, is what you see last of all. What you see first is the diagonal movement, the dynamic upward sweep of the forms, pursuer and pursued, which at once repeat each other in two distinct arcs and flow into each other in a coalescing fusion. They are one? Their distinctness is certified. Then they are two? Their identity is also certified. The formal principle which governs the design is a principle of regression. The right side of the oval is too unbroken to permit the eye to enter there; the eye enters, as Bernini intended that it should, through the cusped open side of the oval at the left. The dominant sequence, which begins there, moves in *diminuendo* through the arc of Apollo's body, through the attenuated arc of Daphne, to the last muted echo of them both in the foliage of Daphne's upturned hands.

Overlaid upon this percussive sequence is a fluent one, which, once stated, is repeated in inversion. From Apollo's trailing hand an undulatory movement surges upward over his shoulder and into hers, subsides at the turn of her arm, then rises swiftly once again in a flutter of leaves. An alternate undulation, opposite to the first and equal to it, the visual inverse of it, begins in that same hand of Apollo. It sweeps through the flung drapery, surges upward through the torso of Daphne, and issues in the foliage of her upraised left hand and in her hair. The two flows are the flows of meanders. The two meanders interlace, each the inverted complement of the other; and both diminish as they conjointly move. They are the visual image of the dramatic rhythm. They expand in violence and contract in tremulousness, as the torrential uprush of Apollo's desire expands, celebrates its ardor, then subsides unassuaged, still restive, in a disappointed conquest which sought a maid and embraced only a laurel tree.

The movement of *Apollo and Daphne* recurs upon itself. The arc of Daphne's upraised arms is the sole element which erupts beyond the limits of the stable basic oval. By that arc, which terminates in the foliage of the metamorphosis, the eye is transmitted back to the cusped side of the oval, there to resume its exploration of the forms. The rhythm is itself stated only once: it needs no repetition in order to announce itself; it is sufficiently appreciable in the one

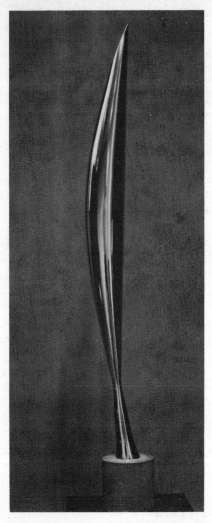

PLATE 30. Constantin Brancusi (1876–1957), "Bird in Space" (1919), Bronze, 54". Collection, The Museum of Modern Art, New York.

This form is justly considered one of the purest achievements of the music of vision. It is a study in the absolute rhythm of ordered sequences in space—regression, progression, regression. Brancusi entitled it "Bird in Space." The flight of a bird is like music: it leaves no trace. Yet the image of the bird at rest is what is least essential to the idea which experience seeks to hold. For the poor thing that flew is paltry and trivial. Its meaning was in its flight. Meditate then its flight only, and forget the thing in the image of its pure transiency, and you have in that phrase of rhythm all that matters permanently; nor, having that, will it concern you greatly, any more than it concerned Brancusi, that it was a bird that flew. Art, Aristotle once said, is a graver and more philosophic enterprise than history. Brancusi would have understood him.

statement. Were one to multiply the image of Bernini's sculpture a hundred-fold, the rhythm would become insistent, as ornament is insistent by repetition. But the repetition of such a motive would be superfluous and distracting. As I multiply elements within a field, I diminish the importance of any one of them. I note the property of the sequence; I omit the sufficiency of the motive. Give me a polka-dot, the sequence is all that matters. Give me a work of art, the motive is all that matters. In its intrinsic rhythm is its sufficiency, and its sufficiency is its art (Plate 30).

Nothing to my mind is so melancholy as the fragments of the *Processional Frieze of the Parthenon*, those estranged reliefs housed in London and Paris and Athens which time, accident, cupidity, and theft have separated. The panels of the frieze of the *Parthenon* belong together: they are parts of a single work, elements within one single sequence. All are individually superb, none is self-sufficient, each requires its complement in those others. For the work of art is here not the elements, but the sequence of the elements, which once appeared, when the work was whole, a music in stone, developing in progression and regression, before the eyes of the community whose reverence it celebrated.

The goddess who was specially revered in the communal worship of the Athenians was Pallas Athena, the virgin goddess of wisdom, who stood guardian over the destiny of the city which bore her name. Her sacred precinct in Athens, the place reserved for her temples and her worship, was the Acropolis. There, in the ancient hill-citadel which rose above the habitations of mortal men, was the house of the goddess, the *Parthenon* (Plate 11), in which the cult-image stood. Every fourth year, in the Panathenaic festival, a procession was formed in the city below which moved, mounted and afoot, bearing the city's offering up the winding road upon the hillside, past the *Propylaea*, the monumental gateway to the Acropolis, past the gigantic bronze Pheidian sculpture of *Athena Promachos* visible even to ships at sea, past the *Erechtheion*, to the sanctuary of the goddess.

The Panathenaic Procession is figured in stone relief on the inner frieze of the *Parthenon*. Mounted youths, charioteers, lowing sacrificial animals, maidens with ceremonial vessels, aged magistrates, converge, above the central doorway of the temple, upon a semicircle of seated gods, who witness in solemnity the presentation of the city's gift to its proper divinity.

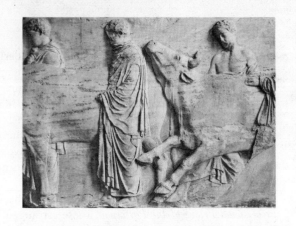

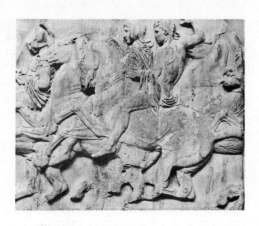

PLATE 31. Pheidias, Processional Frieze of the Parthenon (447–432 B.C.),
Athens (Alinari).

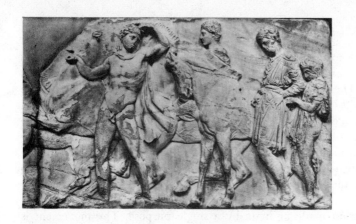

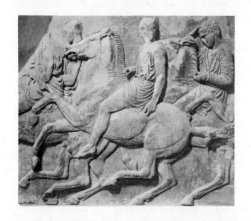

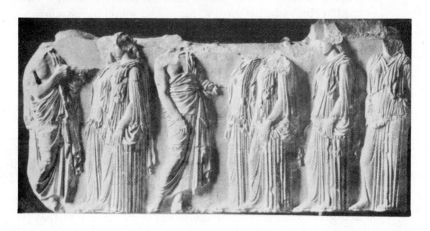

Look to the frieze (Plate 31). Characteristically in Greek art no
scene is provided for the action: the environment proper to man is
man. The figures are distributed in a sequence, and as the sequence
moves, so in disciplined subordination to it the scene is presumed
to change, suggested, never stated. You see first figures of nude
youths, of horses, of sacrificial animals, ranged statically side by
side, awaiting the moment at which the procession shall begin. The
movement begins: out of the diffusely directed attitudes of standing
figures the forms take on one common direction, which groups them
together, despite their differences from each other, into a single
procession made animate by a single purpose. The movement is
slow according to the solemnity of the occasion, a succession of
stately profiles, persons nude and draped, mounted and afoot,
hulking oxen led in the general concourse by which the community
is drawn. Then, as the direction is confirmed, in the magnetism of
the occasion the intervals diminish, the tempo quickens, figures
overlap, the movement sweeps forward, contracts, and relaxes to
sweep forward again. Curbed horses rear, forms agitated by their
proximity to each other, their curved necks, like a sequence of
advancing waves, bridled in, held and released. Such is the progress,
gathering momentum, until at last, as the altar is neared, it mutes
itself and from its taut ascent reverently subsides, diminishing by a
sequence as measured as its increase, slowed by the repeated ver-
tical accents of beautiful draped columnar forms, Athenian maidens
bearing amphorae and the sacred *peplos* into the presence of the vir-
gin goddess. Music? Music made visible in chiselled stone? That
is what Pheidias, who designed it, heard and would have you see.

> Beauty is momentary in the mind—
> The fitful tracing of a portal;
> But in the flesh it is immortal.

33. *Theme and Variation: Poussin's "Amalthea" and Seurat's "Sunday Afternoon on the Grande-Jatte"*

A man of craft knows, if philosophers do not, that in things
fashioned by craft the craftsman has left always a part of himself.
The thing fashioned may survive the act that fashioned it, and even
the craftsman who performed the act. Yet to the extent that its

forms respond sensitively to the demand for equilibrium which he sought in them, the thing fashioned by craft is never a mere thing. It is a silt of the spirit that once animated it, an embodiment of the person who found expression in it and recorded there his way. In the forms of a free society a statesman will read forth the character of its members, as in the forms of a slave society he will read forth the character of its tyrant. Whether the society be slave or free, character is implicit in those forms for the eye which knows to read them. As in the political art, so in all others. In the way in which another has couched a single sentence the master of a language will identify the distinction or the mediocrity of the mind behind that sentence. In the style of the utterance the truth or falsity of the sentence is not in question. Only the wisdom or foolishness of the mind is in question. For wisdom consists not in speaking the truth, but in caring for it. A wise man may on occasion by inadvertence speak falsehood, as a fool may on occasion by inadvertence speak truth. But it is impossible to care for truth by inadvertence. The wisdom of a man's utterance is not in the speaking, but in the consistency and seriousness of the principle that governs it. That consistency and seriousness of principle is not ordinarily what a man essays to state. It is what nevertheless, in the manner of his statement, he invariably betrays, the style of a mind, not the style of a tongue.

Men who know craft know therefore never to despise even the simplest of its products. The master of a visual craft will identify, even in ornament, the differences in spirit which have animated ages and nations. He may not, out of a borrowed erudition, name these differences. But he will know where to acknowledge a distinction worth naming, which is the only erudition worth borrowing.

The expressiveness of ornament is unquestionable. But the range of expression which can be achieved by ornament alone is very limited. It is limited exactly by the principle upon which it will be found invariably to work, namely, the principle of simple repetition. The principle of *theme and variation* is capable of producing a vastly wider range of effects. It is simply the combination, into a single principle, of two principles already exhibited, the principle of repetition and the principle of contrast.

Let a theme be stated, it may then be given a series of restatements, each recognizably the same, though each works a variation upon it.

The principle is named from a musical form: a theme, once heard, is carried through a series of variations, each allied to the germinal motive, but none identical with it. The last movement of Mozart's *Clarinet Quintet* is the purest illustration of the principle. The grandeur of its possibilities may be found in Bach's *Passacaglia and Fugue in C Minor*, in the last movement of Beethoven's *Eroica Symphony* and in Brahms' *Variations on a Theme by Haydn*; a modern instance in Stravinsky's *Octet*. Theme and variation is, I suspect, the most generally diffused principle of composition in all art. In the visual arts it is in incidental use on every hand. On occasion it may supply the latent basic structure of a total composition.

A row of poplars, though the trees are in fact of equal height, will appear to diminish in size as it recedes into the distance. Visually, that perspective recession will be represented as a regressive sequence: the sequence of gradually diminishing elements exhibits an emergent direction, and that direction will be construed by a spectator as a direction into depth. The phenomenon is evidently, at the same time, an instance of theme and variation. Any regression or progression will exhibit the principle. But the principle of theme and variation is not restricted to such gradually ordered sequences. The sequence may exhibit no positive direction. The focus of attention may fall solely on the similarity of the elements amid their differences (Fig. 61). The elements are visibly different; they are

Figure 61

bound together, despite their difference, by visual affinity (Plates 32, 33).

In the Kaiser Friedrich Museum in Berlin there hangs one of the most poised of all classic compositions, a work of Poussin, representing *The Infant Jupiter Nursed by Amalthea* (Plate 34). To save him from the parlous appetite of his father Saturn, the child Jupiter was entrusted to the nymph Amalthea, who nursed him in hiding, the future king of heaven, on the milk of a goat. To Amalthea Jupiter gave the goat's horn, which he endowed with the power of supplying whatever its possessor wished. The subject of the painting is this horn of plenty, the cornucopia of legend. Attend therefore to

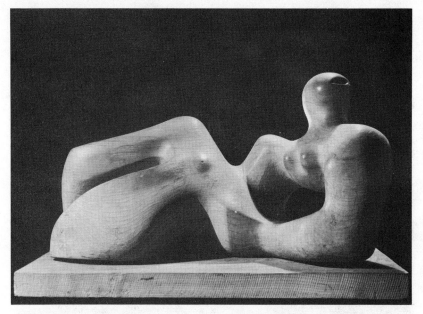

PLATE 32. Henry Moore (1898–), "Reclining Figure" (1935), Elmwood, Room of Contemporary Art, Albright Art Gallery, Buffalo, New York.

The range of effects which may be gained on the principle of theme and variation is as extraordinary in the visual arts as in music. Henry Moore's "Reclining Figure" is formally, in its basic design, a theme and variation—simply one which has been complicated by inversions and progressions, by changes of direction and diffractions of plane. A slow serpentine diagonal ascent begins at the extremity of the left leg, crawls through the undulation of the shoulder, sweeps aloft and terminates climactically in the head, the mass diminishing as the measure of that simple undulation swells. Except for the head which is party to the climactic sequence, all of the large masses fall within the basic configuration of a swastika-pattern. The pattern hinges at the navel. It is muted only by the circumstance that its projections move in different planes and struggle in slumbrous variations on each other. Let the eye move vertically downward from the head to the supporting shoulder which massively repeats it. In a sequence of almost rectilinear transitions (shoulder to elbow, elbow to hand, across the pelvis, to the upper contour of the right leg), the basic motive is struck, one arm of the swastika, each of its two projections the inverse complement of the other. Immediately below, in the left knee, there begins a decelerated responsive sequence, which imitates the first but varies it, like a dull inchoate thing struggling to be born, absorbing into itself that undulation of shoulder formerly seen as line of silhouette, now employed as index of a change of plane across the breasts to the starting point. As a piece of sheer sculpture the thing is superb. Every sculptural sequence is but an echo of a sequence which has somewhere preceded it, and there is no sequence which has not its response. The monumentality of the work is incontestable. It is but nineteen inches high.

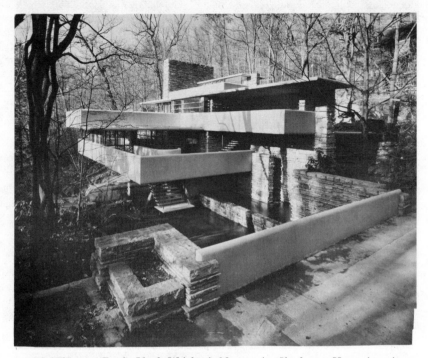

PLATE 33. Frank Lloyd Wright (1869–1959), Kaufmann House (1937), Bear Run, Pennsylvania (Hedrich-Blessing Studio).

The composition is a theme and variation, a lyrical expansion of geometric forms which ring changes on each other. As Romanticism in poetry invariably gains in concentration and poignancy by discipline to the sonnet form, the special quality of its freedom emerging in its act of servitude, so Wright's best work is invariably

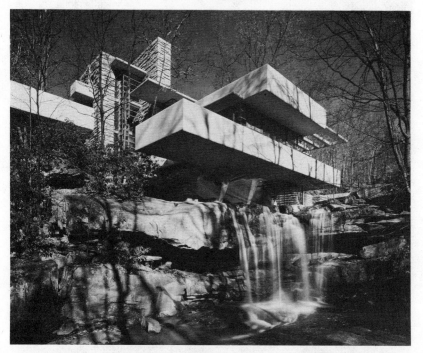

the sparsest in its means. Its characteristic quality is the sheer geometric lucidity with which space is molded. The composition works in horizontals, disposing volumes about the rusticated chimney's mass. Cantilevers free the several levels from the dominion of the ground plan, generating new plans at a loftier story. The contrasted levels remain nevertheless related in an abstract design of line and plane and volume, as inevitable as geometry, as relaxed as the flight of a bird, as purposeful as the reaching of a plant for the light.

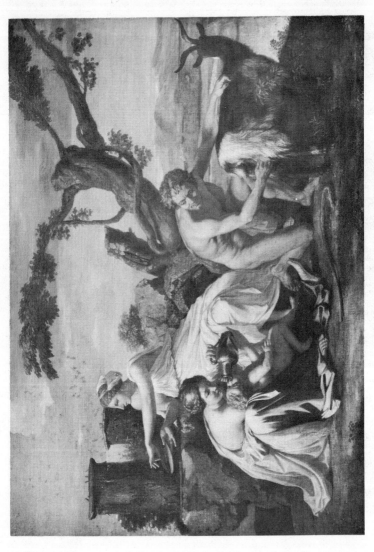

PLATE 34. Nicolas Poussin (1594–1665), "The Infant Jupiter Nursed by Amalthea" (1643–1644), Kaiser Friedrich Museum, Berlin.

it: the horn of a goat will afford, in the hands of such an artist, who knows how to dramatize simply, the key to the formal scheme. Formally as well as dramatically, it is the fundamental theme. From the head of the goat the horns rise in their own characteristic torsion. Nothing could be simpler than the symmetry of their statement. The form is restated at once, echoed above in the branches of the tortured old tree at whose feet the event is laid. But the theme thus stated and at once confirmed is no sooner identified than it is observed to underlie the composition as a whole. The total array of assembled shapes combine in one large concert to celebrate it. Amalthea, seated, turns in a superb *contrapposto*, drawing honey for her charge. In a movement as beautiful as it is simple and unforced, the form turns upon its own axis. It is of course simply the obverse of that torsion which begins in the back of the kneeling shepherd and extends itself into the rough tree trunk opposite her. The two together are the last expanded variation on that quaint motive set eccentrically by the horns of a goat from which plenty flows.

The principle will not always betray itself. It is the secret underlying the mute dignity one sees in the figure of Toulouse-Lautrec's prostitute, a theme and variation on expanding arcs, as exquisite a design as the language of art holds anywhere (Plate 35).

Seurat produced variations on themes in all that he ever touched. He saw them everywhere—in circus (Plate 16) and cabaret, in landscape and riverbank, in textures, even in the resemblances of shadows to each other. There is a sameness in all things, and a difference too, and in the balance of these, for the eye which can see it, and the hand which has the patience to hold it, is a lyric serenity —a serenity of the soul for which nothing in the world can ever appear banal, since all things in the world are at last allied in the act of the mind which embraces them. Such was the genius of that strange solitary who in the bare ten years he was granted to work produced as the crowning masterpiece of his art the *Sunday Afternoon on the Grande-Jatte* (Plate 36). This frozen image of the sunlight is so impassive to change that it belies the casualness of its subject. What reason for change, if the range of all possible variations are seen already, suspended in the sunlight, at once? Nothing in that scene shall ever move, for time has been obliterated in it. Airy, spacious, steeped in color, the atmosphere is felt only for the sake of the permanence of its volume. The figures are all studies in relaxed immobility. Not one communes with any other, each only with himself,

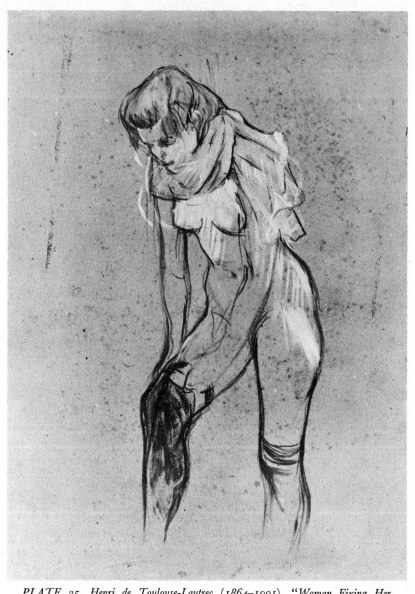

PLATE 35. Henri de Toulouse-Lautrec (1864–1901), "Woman Fixing Her Stocking" (1894), Museum, Albi.

in a soundless consent to a pattern which no one has premeditated. The variations are not in them, but in their unsolicited imitations of each other, man and thing floated alike, and on equal terms, in this texture of verticals and horizontals, of radiating forms and diagonals, where even the shadows play in concert, each taking up and resuming an interrupted oval or circle which another has let fall, like the ripples of a lily pond which catch the light irregularly. Men have from the first identified the Classic spirit in Seurat. In that sparse but gentle vision turned upon a scene in which all is accident, no accident any longer remains. The thing alone is random; the seeing of it is not. The miscellany is uncalculated, yet nothing in it is incalculable or unmeasured in its stress. The negative areas are as shrewdly seen as the positive ones, and as the positive forms repeat themselves, each but the modulation of some other, so do they. Uccello would have renounced his dear Perspective out of love of this art, and I daresay even she would have been reconciled that youth, deserting her, should pursue love beneath a coverlet which she had woven.

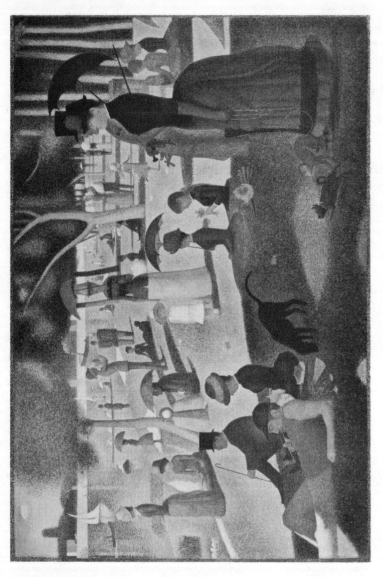

PLATE 36. *Georges Seurat (1859–1891), "Sunday Afternoon on the Grande-Jatte" (1884–1886).*
Helen Birch Bartlett Memorial Collection, The Art Institute of Chicago.

V. Color

34. Physical Light and Sensed Light

Out of the abyss of space, out of its illimitable solitudes, there falls upon my eye the light of a star. I see a glow of color in the night sky. Thus simply, in experience, I mark a physical encounter. That beam of light which falls now upon my eye originated, I am told, in a part of space distant beyond any power of mine to imagine its distance, and at a time before ever I was born with a quick eye for it to fall upon. It originated in some remote cataclysm of a star which sent it hurtling, till now unchecked, through space, like an annunciating Gabriel with a message for the earthborn. So that now, when I, valiant opaque dust-mote, sunken profound in the same silent and infinite universe in which the beam has moved, arrest it in its flight and cancel its career, the star which emitted it may already have expired or become like our earth lightless, a dead cinder in the path of suns.

All this, I confess, I have had to discover or be told. For the experience which I have is, like the unacquisitive experience of a child, an experience simply of the color in the night sky. The color seen, the yellow glow against the sky, is my way of registering the effect of that beam, irradiated from a star, which impinges on my eye. But in the innocence of sight, in my life of simple feeling, I know nothing of that star, or of its beam, or even of the eye which it excites. I know only the effect of that excitation, which is the color seen. That simple quality immediately witnessed in awareness is without question, despite its familiarity, the strangest event of all, stranger than that guttering star, or its transient ray, or the nerve of an animal body which it quickens—stranger than any of these and distinct from them all. I have had to learn its causes, the conditions beyond my body and the conditions in my body, which have

conduced to its appearance. That intrinsic color quality is the product of a very complicated transaction, the description of which belongs in part to physics, in part to physiology, and in part to psychology. The transaction we can describe; the color itself we can but name. For it is a mistake to suppose that one knows the color by knowing the causes of its occurrence. One does not. To a person born blind that simple presence—the quality yellow—could be never known, though he were to master all that physics and physiology and psychology have to say, or will ever have to say, on the matter. For color is one of the elements in our experience which is not amenable to definition. It cannot be defined; it can only be exhibited. And if one had not already, in the innocence of sight, the experience of it, the experience of it as something simply found in the silence of intellect, there is no exercise of intellect which would suffice to impart the knowledge of it, or to compensate for the destitution of a life without it.

The human eye is, like star and light of star, part of the physical universe. Intricate, sensitive antenna of an animal body, part of the world, this eye of mine is my avenue upon the world. It is simply, along with the other organs of sense in my body, that part of the physical universe with which my experience is most intimately conjoined. For is it not the case that the world which I see is seen always in a perspective, from a point of view, from a coign of vantage, which my eye supplies? I am spectator of the infinite web of things from a position within the web. I see the world from a place within the world, not from a place beyond it, for beyond it there is no place. My body is my place of seclusion, my "here," the standpoint for any perception I may have of the streaming course of things. All that I do ever know directly in experience is hinged upon it. It is, for my experience, the petty pivot of the stars, for the experience which owns this body owns also this perspective of the world, and stands inevitably at that world's center, in a solitary dominion.[1]

Fundamentally, the eye is a registering instrument. That is its function in experience, to register effects of light. It registers effects

[1] Such was the sense of the philosopher Whitehead's piquant remark, that the traveller lost in the forest should never ask, "Where am I?" "I" am always "here." The only pertinent question is, "Where are the other things?"

To make out a universe which shall include your body and your experience too is another matter. But I am content to leave you, as I am content that you should leave me, for the moment unaccounted for.

of light in much the same way that the mercury in a thermometer registers effects of heat. There is this difference, that I may dispense with the thermometer and experience the heat directly by touch. But the eye is itself a form of direct touch. It is one of the organs by which I touch the world, by which it touches me. The part of the world which it touches is the light of the world, not the star, but the light of the star, the emitted beam which the star has diffused radiant into space.

Like any registering instrument, the eye gives a selective report. Of the taste of things, of their smell, their heat, their hardness, their sound, it makes no registry. It registers light and only light, and, as we learn, not even all of that. There are rays of the sun which instruments more sensitive than the human eye will register, infrared and ultraviolet rays, which the sun flings equally into space, which strike equally on the eye, but which leave the eye impassive. They are certifiably there to be felt; they are not felt. They occasion no visual response. Which is the same as to say, they occasion no awareness of *color*. For the lights which alone the eye will register, it registers in our experience as color. Color is not the property of light, but the manner of our response to it. The light-rays emitted from a source—from a star, from the sun, from a lamp, from a signal-flare—have in themselves, in their bare physical estate, no color. Color is the effect of their action upon a sensitive eye, as that effect is admitted into awareness. It is the subjective form under which lights thus registered are felt, immediately witnessed, in experience. When therefore I see color in the night sky, I have in fact projected into the face of physical nature a character which does not belong to it apart from its relation to my body and to the forms of my feeling. If there were no eye, or if there were an eye but no feeling, if the eye were blind, or the world were dead, emptied of all life and consciousness, the stars still would hurry their rays, the rays would still glance and reflect themselves upon the earth, but there would be, in the spent frame of nature, no such thing as color. The poet Gray wrote:

> Full many a flower is born to blush unseen,
> And waste its sweetness on the desert air.

Alas, gentle Gray, he was mistaken. The flower that blushes unseen blushes not at all. As there is no red in the petal of a rose on which no light falls, so equally there is no red in the petal of a rose which blushes unseen. The rose, I regret to say, is like man shameless: it

blushes only on discovery—never at the nakedness in itself, but
only at a nakedness which others see.

Thus, when one says of a painting that it is a thing of light, one
speaks ambiguously. For the term "light" may be understood to
mean the physical ray reflected from a physical surface, which falls
upon a physical eye. Or, alternatively, it may be understood to
mean light as we experience it, *sensed light*—in short, *color*. Artis-
tically, the latter alone is ever in question. A painter works in color.
He orders a pictorial field in terms of it. Except by its elemental
contrasts he can establish neither texture nor shape nor position
nor interval nor measure. The distinction between a gray spot on
white paper and a shadow cast by an object upon it concerns him
not at all, so long as the value of the sensed light is the same. The
relation of color to the physical conditions of its appearance con-
cerns the artist only indirectly. It concerns him only in his capacity
as technician, in his capacity as man of craft, as person skilled in
manipulating the material conditions of his art. The preparation
of his canvas as a reflecting surface, the mixture of his pigments as
means of producing variations of reflected light upon it, the tech-
nique of laying on—these matters have much to do with his skill
of execution; they have nothing whatever to do with artistic rela-
tions, with the relations of design to which his skill is committed.[2]
That an Indian sand-painting has the physical impermanency and
fugitiveness of loose sand, that the incandescence of a Gothic rose
window is as various and fluctuating as the light of physical day
outside, that Turner wrought his etched line with the tine of a
fork—these are technical matters of great interest for one who is
interested in producing those effects. But the justification of sand,
or of light filter, or of fork-tine, is never to be found in technique.
Technique justifies nothing. On the contrary, it requires to be justi-
fied. Its justification is to be found, if it is to be found at all, in the
perceived contrasts, the visible types of order, which it enables art
to produce. It is to be found in the softness of interior edges, in
the brilliance of transparencies, in the succulence of a line—in

[2] The limits set by the nature of the materials in which the painter works are
not in question. A painter cannot realize in pigments the intensities of saturation
which appear in the spectrum: therefore, no design can require those intensities.
But that is not to say that the pigments dictate what the design shall be. They
dictate only what it shall *not* be. They limit the range of possibilities available.
Within that range their role is perfectly abject and subordinate.

brief, in variations of color immediately seen. The relation of color to the conditions of its appearance—to the physical sources of light, to physical rays, to a physical retina of a physical eye—is not an artistic relation. Artistic relations run between terms, all of which are directly known, or are at least directly knowable, in contemplative experience. In the visual arts they are relations among color qualities, types of order of which the terms ordered are colors. To explain those variations of lights immediately sensed is the work of science. To control those variations is the work of craft. To exploit those variations in the interest of expression is the work of art.

35. *White Light and the Spectral Colors*

The white light of the sun is in fact composed of all of the rainbow hues. That composition of white light is precisely what one observes whenever a rainbow is seen arched against the sky. The moisture in the air, acting as a natural prism, has divided the sunlight into its component rays. It is the same light as always, the same light but with its rays unmixed, so that the thing seen is the gamut of colors from red through violet.

The rainbow is nature's serene accident, pure and promissory, like the touch of a woman's breast the barest intimation of the powers she conceals. Nature's essential riches, the intensities of color she is capable of producing in the human experience, only an artifice can disclose. Light is in its physical estate a form of radiant energy. A source of light diffuses its energy in all directions in waves of varying length and amplitude. The length of these waves, the distance measured from crest to crest, determines the color seen when a ray impinges on the eye. If rays of sunlight fall perpendicularly on an

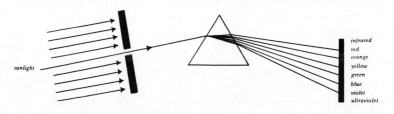

Figure 62

ordinary window-pane, the pane will transmit them undeflected from their straight path. A glass prism acts contrarily. It too will transmit the rays, but in transmitting them it changes the direction of their movement (Fig. 62).[3] The path of a ray is, in the language of the physicist, refracted. As the ray passes through the prism, its path is bent, and the angle of its deflection is found to vary according to its wave-length. Thus, in a darkened chamber a beam of sunlight, admitted through a slit so as to strike directly on the eye, appears as a white of dazzling brilliancy. Directed through a prism, it will distribute itself into an indeterminate number of colored rays. Language is too impoverished to name them all. We name them only by groups, according to their differences of hue. These groups are the bands of the visible spectrum—red, orange, yellow, green, blue, and violet, and their intermediates. The red band consists of the longest rays and corresponds to the series of reds in our experience; the violet band consists of the shortest rays and corresponds to the series of violets; and the others fall between.[4] The visible spectrum is simply the effect of nature's rainbow, but of a rainbow fully saturated with pure color, less blond and faded than nature unassisted by artifice ever succeeds in producing. Remove the prism, the light appears again as white. Replace the prism, the rainbow hues are reinstated with a saturation undefiled. Duplicate the prism, let a second prism, inverted, be made to intercept the rays which have been thus decomposed, they will again mix themselves pacifically into a single node of white light.

That is what a scientist understands by an experiment. The effect is still nature's: he the experimenter does not produce the effect; he simply liberates it. The act of the experimenter is, like the act of the artist, obstetrical, a piece of midwifery that releases in nature powers which nature already includes. When Michelangelo regarded the form of his sculpture as already implicit in the unhewn block, waiting only by the artist's hand to be set free, he meant just that. And he meant rightly. The only error is to suppose that by that circumstance the artist's role is diminished. The artist's role is, on the contrary, elevated, for it is he, not nature, who knows to

[3] After Ralph M. Evans, *An Introduction to Color* (Wiley: New York, 1948), Figure 4:8, p. 45.

[4] A ray from any one of these bands is simple: separated from the others and directed through a second prism, it will be a second time deflected, but its quality remains unchanged.

discriminate the form which makes stone speak from the innumerable forms, equally implicit in it, which leave it mute.

Why, if objects are lighted alike by a common sun, do they appear to wear different colors? The light which falls upon the petal of a rose falls also on its leaf. Why does the one appear red and the other green? Because the one *is* red, and the other green? That answer, in its way, is true, but its way obscures what it professes to explain. Neither petal nor leaf, unlighted, gives forth its color. Neither appears at all unless light falls upon it. Yet when light falls, though the same light falls on both, each gives forth its own quality. Each selects from among the component rays of white light, and greets the eye only with those which convey its proper vestiture. Evidently the difference is occasioned by a variation in the things lighted. Each subtracts from the light of the sun, but each subtracts differently.

An opaque physical body will either absorb light or reflect it. The colors which are seen in its surface are determined by the rays it reflects, and by these alone, since these alone meet the eye.

A flat surface which reflected all light that fell upon it would, if polished, precisely mirror its source: exposed to the direct light of the sun, it would appear to have the white brilliance of the sun itself. A surface which absorbed all light that fell upon it would mirror nothing: exposed to the direct light of the sun, it would appear as if no light fell upon it, and would be seen not at all.

But ordinarily, when light strikes an opaque surface, the surface divides it into two parts: one part of it is absorbed, the other part is reflected. The visible aspect of the frame of nature is structured out of these reflected rays, rays which rebound and interweave themselves curiously into a Joseph's coat. In what men commonly call a mirror some rays are in fact absorbed. But the majority are thrown back, and appear to the eye as a version, but slightly diminished, of the light from their source. Such is the character of a true mirror that, except for this quantitative reduction, it leaves the quality of the light unchanged. A white light that falls upon it is still white as reflected. Which is to say, that rays of different wavelength have in reflection approximately the same relative proportions which they had in the source. The mirror surface is unselective with respect to the rays it reflects and the rays it absorbs. An ordinary surface, struck by the same white light, has not this self-effacing neutrality. Like the mirror it will absorb part of the light

and reflect the remainder. But it does not absorb all of the component rays of white light in an equal proportion. Its absorption is selective. The petal of a rose absorbs an excess of the green rays and reflects an excess of the red; its leaf absorbs an excess of the red and reflects an excess of the green. Each selectively subtracts from the total incident light, so that the color seen in either surface is simply the color associated with the rays which have not been withheld.

In white light the relative amounts of rays of different wave-length are approximately equal. Every material body will reflect some measure of white light. In some measure, at its surface, it gives back this roughly equal distribution of varicolored rays. The difference between a pastel and a grayed version of a rainbow-hue—between the pink of honeysuckle and the red of a rose—is determined by the measure of white light thrown back along with the rays of that hue.

But in addition to this measure of white light there is the hue itself. The majority of opaque surfaces are selective in their absorption. Under illumination they absorb some rays in greater measure than others, so that, unlike mirrors, they disturb the proportions of the incident mixture of wave-lengths and give back a different distribution from the one which fell upon them. Therefore, according to this difference, since only the reflected distribution meets the eye, the colors of objects vary in hue as well as in brightness and saturation.

36. The Constancies of the Field

Physically, a stretched canvas is a reflecting surface. All of its lights are borrowed. It depends for its visual character on the lights that fall upon it. Initially, before it has been worked, it reflects lights uniformly. Let light from a single source be projected evenly over its surface, any part of the surface will reflect the same distribution of rays as any other part. It may itself have color, gray or a grayed version of one of the rainbow-hues. Which is to say, there are some lights which, already before it is touched, are absorbed by it. But as it reflects some lights uniformly, so it absorbs others uniformly. That is its virtue as a possible pictorial field, not that it will reflect all lights and absorb none, but that it reflects and absorbs with an even constancy. Considered simply as a thing of light, it is visually homogeneous.

The uniformity of the artist's field as a reflecting surface is as indispensable to the artist's government of lights as stability is indispensable to his government of shapes.[5] For his task is, as always, to impart to the field a visually appreciable order. In that enterprise the uniformity of the field is demanded as a visual constant, against which his changes may be registered. Unless this uniformity can be supposed, it is impossible within the pictorial field to discriminate, among the contrasts which it contains, those contrasts which are to be accounted *transforming contrasts*. For what alone is the artist's, all in nature that he can ever call his own, is the order he produces in nature, not the order he finds there. The order he produces is the mirror of his act. The order he finds is the mirror only of his passion and omission.

There is a second constant which he requires and which that stretched canvas offers. A perfectly polished mirror would reflect all lights, or almost all, and would reflect them uniformly. That for other purposes would be its virtue. For the purposes of the artist that precisely is what disqualifies it as a possible pictorial field, that having no texture of its own, it appears always as a source. Isolated, set apart from the external clues which normally accompany it, it is not seen, neither is it seeable, as a reflecting surface. It effaces its own thinghood. Its character is so volatile that it changes with every setting, and denies itself in all settings. In its vacant vicissitude it borrows all that it can ever appear to be, not only light but disorder and inconstancy as well. For to have every character is at last to have none.

The painter who aspires to mirror nature will do well to meditate the moral of this, that art is partisanship, that only a silly mirror can be neutral, and that if the artist trades, for the image of nature, the image of man, it is because the artist reveres what nature only holds, and science forgets. Science in its proper function forgets the scientist; art in its proper function images him.

When Cézanne works a surface, the touches of his brush enact a dual function (Plate 37). They function as elements of representation, out of whose concert emerges a pictorial illusion of space in depth. In this function it is not they, but the landscape—the poplars or Mont Sainte-Victoire—that is seen. But, unlike the colors of the landscape itself, these colors never shed their character as *touches*. The painting is, like the work of any honest craftsman,

5 See Section 5.

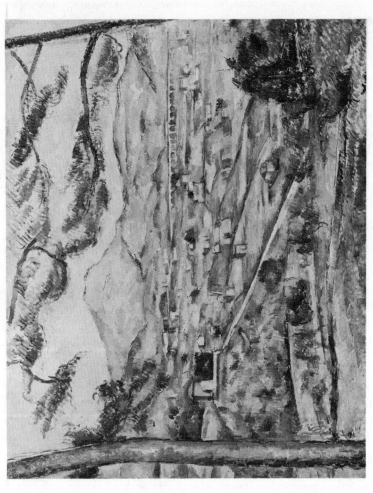

PLATE 37. *Paul Cézanne (1839–1906), "Mont Sainte-Victoire" (1885–1887), Duncan Phillips Memorial Gallery, Washington, D.C.*

unashamedly and frankly an artifact, a thing made, each touch recording an act, a deliberation, a decision of its maker, so that he is present in it, as also the landscape is present in it. Its function is, besides being representational, so to put it, biographical as well. In those immaculately ordered touches, diagonal to the axis and parallel to each other, you trace his vertical progress over the surface with the same assurance with which you trace its transformation into depth. When, therefore, one finds, in a Cézanne canvas, certain parts which have been reserved from any pigment, parts where the canvas itself is allowed to reflect its proper light and texture, there is never any question that the omission was intended. The painting is not unfinished. It is simply that the painter, like a lover, knows the value of a silence, of a word unspoken. The omission has a positive value, and the hand is withheld.

The capacity to see that value is grounded in the constancy of the pictorial field.

A stretched canvas has then this constancy, that it reflects light uniformly and by its texture declares its thinghood. The art of painting makes use of this property. A spot of pigment applied to any part of the surface, if it reflects more or less light than the canvas, or a different selection of the rays of light that fall upon the canvas, will have altered its visual effect. It will, as we know, have produced a contrast of shapes, the contrast of positive and negative areas within the reflecting surface. But that is not the matter which is presently in point of interest. The light reflected from any part of the spot is different from the light reflected from any part of the canvas beyond the spot. The spot of pigment, whatever its shape may be, has disturbed the uniformity of the field considered simply as a thing of light. There is in the field, besides the contrast of shapes, a contrast of colors. These two contrasts are distinct. They vary independently. The shapes may remain fixed while the color-contrast changes. Or the colors may remain fixed while the shape-contrast changes. That, for the master artist, is a matter of perfectly fundamental importance, for if it is the business of design to produce an order among visual elements, then, just as elements may be ordered with respect to their shapes, so equally they may be ordered with respect to their color qualities.

The kinds of order which art is capable of producing among color qualities will depend on the physical circumstance, that the color

seen in an opaque surface is determined by the lights it is permitted to reflect.[6] Therefore, in a pictorial field, if the proportions of reflected and absorbed light may be governed by the action of selected pigments, the colors seen may be made to vary by design.

The problem is, to determine the kinds of variation which can appear among colors. For the kinds of order which can be produced among them will depend at last on the range of contrasts they are capable of.

37. *Hue, Saturation, and Value*

I once heard Abraham Rattner describe how as a young artist in Paris he went to see Papa Monet at work. Monet was already advanced in age, master of an older generation, whose spirit, if it presided still in Paris in the work of others, presided also, and presided more vitally, at Giverny, on the outskirts of the city, in his own. There, of a morning, he could be seen, that unscorched Phaëthon who had ridden with supple skill so near the sun, whose skill had grown suppler as his eye grew innocent, and his body old. He sketched out-of-doors—*en plein air*, as he taught the French to say— in his sunlit garden, beside a lily-pond, which walls secluded from any visitation but the sun's. And it was a thing to see, that mobile brush of his, which refused to niggle on any one part of his canvas, which moved, at arm's length, in broad, sweeping, rhythmic transitions from his palette, distributing *taches* of pure color across the face of a painting which he began and concluded as a total surface. Not that everyone was invited to observe this remarkable phenomenon. On the contrary, no one was invited, and Rattner was included in that invitation. You watched him from a tree beyond his garden wall, which could, if one had the quietness of a caterpillar, the curiosity of the young, and the hunger of a *fauve*, be climbed. There, reverent, precariously hung aloft in the sky, unobtrusive as an acorn in the oak and clinging as fast, you had the reward of your pilgrimage from Montparnasse, in a demonstration beyond all gainsaying that art was nature seen at a second remove!

[6] The art of stained glass works with translucent surfaces—with transmitted lights, not with reflected ones. The selective action of the transmitting surface remains identically the same: the color seen is the color associated with the rays which have not been withheld.

Well, imagine redoubtable old Monet in his garden, confronting his canvas which is placed, like himself and his lily-pads, *en plein air*, in the sun's full light. They swim all alike in color, in a salamander world—Monet, the untouched expanse of his canvas, the budding riot of his garden, all in a bath of flame. For Rattner and for you and me, the better part of whose imperilled energies are spent in adhering to the trunk of a tree, that description has normally to suffice. And normally, in fact, it does suffice, for our business with that color is normally not to seize *it*, or to register its variation and its movement, but to seize other things by means of it. We treat the color not as an intrinsic value, but as a sign, valuable only for the sake of the things it signifies, as now it signifies Monet the executant, the painter at his task, in the sea of light which is the occasion of his task. Therefore, in seeing Monet, we do not see as Monet sees, who sees the color and its movement, and is careless what it signifies, and would be as solicitous of its nuances even if it were found to signify nothing. The description of his circumstance which suffices for our observation will not, therefore, suffice for him. For he looks not, as we, *through* color, but *at* it, and he discovers in it the terms to be ordered, and the relations of possible order, of his art.

The word "color," as it is commonly used, has a narrower meaning than Monet ascribes to it. By "color" a tree-climber is content to understand red, orange, yellow, green, blue, and violet, and there is an end to it. Monet understands this too. But he will discriminate, in addition to the rainbow-hues, other differences among colors of which tree-climbers take no separate account. A charcoal drawing in black and white and in the intermediate grays is an effect of sensed light: it is therefore an effect of color. The red of a cardinal, the pink of phlox—both are red, but though in that respect they are the same, they are nevertheless, despite their similarity, distinct. For a person whose craft consists in manipulating light and in producing effects of visible order by means of it, it is indispensable to have names for designating these differences.

The difficulty is, that language, which has been evolved for purposes quite distinct from the purposes of art, does not provide the names. It supplies words only for making those practically useful distinctions—red, orange, yellow, green, blue, and violet—which the ordinary purposes of action have rendered important.

Yet even if language had been evolved by painters for the uses of painters, it would still remain too coarse an instrument for

designating the total range of differences which the painter's eye sees. He discriminates more finely than he speaks, and marks intervals between terms which, apart from their intervals, he never attempts to name. He contents himself, therefore, by referring only to the *kinds of variation* among colors. The terms themselves are inexhaustible in number; their modes of variation are not. He does not therefore profess to name the terms. He names only the respects in which their variations are found to occur. Colors may vary with respect to *hue*, or with respect to *saturation*, or with respect to *value*. If I note in language to Monet the kinds of color variation which I think at fault in a passage of his work, he will tell me crisply, in terms of his own, to mind my business as he minds his. But he will understand my meaning, as I have understood his.

Let, therefore, the differences noted by the tree-climber be described unambiguously as differences of *hue*. If you ask him what is the color of a lemon, he will answer "yellow." If you ask him what is the color of a lemon on a dark day, he will answer still "yellow." By "color" he understands what the artist means by "hue," namely, the differences most commonly attended to among the rainbow-colors. There are in the rainbow other variations of color besides contrasts of hue. The master artist employs the word "hue" to mark the difference between red and orange, between orange and yellow, between yellow and green, and so on. By this technical term he takes account of that aspect of color which enables him to describe his loss when, in winter, in the surface of the snow at his feet, he sees the blue sky change to slate.

Hue is but one aspect of color. Select a given hue, such as red, and ask how one shall describe the difference between two examples of red which the eye quite clearly discriminates. Fire-engine red and petticoat pink are the same with respect to hue: that is to say, both are reddish in hue. But they are nevertheless as different from each other as boudoir from station-house. Even the tree-climber makes this distinction, but he has no way of stating it. The artist describes it in terms of *saturation* and *value*.

By "saturation" he understands that aspect of color which varies with *the amount of a given hue*, its relative purity in the light which meets his eye. The difference between red and yellow is a contrast of quality; the difference between fire-engine red and petticoat pink is a contrast of proportions, of relative quantity. In reflected light which meets the eye there is always an intermixture of white or

gray light. In a reddish surface the red rays are dominant: the degree of their dominance is the thing indicated by saturation. Thus, granted that fire-engine and petticoat are both red, it is nevertheless clear that a square-inch of the fire-engine is more purely red, has less white light mixed with it, than a square-inch of the petticoat. It is a pity to say it, but the petticoat which contains such blissful white has only the redness of a brick.

This difference in the relative purity or strength of a given hue the artist describes as a difference in saturation. It is a distinctively quantitative variation among colors. Just as a sock can be more or less damp, so a red can be more or less saturated. One says the same thing, but says it conversely, in describing a hue in terms of its degree of neutrality. If one were to gather together all the reds in the world, they could theoretically be ordered in a scale from least to most saturated, and of any two reds it would be possible to say, either that one was more or less saturated than the other, or that they were of equal saturation.[7]

Such a scale is possible for each of the several hues. The blue of the sky is more strongly colored, more saturated, after a rain than before it. The fruit which men call orange is more saturated with its hue than the kelp on the seashore.

The pastel quality that belongs to the kind of painting produced by the Impressionists is in part unpremeditated (Plate 43). The Impressionists were interested in capturing the effects of sunlight. But in seeking the effects of out-of-doors lighting, they inevitably diluted the hues which appeared on their canvases. As brightness increased, saturation diminished. The color is dilute. The effect is the effect of pastel. It is the art of the petticoat. For the art of the fire-engine you must look elsewhere—to Goya, to Manet, to Van Gogh, to Matisse.

There is yet a third aspect of color. Suppose you were to take a black-and-white photograph of the gardenscape which old Monet is engaged in painting. The photograph evidently captures the effect of the garden. But just as evidently it omits, alas, everything we have

[7] There is some disposition in current literature to refer to this distinction of saturations as a distinction of "intensities." Arthur Pope employs the latter term with meticulous consistency, and I depart from his usage only with reluctance. The name used is a matter of complete indifference, provided the same thing is on all occasions understood by it. But that is by no means the case. In the literature on color the term intensity is as frequently employed to mark differences of *value*. I therefore renounce it in both uses.

been discussing. It omits the hues of the gardenscape, and in omitting these, it omits also the saturations, since saturation is nothing but the relative amount of a hue. What it records, the *only* thing that it records, is what the artist describes as *values*, the degrees of relative brightness in the objects imaged. The black-and-white photograph is the record of the contrasts of lights and darks in the garden scene. It abstracts from hue, it abstracts from saturation. It grasps only *the amount of white light* which was reflected from the various objects in the flame of a garden.

A charcoal drawing is like a black-and-white photograph an essay in values. The sole means which it employs are lights and darks. A black-and-white medium has not, however, any exclusive claim upon these lights and darks. A red may have the same light-value, the same brightness, as a blue, an orange as a green. These variations in light-values appear equally in all painting. They are the most ineradicable aspect of color for the art. There are painters like Ingres who know how to dispense with hues and saturations. There is no painting which can dispense with values.

Masters of painting who work predominately in terms of contrasts of light-values are known as "tonalists." Rembrandt's art is an art of tonality (Plates 23, 51, 52). His paintings are tonal studies. The hue remains constant; it is the lights that vary, and the measure of saturations does but follow their adventures.[8] Within tonal art the most extraordinary variety of effects is possible—the psychological studies of Leonardo da Vinci (Plate 38), the crass *tenebroso* realism of Caravaggio, the classical serenity of Poussin (Plate 34), the pulsation of lights in El Greco's mystic vision (Plates 15, 22), the surrealist evocations of Goya (Plate 39), the obsessive terrors of Munch (Plate 40), the introverted melancholy of men, of men who suffocate alone even in groups, of Picasso's Blue Period (Plate 41).

[8] The *contrast* of light and dark is the essential emphasis of a tonal art. The Impressionist painters were interested only in light, not in tonality, the contrast of lights and darks: they are not properly describable as tonalists.

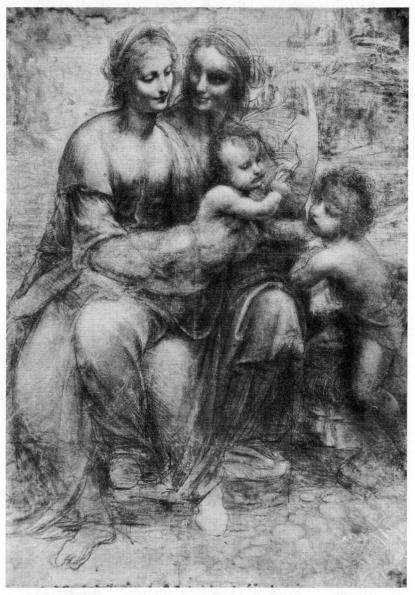

PLATE 38. Leonardo da Vinci (1452–1519), "Madonna and St. Anne" (c. 1498), Cartoon, Charcoal, Reproduced by courtesy of the Trustees, The National Gallery, London.

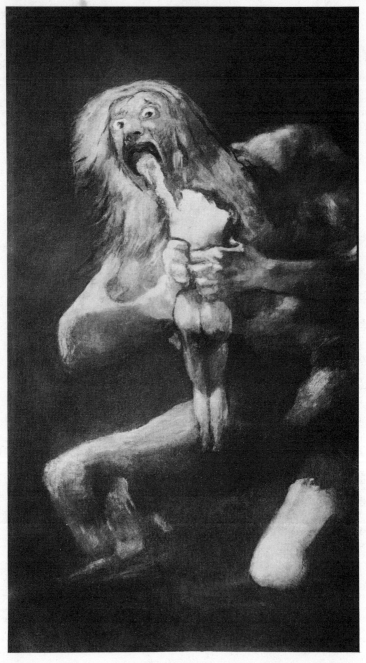

PLATE 39. Goya (1746–1828), "Saturn Devouring His Children" (1819–1823), Prado, Madrid (Anderson).

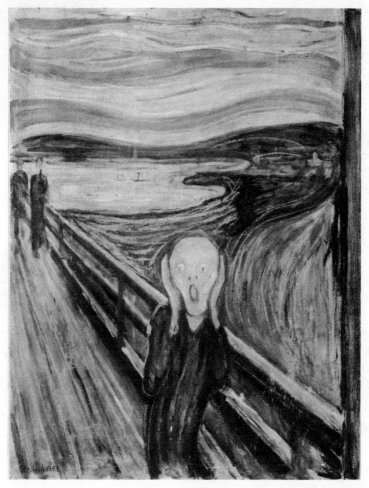

PLATE 40. Edvard Munch (1863–1944), "The Cry" (1893), National Gallery, Oslo.

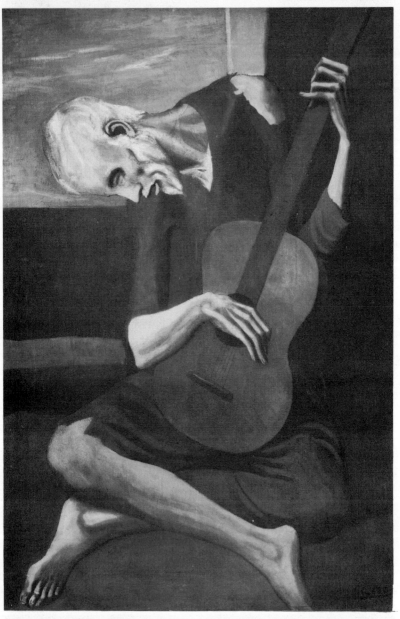

PLATE 41. Pablo Picasso (1881–), "The Old Guitarist" (1903), Helen
Birch Bartlett Memorial Collection, The Art Institute of Chicago.

VI. The Ordering of Silence

38. Scale and Consonance: Toulouse-Lautrec's "At the Moulin Rouge"

The hues of the visible spectrum exhibit always the same order—red, orange, yellow, green, blue, and violet. This order is a fact of physics, a fact of the world, not merely of our vision of the world. It is the simple consequence of the order of decreasing wave-lengths among the associated rays.

Within limits that order coincides with the way in which hues stand related in the human experience, and a great dust has on that account been raised about it. For it would appear that the felt affinities among hues are, like the felt affinities among the tones of music, grounded in physical circumstance.[1]

The hues of the spectrum bear to each other, in the human experience, degrees of felt affinity. The color orange, for example, has plainly a more intimate relation to red and to yellow than it has to blue. I see red in it, I see yellow in it; I see blue not at all. That visual affinity is artistically of the greatest possible interest. It constitutes, for that hue, the matter to which an artist's eye is singularly sensitized, for in the production of any order among

[1] The octave of a tone in music is twice the frequency of the tone itself. To double or to halve the frequency of vibration of a given tone is to produce a tone which appears to be identical with the first at a higher or lower pitch. The musical scale on a piano keyboard has in consequence this property, that it is felt to repeat itself identically seven times over, the same set of intervals recurring periodically at each successive octave. To master the relations of pitch among the tones in one octave is implicitly to have mastered the intervals of the seven-octave system as a whole. The order of felt affinities coincides, throughout the system, with a regular period among the physical magnitudes, for it remains true generally that the greater the felt interval between any two pitches, the greater the interval between their respective frequencies will be.

hues the things he discriminates are never hues simply, but the relations of affinity in which they stand.

Artistically, the interest of the order of the colors in the spectrum consists in this, that the sequence

$$R - O - Y - G - B - V$$

in part represents these relations of felt affinity, each term in the series having in fact the greatest felt affinity with the term or terms immediately adjacent to it.

That coincidence between the physical basis of the colors and the relations of felt affinity found among them is, however, only partial.

The physical basis of the affinity which orange has to yellow and to red the physicist is prepared to countenance: orange corresponds to a wave-length intermediate between the two. But red and violet, the two ends of the spectrum which are physically most remote, are visually, in point of felt affinity, as near to each other as red to orange, or as violet to blue, and they are nearer to each other than either is to yellow or to green.

Of purple, of the hue which men sometimes call red-violet (RV) or magenta, the physicist has not a good word to say. He is, I suspect, a little ashamed of it. Purple—the hue in which the eye sees both red and violet in illicit embrace—has no place in the physical spectrum. It corresponds to no simple wave-length, but has been compounded out of the wave-lengths of greatest and least measure. Red-violet is nevertheless, visually, a color as indefeasible as orange, and is in no sense in its generation naughtier than that shameless violet, falsely thought modest, in which the eye sees both red and blue embraced, in Shakespeare's nice phrase, like "country concupiscents."

The hues of the artist have visual affinities which are not, in short, in all cases directly derivable from the physical measures of simple wave-lengths.[2] Violet, if a coincidence did actually exist between the order of felt affinities and the order of physical circumstance, should have a wave-length intermediate between the wave-lengths of red and blue. It does not. That intermediate frequency falls in the band of rays of yellow hue, with which it is

[2] The wave-length may vary while the hue remains the same. In the physical spectrum wave-lengths longer than 655 millimicrons remain still visible; wavelengths shorter than 430 millimicrons remain still visible. The intervals at the two ends of the spectrum—the interval between 655-700 in the red band, the interval between 430-396 in the violet—exhibit each a constant hue.

felt to have nothing whatever in common. Red-violet (purple, magenta), for its part, has no right to be at all: it is nevertheless a visually certified phenomenon, and, as every printer knows, one of the decisively important hues which he employs in the exercise of his craft.

What then shall be done to bring, if not modesty, at all events order out of this? For the purposes of art one thing only is imperative, to respect the affinities which are felt. "Color," as Ralph Evans once said, "is what you *do* see, not what you should see."

It is well to begin with the rebel hues. Purple (magenta, red-violet, RV) is felt visually to lie between violet (V) and red (R); and violet between red and blue (B). The sequence

$$B - V - RV - R$$

satisfies these conditions. But it lacks the very property which could ever cause it to interest a master artist. His mastery as a craftsman consists after all not in cataloguing the color terms, but in marking the orderly intervals among them. For it is out of such intervals, and out of these alone, that he can acquire what he will describe as a *scale*. He may speak, with a forgivable brevity, of scaling his palette. But his palette and his pigments are not at all in question. What in fact he is interested in scaling are his *lights*, here specifically the *hues* of light, for those alone, not the pigments, are his proper terms. If, then, to accommodate him, I speak of scaling his palette, let it be understood that the sensed light alone is meant.

He can scale his palette on one condition only, that the terms it includes shall stand to each other in relations of immediately appreciable affinity. But that will not of itself suffice. The affinities must be *graded*. It must be possible to note, besides the fact of affinity, its measure. In a scaled palette the degrees of affinity among the included hues will be visually calculable. They will be expressible as proportions. It will be possible to observe, for example, of three hues, that they stand separated in the scale by intervals such that $A : B : : B : C$; or of four hues, that they stand related by intervals such that $A : B : : C : D$.

The sequence thus far established

$$B - V - RV - R$$

has not that systematic property: it expresses the affinities of the hues which are its terms, but not the measure of their intervals. It is not *uniformly graded*, so that terms equally separated in the sequence are equally separated in the measure of their felt affinity.

The measure of red in red-violet is equal to the measure of violet, as the sequence shows. But blue and red are present in violet in equal measure, and the sequence makes them appear to be unequal.

The thing needed is another term, a transitionary term between blue and violet, which stands to blue and violet as red-violet stands to violet and red. Newton named that term in the spectrum itself. He called it "indigo," a blue-violet (BV). Supply that term, the sequence is then scaled in the uniform gradations which the master artist requires:

$$B - BV - V - RV - R.$$

For it is now possible to observe of this sequence that terms equally spaced have equal affinity: for example, that pairs of terms stand related by constant intervals of the second degree

$$B : BV : : BV : V$$
$$BV : V : : RV : R;$$

that pairs of terms stand related by constant intervals of the third degree

$$B : V : : V : R$$
$$B : V : : BV : RV.$$

A scale is simply a definition of the artist's terms, in which their systematic relations to each other can be seen. The equilibrium of a work of art is at last a matter of proportions. Such proportions can be made visible on the one condition that the terms of art are limited, and their mutual relations fixed.

Suppose the master artist, then, to have elected to work with a scale whose least interval is stated, and then once repeated, in the sequence, $V - RV - R$. His scale will be found to appear, not like the physical spectrum a succession of hues disposed in a straight line, but a succession of hues disposed in a circuit, in a "color circle," which draws together the two ends of the spectrum and supplies red-violet to join them (Fig. 63).

A sensitive eye turned upon the hues disclosed in Monet's garden will discriminate many more hues than these.[3] But the number of the terms is not after all the matter in question. Were their number to be increased, were it to be diminished, the principle which governs their order would remain identically the same. Any expansion or contraction of the number of terms would have necessarily

[3] The actual number, determined according to the method of just perceptible differences, has been variously estimated: it falls somewhere in the range between 125 and 165.

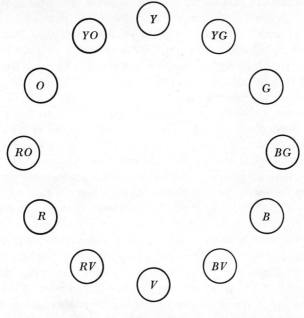

Figure 63

to respect the property of the present scale which orders the terms in a uniformly graded sequence according to the felt affinities between adjacent terms. The circuit may be wider, it may be narrower: the number of its terms will be in all cases determined by what has been chosen as the least interval. It will remain still true that between any pair of adjacent terms that interval will be constant. Thus, the sequence

$$R - O - \Upsilon - G - B - V - R$$

is an alternative scale, a contracted circuit, in which the number of terms has been systematically reduced. But the sequence

$$R - O - \Upsilon - G - BG - B - V - R$$

is no scale at all, since the interval—the degree of felt affinity between adjacent terms—is inconstant.

A single scale will not be found to govern all art; but there is no art without scale, and can be none. For the art of a work lies, everywhere and at all times, not in what is done, but in the consistency of what is done; not in the act performed, but in the equilibrium which required it. That visible consistency is what art

incorporates, so that the thing made retains in it still the impression of its maker, even when the maker's hand has been withdrawn.

By a "scale" I do not intend the artist's "palette." The visual scale of an artist is a systematic ordering of the intervals between the terms of his art; his palette is the selection of terms from that scale which he has chosen in fact to employ.

A Classical artist may restrict his palette to the triad, *R*, *Y*, and *B*, selecting as the terms of his performance hues removed at equal intervals on the color scale. That simplification belongs to the economy of a particular style of art. An alternative mode—a restriction to the triad, *O*, *G*, and *V*, or to the complementary pair, *RV*, *YG*, or even to a single hue, *R*, rendered in contrasting values—would for other purposes do as well. Nothing forbids that the entire gamut of the scale in Figure 63 should be employed, or even that the hues adopted for use in the palette should be separated on the scale at unequal intervals, as *O*, *Y*, and *B*. The manner of the simplification is not in question; only the demand for clarity and regularity is in question. Regularity is the limit he imposes on himself, his sole defense against the glut of hues in nature. For in what the artist does, unless there be some discernible regularity, some clearly discernible restriction which is apparent in the range of color-intervals he employs, his work will appear insensate, miscellaneous, disordered.

The range of hues which an artist's eye discovers in nature he does never attempt to capture in his art. It is as well that he does not, since no artist who ever lived has commanded that measure of dexterity. But the demand for a scale of hues is not imposed at last by the physical limits of men's craft. It is imposed by the conditions of artistic performance. Even if one were to suppose in an artist the capacity to reproduce the full range of hues in nature's motley, to reproduce them all would be in effect to confuse his artistic performance and to misconstrue his proper interest. For his performance consists not in capturing hues, but in capturing a vision of order out of them. The hues of nature have an order, but the terms are too numerous, and the intervals among them too indecisively vague and manifold, for that order to be perspicuously grasped and appreciated. Therefore, arbitrarily, the artist imposes on himself a limit, within which he obliges himself to work. He institutes a set of intervals, a set of uniformly graded affinities, which define for him the terms admissible in his art. The terms themselves are in fact

of less interest than the system of intervals which is announced through them, for it is that system of uniformly graded intervals, standardized and repeatable, which is actually read as the *harmony* of his color-scheme. To employ those terms is to preserve harmony. To employ others is to desert his resolution, and, in the measure that he deserts it, to produce disharmony and dissonance.

Harmony of hues is not, in short, an absolute. There are no hues in nature which are intrinsically disharmonious. It is only in relation to a scale which we bring to nature that harmony or disharmony can be identified. A scale is simply the systematic exhibition of a regularity which we demand: what is consistent with it is harmonious, what is not is discordant.

Men have a way of supposing that harmony is a fact of psychology, that there are some color-combinations intrinsically approvable, and others not. In this they dignify as psychology what is simply familiar in the habit of vision to which they have grown used. When a Mannerist artist like Pontormo works in terms of secondaries—in terms of the triad *O*, *G*, and *V*, instead of the Classical triad *R*, *Y*, and *B*, the quality of his work is transformed: our awareness of its systematic feature is constant. It is the consistency of his performance, its rulefulness, which is affirmed as the harmony of his work.

The real challenge of art to our color sensitivity is discovered in an authentic experiment in the use of color like Toulouse-Lautrec's. Toulouse's painting, *At the Moulin Rouge*, in the Chicago Art Institute (Plate 42), is a positive experiment in color harmony, made in perfect carelessness of his contemporaries' settled habits of approval. Renoir's incontestable graciousness as a colorist is insipid beside it. Renoir pleases, Toulouse disturbs. Which is only to say, that Renoir ministers to our habits as Toulouse does not. *At the Moulin Rouge* must appear, to any eye come fresh from Renoir, a most acrid performance, a vinegar to Renoir's wine. It not only works in secondaries and tertiaries; it deliberately allows the latter to figure as dominant. Toulouse is to the art of color what Debussy was to the art of music—a chromaticist, who has discovered new possibilities in an expanded scale. The difference assaults the eye. It is an affront to my habit, it disturbs my sloth, and I should turn from it as from a spasm of vision that offends, did it not at the same time hold so imperiously. The thing that holds is not the sting of those tart hues, nor even the strangeness of that angle of vision, but the awareness

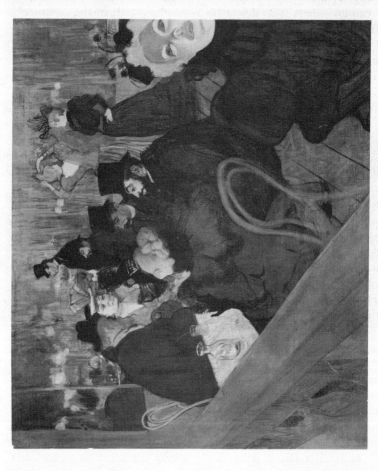

PLATE 42. Henri de Toulouse-Lautrec (1864-1901), "At the Moulin Rouge" (1892), Helen Birch Bartlett Memorial Collection, The Art Institute of Chicago.

that the same regulating artifice which presides sovereign over those shapes presides equally over these color-sequences as well. It is not the colors that are disturbing, for no one of them, taken by itself, will be found to grate upon the sensibility. The thing which disturbs is the combinations which are permitted to appear. In the implicit scale intervals have been contracted, so that within the compass of this field degrees of affinity are admissible which Renoir's scale would have decried. Not a single frank color shall be found in the total array, and if in halt language one would name these colors at all, one finds himself inevitably using analogies with the colors of strange fruits, not the colors of apples and lemons, but of avocadoes, pistachios, and loquats. These combinations are things of chance? Chance has never been so systematic or so sustained. No, you see a new idiom, and unless you see its consistency, you do not see Toulouse. For that is the character of an idiom, that it is capable of repeating itself, and has done so. It is grounded not in nature's accident, but in man's control, in a new principle which makes even of apparent accident a thing of rule.

When a musician develops his material, he is apt to employ a device which in music is known as "modulation." A theme announced in one scale is made to appear in another, and that change of scale, which modulates the theme, is on occasion like a new discovery, disclosing in it possibilities which in its initial statement were unimagined. That transfiguration of the quality of a theme, which comes of modulating it, is possible on the one condition, that the change is capable of being felt. If the theme itself, as it was initially stated, were not already in a scale, and felt to be in one, the departure from it would never be perceived.

A master artist may employ the same device, but he can employ it, in the simultaneity of his art, only to produce a deliberate dissonance. The sense of scale in all he does depends upon a limitation which he has himself imposed: he works with a limited set of terms whose mutual relations are regularly calculable. Nothing obliges him to make use of all of the terms which appear in his scale. But he forbids himself, as he would preserve the lucidity of his art, the use of any term which does not appear. This is the lawfulness which presides over his ordinary act. In law itself there is a dictum, *nullum crimen sine lege*. Which is to say, it is impossible to sin unless there be a rule to sin against. It is so with the work of the artist. Unless there be a law which defines right, there can be no wrong.

If consonance has no rule, no dissonance can offend. Where no order is ever felt, no disorder can ever shock.

39. *Complementaries: Additive and Subtractive Effects*

A material body placed directly in a path of light will either reflect the light, or absorb it, or transmit it. In many cases it will do all three. The light it reflects it throws back; the light it absorbs it converts into another form of energy, usually into heat; the light it transmits it leaves unchanged except for a possible bending of its path. In this physical transaction none of the incident energy is lost or destroyed: it is simply redistributed.

All that one says on the techniques of the artist's craft has at last to do with governing that redistribution.

The artistic phenomenon depends upon the channeled light that meets the eye. In an easel painting that light is light reflected; in a stained glass window it is light transmitted. In both it is a subtractive remainder. The artist's technique consists not in producing light, but in withholding it. The lights one sees are the lights which he has left unarrested in his field.

Monet is in his garden. Compare the light which falls upon his canvas with the light reflected from it. The color seen in the canvas is not white, but gray, a degree of light appreciably less than the light of the sun which strikes it. Evidently part of the light has been absorbed by the canvas, or has escaped through its interstices and been transmitted beyond it, so that the light reflected is but a diminished record of the sunlight. It has been diminished exactly in the measure that the canvas has absorbed light or has failed to intercept it.

Accordingly, let W represent the light that falls directly on the canvas from the sun, let R represent the reflected light, and A the light absorbed or transmitted. Then, the formula

$$R + A = W$$

will be true of the present case: the part of the light which the canvas reflects and the part of the light which it transmits or absorbs together equal the whole of the light which was incident upon it.[4]

[4] I am assuming, for the sake of simplicity, that the sun's direct light is the only light that falls upon the canvas, that it is struck by no light already reflected from other objects. This will be true only under controlled conditions which Monet's

This formula will be found to be true of any object lighted directly by the sun. It will be true of the petal of a rose; it will be true of its leaf; it will be true of the mirroring surface of Monet's pond. Each reflects a different selection of the rays of incident light. But in this one respect they will be all alike, that if the portion of light they reflect and the portion they absorb or transmit were to be combined in one quantity, their sum would be equal to the total amount of light that fell upon them.

I shall refer to any two quantities *R* and *A* as *physically complementary* if together they represent the total presence of light, namely, *W*. And I shall speak of the colors associated with the quantities *R* and *A* as *physically complementary colors*, since together they will form white light.

Thus, *white* and *black* will in this usage be physically complementary colors. Black is the quality which represents in experience the zero presence of light; white the quality which represents its zero absence. Thus, the physical complement to the light reflected by a surface perfectly white is zero; the complement to the light reflected by a surface perfectly black is totality.

In calling black and white complementaries, I do not mean that if in the light of the sun you mix a black pigment with a white pigment, you will find in the mixture an undiminished image of the sun's light. You will not. You will get an intermediate gray, a gray darker or lighter according to the proportions you have used. I am speaking of a relation of light-quantities and of the colors associated with them. A pigment is not a quantity of light. It is, like Monet's canvas, a reflecting surface, and it will behave, just as Monet's canvas behaves, subtractively: it will subtract from the light that falls upon it, reflecting only some of it, absorbing or transmitting the remainder. A white pigment reflects much and absorbs little. A black pigment absorbs much and reflects little. A mixture of the two pigments will subtract more than its white component, and less

garden does not afford. About 20 per cent of the incident light is skylight, bluish rays scattered by particles of dust in the atmosphere and by the molecules of the air itself. The greenish light reflected from Rattner's tree, even the light reflected from Rattner himself, are mirrored and remirrored in the canvas. The canvas is, before Monet touches it, what Plato thought art to be after he touches it, the reflection of a reflection.

These complications do not affect the truth of the formula, but only the quantities assignable to its terms.

than its black. The result of the mixture will be an intermediate gray.

But what is true of these is true of all pigments whatever. There is a physical complementary for every hue which the eye identifies. For the light associated with a given hue there will be a light which, mixed with it, will give white light. A red-orange light and a blue-green light, if the two be superposed upon a common screen, will fuse as white. But if a red-orange pigment be mixed with a blue-green pigment, they give forth black. Every pigment is a subtractive agent, and every mixture of pigments compounds their subtraction. To add lights to each other is to increase light according to the sum of positive quantities; to add pigments to each other is to diminish light according to the sum of negative quantities.

In the stained glass of *Chartres Cathedral* it is precisely this subtractive effect of pigments which is witnessed. The lights seen in the interior are a transmitted residue. The glass screens of the building, as they are seen from the outside, are void of magic. They bare to the world a gray face and appear to be opaque. The glass reflects the light incident upon it without changing the relative proportions of the reflected wave-lengths, but all are so greatly reduced that the brightness of the incident light has been dulled and blunted, and the surface appears neutral, somnolent, unadorned with any hue, homogeneous except for the texture of the leadings which hold its flakes together and the iron grille which braces it against the wind. A part of the light has been absorbed: the surface would be warm to the touch, warmer at least than the atmosphere to which it is exposed. But a portion of the light has been of course transmitted. It has penetrated the translucent screen and passed beyond it into the space of the nave, so that that same surface which appears on the exterior so dull a thing appears, on the interior, incandescent and alive, a jewelled sea of color that glows subdued, awakened into light, saturated with hue and incredibly sensuous in impression.

These blues and reds which the screen has liberated are the self-same rays which one sees by looking directly at the sun, which one would see now, on the interior of the cathedral, if its glass screens were removed. But in that direct vision of the sun one sees them intermixed and interfused with other rays which obscure and cancel this their present clean solemnity. In white light their separate identity is, like the hand of God, invisible. In the light of the

cathedral's interior, by a purifying exclusion of those other rays, they are, like the hand of God, in simple presence, permitted to appear.

The impression which one takes from the colored screens on the interior of *Chartres Cathedral* is, in physical terms, the effect of an act of subtraction. The light seen, the only light seen, is a residue, the residue of light which has not been withheld. If I subtract 2 from 3, I call the result their "difference." In *Chartres Cathedral* what one sees is such a difference, for if one subtracts from the total light that falls on the glass screens the light reflected from their exterior surface and the light absorbed which warms them, the remainder of the light, which alone is seen, is their difference.

Painters whose noses are too near their palettes and their easels call that difference a "subtractive mixture" of color. There is no single term in the theory of color which so confuses the general understanding of it. What is meant is important. But what is meant is exactly the opposite of what the term implies. For they mean that the effect of color which is seen is the result of the subtractive action of the materials which they use, that in effect the interior lights of *Chartres Cathedral* have been filtered. But the action of a filter is not to "mix" lights, but precisely to "unmix" them, to separate off the one set of rays which it transmits from another set which it has reflected or absorbed. The tendency is toward black. The effect of the pigments in a filter is to diminish light, not to increase or compound it.

Suppose a light-projector to be the single source of light in an otherwise totally darkened chamber, and suppose that light to be turned on a screen which reflects all rays that fall upon it, absorbing none and transmitting none.

The light from the screen is then capable of two extreme conditions: if the projector is lighted, it is white; if the projector is turned off, it is black.

Between these extremes a number of intermediate conditions is possible. No one of them will equal the degree of brightness which belongs to that white; no one of them will equal the degree of darkness which belongs to that black. No hue can have the brightness of pure white or the darkness of pure black.

The effect of any filter placed in the path of light will be to subtract from the light that meets the screen. The light will be diminished toward black exactly in the measure that rays have been absorbed.

A yellow filter extinguishes the blue and violet rays at their source: they have been suspended in itself, absorbed as heat, simply removed from the transient light that meets the screen. Rays from each of the remaining wave-lengths have been transmitted. If the transmitted light were prismatically decomposed, it would be found to contain, besides yellow rays, rays in the red, orange and green bands as well. But among these the yellow rays predominate, and from them the filter takes its name.

In the same way, a blue (cyan blue) filter will extinguish the red, orange and yellow. The green, blue and violet rays are transmitted. Among them the blue and green are dominant.

What will be the result if both filters—the blue as well as the yellow—are placed in the common path of light?

It is precisely the effect which comes of mixing pigments on the palette. The effect is subtractive, but the subtraction has been compounded. The light which alone is transmitted to the screen will consist of the one set of rays which have not been withheld, namely, the green. That effect comes not of mixing lights, but of mixing pigments. The pigments are mixed; the lights are simply, reduced, those alone appearing which remain, after the mixture, unabsorbed.

> Yellow Filter: *R O Y G B̸ V̸*
> Blue Filter: *R̸ O̸ Y̸ G B V*

A red filter will transmit the red, orange, yellow and violet rays in a fusion in which the red rays are dominant. It extinguishes the green and blue rays. Therefore, if the red filter be placed, together with the yellow and blue filters, in the common path of light, the result will be black. For the red filter will have absorbed the one remaining set of rays which the yellow and blue left unarrested.

> Yellow Filter: *R O Y G B̸ V̸*
> Blue Filter: *R̸ O̸ Y̸ G B V*
> Red Filter: *R O Y G̸ B̸ V*

Very well, in this we deal with results which could be anticipated. But what shall be the result if one mixes not pigments, but lights? Suppose that three light-projectors are turned upon the common screen, so that when they are lighted their lights will be superposed. Then, if in succession I light the first projector, then the first and second together, then finally all three at once, I mix their lights, I add to the light of one the light of those others, and I observe a succession of increasing brightnesses as the light is compounded.

That is an additive *mixture*, and properly so-called: its tendency is to increase light, not to diminish it. The screen is three times as bright as the light I formerly called white.

If in pigments I mix red, yellow and blue, I get black. Suppose, then, into the first projector I insert the red filter, into the second the yellow, and into the third the blue, what will be the effect if these three lights be superimposed upon the one screen (Fig. 64) ? A black? By no means. The screen will appear white, almost identically the white to be obtained from a single projector whose light is

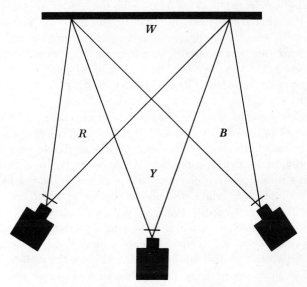

Figure 64

unfiltered. The three positive quantities of light have been compounded, added one to the other, each supplying the components of white light which the others had removed or partially withheld.

To add pigments is to cancel the effects of light; to add lights is to cancel the effects of pigment.

When Monet and Pissarro began first to exhibit those canvases the texture of whose surfaces appeared to their contemporaries so alien to the settled habit of the eye, that technically was the ground of their novelty. For will not the visual impression be the same, whether lights are fused upon a screen, and then reflected to the eye, or, alternatively, are fused directly in the eye itself? In the latter

alternative the character of the painter's surface will be radically changed in accordance with its novel function. It must appear, not as in traditional art a clear representational field, inviting a minute inspection, but a physical stimulus which fractions light, whose value as representation is found only in its visual effect.

The technique of "broken color" is simply the deliberated and frank introduction of additive mixture into the art of painting. To mix pigments on the palette—for example, a yellow and a blue to make a green—is to compound the subtraction of lights. The green light reflected from the mixture on the canvas will be brighter than the blue component, but less bright than the yellow. The problem of Monet, the problem of Pissarro, in point of technique, was to discover how to obtain, with these means, a green which had a value equal to that yellow, how in short to procure the effects of mixture without loss of the brilliancy which painters *en plein air* sought to hold.

Suppose, instead of mixing the pigments on the palette, I set down touches of pure color side by side, a node of yellow and a node of blue. So long as the eye is close enough to the surface to discriminate the individual touches, it registers a yellow and a blue. But let it retreat a little from that physical surface on which the touches have been laid. There will be a distance for the eye at which the surface will become, in its apparent feature, especially active. Beyond that distance the touches, no longer individually discriminated, will stably fuse; short of that distance they continue still to be seen as stably separate and distinct. But at that distance the surface will be found to fluctuate actively between these two stable conditions. The phenomenon is instable and precarious, and the surface vibrates in the eye. The touches are seen separately, they are seen also at the toppling point of fusion, and in that condition of apparent ambivalence the surface has a degree of brilliancy which belongs to neither of its stable estates. An Impressionist painting prescribes to its spectator an obligatory distance for the viewing of itself. Observed too closely, it appears simply insensate; observed at too great a remove, it appears simply tame. At the prescriptive distance for which the viewing of it has been calculated, it clicks on like a light.

The mixture is visual, a visual mixture of lights which fuse themselves in the eye of the beholder. The spectator has been made an active participant in the production of the effect, as necessary to its

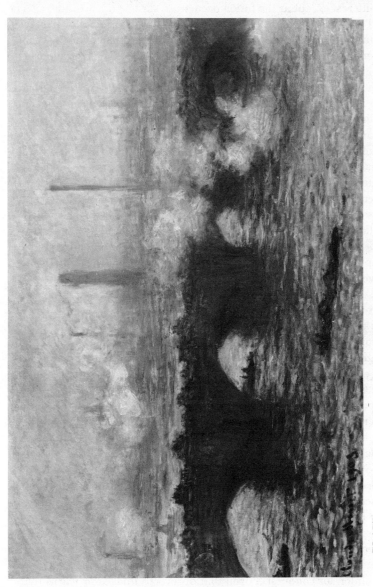

PLATE 43. *Claude Monet (1840–1926), "Waterloo Bridge, Gray Day" (1903), National Gallery of Art, Washington, D.C., Chester Dale Collection.*

production as the pictorial surface, which is its bare catalyst, vacant
of interest except as the fusion occurs.

The name "Impressionist" was pronounced originally, like the
names "Gothic" and "Baroque," as a term of disparagement. What
after all was Waterloo Bridge (Plate 43) but a thing of gravitating
stone? What the Gare St. Lazare but a railway station, a thing of
grit and steel? Yet here, in an act of disengaged vision, Monet had
the audacity to suppress the plain properties of his subjects, to find
in light a pure poetry, lyric, evanescent, delicate, without suggestion
of any sense of touch, or of sound, or of the stench of fish and coal-
smoke. Of the one he made, if he made portrait at all, a portrait of
fog, of the other a portrait of steam, pierced with jets of light that
suffused all things in a common insubstantial identity of atmos-
phere. It is easy to underestimate the significance of Monet and
Pissarro, of Renoir and Seurat (Plate 36), by supposing their merit
to lie in a mere technical capacity, in a trick of handling the mate-
rials of their art. If Impressionism were simply the technique of the
Impressionists, it would be historically without interest. It would
have the virtue only of a stunt, and its virtue would be cancelled in
the moment that, being understood, it had lost its capacity to sur-
prise. The thinness of Impressionism, considered as a movement,
lies precisely in this, that its technique was so tediously imitable as
to obscure, almost at once, at the hands of others, the authentic
originality of the mode of vision which had required it. The tech-
nique itself had only the value of a tool. Its value lay in its enabling
the artist for once to snatch from the tangible face of nature an
appearance addressed exclusively to the eye, to disengage the vision
of art from its workaday involvement in the interests of action and
the associations of memory, to produce a music purely visual, which
solicited no response save only the simple contemplation of itself.
The appearance of a haystack or of the façade of a cathedral at a
given time of day has neither less nor more relevance to the pur-
poses of art than its appearance at any other time or at all times.
But it has this advantage, that its transiency enables it to be clearly
divorced, as no object in nature can ever be, from the complicating
associations with alien interests, to which permanency subserves it.
The possibility of such an art, once gained, is a permanent new
dominion for conquest. For in that dissevered image one learns that
the value of art is not the value of an effigy, but of the mind that en-
counters it. Historically, the consequences of Impressionism remain

greater than its accomplishments. Its most pregnant consequence is the art of the independent image, and artists who owe nothing to Monet's technique work still under the dominion of the motive which invoked it.

40. The Principle of Simultaneous Contrast

All vision is selective. That is why the experience of men, even of men who confront a common scene, is found to vary. It varies as their habits of selection vary. Each sees what the somnolence of habit has dignified, and blinds himself to what it has omitted.

In general men perceive only what use has taught them to perceive. Old habit, contracted in monotony, seasoned by iteration, solidified in idleness, closes their experience in an unbroken crust. The distillations of awareness which concentrate experience, which quicken sensibility to new vibrancies, are shut beneath it. So that the values actually to be found in experience are as if they were not. They are not superfluous, they are simply never seen, and men live the numbed and famished lives of grocers, who move hurried among tinned and labelled goods which they identify but never taste.

Therefore, the vision of human beings is capable of cultivation. Vision may be educated to rediscover that novelty which habit congealed in the fatigue of experience has excluded. If, marking these differences, men greet them as new, it is only because their habits are so old. Novelty is subtle only in the measure that habit is gross, and no education is authentic which leaves such habit undisturbed. For at last all that education does, or can ever do, is to liberate in men capacities which they already have, to make them what they are, which is to set free in them possibilities they have not imagined, and would not imagine except for the offices it renders. Man is the one creature who is capable of being less than himself. Therefore, he alone is educable, since the image of him is permanently, in any of his seasons, greater than the image which he holds.

Man is not the measure of all things, but the values which a man discovers in his world are measured to the cut of habit which he brings to it.

That is why the habit of vision of the artist is the marvel of all who have permitted themselves to be taught by it. It is the product of discipline, not of innocence. The undulled innocence of vision of a

new-born child is as little available to him as to us. But that in-
nocence which confers upon a child its openness to experience is
never, as the child matures, preserved. It is like all simple innocence
defenseless; like all simple innocence it is therefore lost. The openness
to the values of experience which the artist preserves, which makes
him appear so like a child amid the sophistications of his contem-
poraries, is of a different order. It appears childlike only because it
is open, because in its unjaded and uncompromised quality it re-
tains still, among familiar things, the freshness of a vision awake to
the novelty that is in them. But there is nothing of the childish in
it. In its essential hardness it has, what the vision of no child has,
the disciplined capacity to preserve itself.

I ask you now to open your eye in the way in which the artist's
eye is open. A sophisticated vision is precisely what you do *not* want.
Sophistication is in this, as in all matters that matter greatly, the
thing that dulls men's perception, the thing that maims and desensi-
tizes it. It is the very thing you are asked to set aside. For there are
some questions which can be answered only by a wakened eye. Such
a question I now pose. As for the other questions, the questions of
the sophisticated, the dead may be permitted to bury their dead.

The question is: Why should the interval of complementary hues
be of such interest to the master artist?

Range together two grays, so selected that in a given light the one
is twice the brightness of the other. Then, if the light which falls
upon them be varied, if it be increased or decreased, the amount
of light which they severally reflect will vary too. But the ratio of
$2:1$ in which they stand remains visually constant.[5] The amount of
light reflected from each surface is, in absolute measure, greater or
less than formerly it was; the interval is wider or narrower. But in
the higher illumination as in the lower the proportional relationship
of the contrasted grays remains the same. The one is still seen as twice
the brightness of the other. What the eye sees is that proportion, not
the terms as separate and isolated entities. Were it not so, our
world would be subject to the exorbitant transformations of light
itself, and we should walk bewildered in it, permanently con-
founded in a riot of incident which eye could never follow and mind
never equal.

[5] The rule fails to hold at very high and at very low light-intensities. For the cen-
tral range of illuminations it is true, and it is entirely accurate for any lighting
which would be accounted tolerable in apprehending a visual design.

Such is the thrift of vision that it grasps lights, as it grasps lines and shapes, in pattern, always in terms of the simplest organizing pattern which will enable its image to be mastered.[6] With respect to the two grays its organizing pattern is that proportion. The proportion 2:1 is the simplifying constancy which gives it mastery, enabling it to grasp what is stable amid the flux of things.

Such a constancy is what the artist provides. Nature does no less. But the constancies which nature provides, nature, unassisted, also in part conceals. That is where art is greater than nature; it is nature made perspicuous, or, in that strange phrase of Alexander Pope's, "nature methodized." The design of art is perspicuous pattern, pattern appreciable, and pattern appreciable in contexts more complicated than two grays. With respect to lights men identify that constant pattern as the formal order of colors in a work of art. The light which falls externally upon his work no artist can permanently control. He controls only the ratios which within normal variations of lighting he may aspire to hold constant.

The graded colors upon a palette are such a proportionally related series of terms. One might suppose therefore that the stable relations which they bear to one another there on the palette would preserve themselves when the pigments were transferred from palette to a pictorial field. For is it not the same pigment-mixture in the one place as in the other, the same pigment-mixture translated bodily at a neutral brush's tip, and as the mixture is the same, shall not its graded relations to those others be also held?

A master artist knows better than to expect that simple result. For the terms whose graded relations he has so nicely studied on his palette do not appear, when they are divorced from that context, as they appeared while they were together in it. The variation of the light that falls externally upon them is not the only variation to which they are subject. They modify themselves disturbingly as their immediate contexts vary. A pigment whose value has been calculated with unerring precision in the scale of the palette acquires a markedly distinct apparent value in its new environment. Not merely does it want nicety; it wants rectitude. The illumination which strikes it has not varied; the eye which responds to it is the same eye which calculated its interval. It may nevertheless be visibly displaced from the interval it was intended to convey, so visibly displaced that the difference affronts the eye. Its effect is not at all

[6] See Section 23.

the thing wanted, and the thing wanted can be had only by employing a pigment-mixture which on the palette may be as many as two registers removed. If the palette is limited (say, to *R, Y, B*), and it is a question of hues, the painter may be obliged, in order to preserve the visual economy, to manufacture an intermediate hue which his limits would denounce.

Be content, for the moment, to work with simple grays. If I set lines parallel with each other at a narrow interval, they will tend to fuse and form a gray. That is the simple device which every engraver and every etcher knows, who grades his surface by hatched lines. Observe it, then, in Figure 65.[7] In point of quality, in point

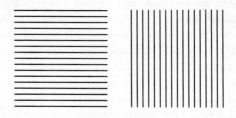

Figure 65

of quantity, the lines in both squares are the same. The illumination which falls upon them is the same. Yet one appears darker than the other. If the image is turned at 90 degrees, so that the lines formerly vertical are horizontal, and the lines formerly horizontal are vertical, the dark and the light will have been transposed. The orientation of the spectator alone has changed. Which is simply to have observed, that where a color effect depends upon directional elements, the color implicates the orientation of its spectator. There are orientations to the field which, simply with respect to its color, are improper to it. A Cézanne or a Signac, built out of parallel brushstrokes, is like an engraver's print: its color changes as the spectator's orientation to it varies; it is grayer in one orientation than in another.

The spectator is an invisible party to the context in which colors appear. Normally no account is taken of him. Normally it is unnecessary that account should be taken. His normative relation to the pictorial field is assumed, and being assumed may be thought

[7] This figure and the next, Figure 66, are drawn from W. M. Ivins, Jr., *How Prints Look* (The Metropolitan Museum of Art: New York, 1943), pp. 154–155.

of as constant. Let it be assumed, then, and attend only to the effects of the visible context.

In Figure 66 I place together a set of black squares, ordered in

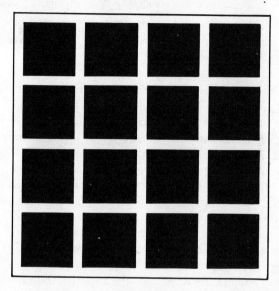

Figure 66

columns and in rows, each separated from its neighbor by a narrow white space which is reserved from any applied color. In short, I work with a scale of two values, a black and a white. My palette is limited to but one of these: the other is afforded by the light of the ground-tone. I am equal to that austerity. The field is not. For though I have renounced any intermediate gradations and am as honest in this resolution as men are ever honest, an intermediate gradation appears. The white spaces which are reserved appear as continuous lines running vertically between the columns and horizontally between the rows. At each of their intersections they gray off. Accordingly, if I would work in such terms, I am obliged to admit a distinction between the visual scale and the physical scale in my performance. The visual scale includes those grays; the physical scale does not.

Suppose then, in order to preserve at least the appearance that the two scales are identical, that gray be included in the physical scale (Fig. 67). I have now a physical scale of three terms—a

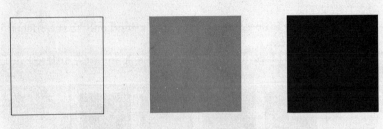

Figure 67

white, a black, and a gray. Never was subterfuge less successful, or remedy more vacant. Formerly the intrusive gray had at least the virtue of singularity, and it could be pleaded, as the mother pleaded for her illegitimate child in William James' anecdote, that it was after all so little a one. But the remedy is worse than the illness. The adoption of that gray into the physical scale begets a brood of six visual tones, and it is perfectly impossible to say which of them has proper claim to legitimacy. "Color is what you *do* see, not what you should see." Let each of the terms of the physical scale be super-imposed upon the other two, so that the gray appears on black and white, the black on white and gray, and the white on gray and black (Fig. 68). Attend only to the superimposed tones, to the smaller ring-shaped areas, which are enclosed. But mark them closely. The matter here in question is not the degree of the

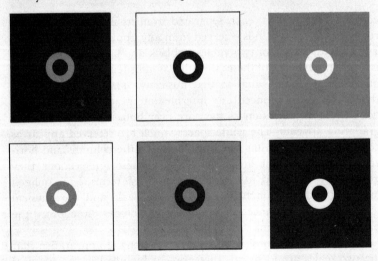

Figure 68

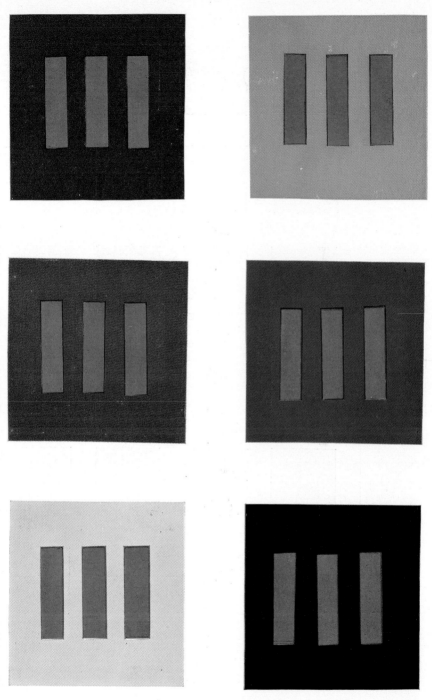

Plate A: The pigment is identical for all grays; the apparent differences depend on simultaneous contrast.

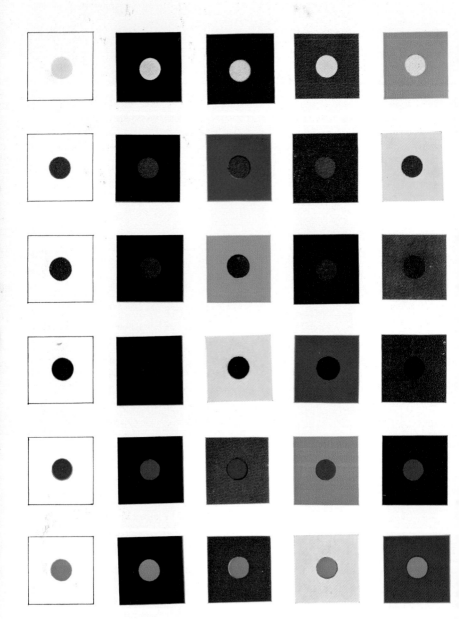

Plate B

difference, but the fact of it. And it is apparent to any eye which will exercise itself without prejudice, that no one of the physical tones is constant: each ring changes its face as it changes its context. The gray is brighter on black than on white; the black darker on white than on gray; the white more luminous on black than on gray.

The phenomenon is purely visual. It has nothing whatever to do with any change in the reflecting surfaces or in their physical illumination. It concerns only the colors seen in them as their immediate contexts alter. In the colors seen a very general principle, the principle of *simultaneous contrast*, is embodied. Chevreul, chemist extraordinary, who interested himself in predicting the effects of dyes in Gobelin tapestries, regarded simultaneous contrast as the fundamental principle which underlies all composition of colors.[8] The principle, in its simplest statement, is as follows: Each of two contrasting surfaces, juxtaposed, will exaggerate its apparent difference in the direction of the other's complementary. Each stretches its felt interval, and the stretch is in the direction of the interval set by the complementary of the color which forms its context.

That is what one observes in the vicissitudes of the rings. Black and white are complementaries, visually as well as physically. They stand visually removed from each other at the extremest interval of the value-scale. A white ring placed on a black surface appears whiter still: it accentuates its difference from black in the direction of the complementary of black. A black ring placed on a white surface appears blacker still: it accentuates its difference from white in the direction of the complementary of white.

From this principle one may anticipate the familiar phenomenon, that a gray placed in a field which has a positive hue will itself exhibit a hue, the hue complementary to the hue of the field in which it lies. In Plate A all of the grays have been rendered with the same pigment. The variations among them may be anticipated in each case, on the principle of simultaneous contrast, by reference to Figure 63. The limitations of size in the diagrams make all of these effects appear more subtle than in fact they are. If a gray sheet of paper be superimposed upon sheets of positive hue, the effect

[8] Michel Eugène Chevreul, *De la loi du contraste simultané des couleurs et de l'assortiment des objets coloriés* (1839). The work has been translated by C. Martel under the title, *The Principles of Harmony and Contrast of Colours, and Their Applications to the Arts* (Bohn: London, 1860).

appears continuous and declarative in the neighborhood of the edge at which they meet. As the eye moves from that edge the effect diminishes, but in the vicinity of that edge it is so pronounced as to erase even a plumber's prejudice.

For anyone who would understand the richness of the blacks in a Frans Hals portrait, the reason is at hand.

It is a confusion of understanding to suppose that in these matters one deals with an illusion. An illusion can occur only where a firm distinction can be drawn between appearance and actuality. But in these cases the appearance *is* the actuality, the sole actuality which the master artist permits himself to consider. With respect to such immediate appearances no error is possible except the kind of error which stems from obtuseness, from failure to attend to the actual differences that are to be found among appearances. An authentic illusion is never a failure to see appearances; it is simply a failure to interpret them rightly. It involves always an error of judgment, a fault of inference which sufficient evidence would correct. But what is immediate in experience is perfectly incorrigible. No evidence could denounce it for the simple reason that all evidence is at last grounded on it. If in a painting I regard the apparent recession into depth as an actual third dimension, I countenance an illusion, for by "actuality" I then mean that the represented spatial volume is continuous with the actual spatial volume in which I stand, that they belong to a common physical order, and that the one can be moved through as the other. That predictive inference is in error, and to act upon it is to discover that error. But in the present instance, with respect to the values which belong to the visual scale, there has been no such inference at all. The only error of judgment has been in supposing that a pigment-mixture from the physical scale would have the same appearance in all contexts, that it would have the same apparent value in the pictorial field as on the palette. It does not, and the supposition that it would was an error. It was an error which the master artist knew to guard against. He knew to guard against it for the one reason that the only actuality that at last concerns him is the actuality of appearances. In his visual field there is no room for illusion, for no inference is ever invited to an actuality beyond its precinct. Its appearances are, for the purposes of the master artist, the things meant by actuality, and to seek actuality elsewhere is to part company with him.

A value from the visual scale is always as it appears to be: it is the same in all contexts. The value seen in a pigment has no such fixity. It varies with the context in which the pigment is placed. The physical scale which the artist arranges on his palette is technically useful only as an approximation to his visual scale. It is a device of orderly procedure, which records in the one context of the palette the full range of values which the visual scale allows. Beyond that it is a perfect irrelevancy in the artistic enterprise.

The principle of simultaneous contrast holds not only for neutrals—for blacks and whites and grays. It holds also for the relation of hues to each other.

If the principle is true generally, what must be anticipated if a dot of positive hue is placed on a field which has a hue complementary to it? It will be the stablest of all combinations in which hues are brought together. Since the two hues are already set at the extremest interval, neither can accentuate its contrast by any further displacement in the range of hues. Therefore, stably fixed in its hue, it solemnizes its estate, celebrates it. It exaggerates its degree of saturation. A hue will appear strongest, most saturated, in the immediate context of its complementary.

In the first column of Plate B a dot in each of six hues is laid upon a white ground; in the second column upon a black ground; in the third upon a ground complementary to its own hue; in the fourth and fifth upon the hues adjacent to the hue of the dot in the color-circle $(R-O-Y-G-B-V-R)$.

The pigmentation of the dot is constant in each row.

Observe, then, the variations in the dot's apparent quality as it traverses the several grounds.

In the first three columns the *hue* remains visually constant. In each row the most brilliant term—the term highest, nearest white, in the value-scale—appears on the black ground; beside it the same hue on the white ground is relatively grayed.

The most saturated colors appear consistently in column three, where they are played against their own complementaries.

The last two columns represent in every case modulations. They must appear, to any eye sensitized to the scale employed in the first three columns, a trifle sour, dissonant. By that I do not mean that the eye finds them, in themselves, necessarily disagreeable. Their agreeableness or disagreeableness is not at all in question, and may be left to the impenitent caprice of him who owns the

eye. Their dissonance is not a matter of taste; it is not relative to men's judgments and does not vary with likes or dislikes. Their dissonance is determined not relatively to men, but relatively to the properties of the sequence in which they appear. They are not simply darker or lighter, or more or less saturated, versions of the hue which appears in the first three columns. They are in fact *different hues*, and have no place in the sequence which the first three columns have established. The reader will be affronted, and will consider himself ill-used, if I say of the red in the orange field that it has violet in it, or of the red in the violet field that it has orange in it. The differences are minimal, and our language has not been designed to name them. But that should afflict no one.

> 'Tis but thy name that is my enemy;—
> Thou art thyself though, not a Montague.

Our interest is not in the names, but in the felt differences. We are interested in what we see, not in what we say we see. And I must ask, for the moment, only that you mark the difference of impression. Unless you see it, all is lost; but if you see it, nothing at all is at stake in the naming of it.

The fact is, that in each row a common principle governs the changes in the dot's felt hue. It is this: Any two contrasting colors will, if they are juxtaposed, transform themselves in each other's presence: if they are complementary to each other, each will appear purer in its proper quality; if they are not complementary, each will tend to gravitate toward the complementary of the other.

Plate C has been designed to exhibit the effect of simultaneous contrast with respect to adjacent hues. In each case the hues adjacent to a given hue form the field; the given hue is their intermediate in the color-circle. The two interior rectangles are in each case the product of the same pigment. The variation in apparent hue at either side of the black line is determined by the field on which the rectangle has been laid.

In each case, the hue of the interior rectangle has shifted perceptibly, on the color-circle, in the direction of the complementary of the hue of its field.

41. Color in Equilibrium: Goya's "Execution of the 3rd of May, 1808"

Colors have different relative degrees of dominance in the human sensibility. Seen together, they do not behave uniformly with respect to the measure of attraction which they exercise upon the eye.

When Giotto, in the frescoes of the Arena Chapel, would make his colors respond to the dramatic demands of the Betrayal, he renders the robes of Judas, who kisses Christ, in a yellow. When Goya would commit color to the function of focalizing vision upon the macabre spectacle of the *Execution of the 3rd of May, 1808* (Plate 44), the central figure among the Spaniards, the murderable but unvanquished Spain upon which the brutality falls, which must therefore transfix and hold the eye upon itself, in symbol of unquenchable defiance—this figure is rendered in part in a massed orange-yellow. Why yellow? There is a foolish answer, that yellow is sinister, that it more than any other hue expresses hate, or disloyalty, or pity, or suffering. Of those literary or psychological associations I know nothing, nor, I suspect, did either Giotto or Goya. But of one thing both were assured, and every sensibility will confirm it, that in those two contexts there is no color of equal saturation which in an equal size and shape will so arrest the vision.

In a pictorial field two black dots appearing on the horizontal axis at an equal distance from the vertical axis will, if they are the same in size and shape, counterbalance one another (Fig. 69a). The

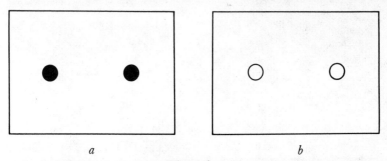

a *b*

Figure 69

field is in equilibrium, nor will this equilibrium be disturbed if the colors are varied, so long as the two dots are rendered in the same color. Any color may under these conditions be made to provide the perfect counterpoise for itself (Fig. 69b).

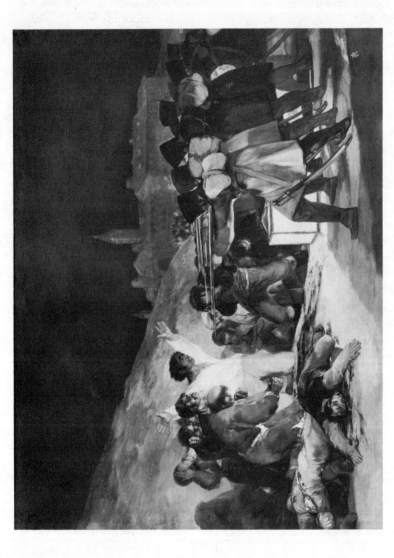

PLATE 44. Goya (1746-1828), "Execution of the 3rd of May, 1808" (1814), Prado, Madrid (Anderson).

That is the interest of these conditions, for it is possible, where this distribution of shapes and sizes is held constant, to permit the color alone to vary and to observe the different degrees of attraction which colors have in relation to each other.

If, for example, the shape of one of the black dots is reduced to a simple enclosing line, to a circle the interior of which is left in the same color as the ground (Fig. 70), the equilibrium is destroyed,

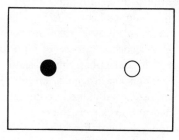

Figure 70

and it becomes necessary, in order to restore it, either to redistribute the elements about the vertical axis or to increase the size of the shape which has been rendered in simple contour (Fig. 71*a, b*).

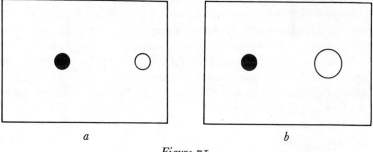

a *b*

Figure 71

The same kind of variation in visual attraction is encountered in the positive hues: on a given ground hues of equal saturation are not equally emphatic.

A dot on one side of the vertical axis will, under the observed conditions, perfectly compensate for a dot of the same color on the other (Plate D *a, b*). But what shall be the effect if for one of the yellows I substitute a violet of equal saturation? The tranquil field is wrenched by the transformation (Plate D *c, d*). It has not the barest

semblance of equilibrium, though the positive and negative areas retain still their faultless symmetry. The color alone has varied; the equilibrium has been cancelled. Which is to have observed, that color no less than shape and size and distribution is a factor in any equilibrium which art can command.

Men commonly understand the notion of equilibrium by reference to a physical analogy. The equilibrium of art is conceived after the manner of the equilibrium gained by distributing weights, above a fulcrum, on a balance-arm (Fig. 25). That image is useful, and in the initial stages of analysis even indispensable, for a clear exposition. But it is too special a case of equilibrium, a case too simple and too limited, to make plain the full sense of the equilibrium of art. If gold be weighed against gold, an equal quantity will be found to coincide with an equal value in commanding an exchange. But if gold be weighed against silver, the equality of their weights is no ground for assuming an equality of value. An equal weight of silver will not command in the market an equal exchange of goods. To determine the value of silver in relation to gold, one has to know, besides its weight, a proportion, a ratio which fixes the number of grams of silver needed to equal a single gram of gold. It is just so with hues. They are not simply substitutable, since they differ in the degree of attraction which they exercise. Equal quantities of different hues are not necessarily equal in value. Formally, the most fundamental problem of composition in color is to discover how to constitute a visual equilibrium in spite of that.

Were Goya to substitute, for the yellow in the figure of the Spaniard, the olive-green or the maroon of the soldiers' uniforms, it would be necessary, in order to obtain from that figure a stress equal to the stress it has, to expand its size five times over. The value of the shape cannot be had with equal force in any other hue. Its stridency in that pictorial world is as inevitable as the motive for it is real. No one who has seen it will ever image the cry of the human resistance or of the human desolation in any other terms.

The image of Justice blindfolded, who holds a scale, does well enough in the ordinary affairs of mankind, for, ordinarily, justice in those affairs is not a matter of appearances. Justice blinds her eyes to appearances, since ideally her dispensation must be the same, whether her suppliants be rich or poor, of high or low estate, illustrious or obscure, dark-skinned or light. She repairs a wrong done, and the offense is measured not according to the demeanor of men,

but according to the rights of persons. But a blindfolded Justice shall never determine the matter here at hand. For in a visual equilibrium the appearances are so far from not counting that they alone must count. Take therefore from Justice not her scale, but her blindfold only, if you would discover where the justice of a work of art must lie. For it will lie inevitably in an equilibrium of appearances, in an appreciable balance not of shapes, or even of shapes and sizes, but of stresses, of visual emphases. It lies in a proportion. Therefore, no positive contribution to the visual array can be discounted. In a visual art no appearance can be accounted ineffectual if it makes a difference in the felt economy. That is formally what one means by an artistic economy, that its parts are felt as complementary to each other: *its* wholeness is *their* complementarity.

Colors preponderate in the human sensibility according to the measure of their contrast with the ground on which they lie. The attraction of colors is a relative, not an absolute, property. It varies as their contexts vary. A color which is relatively dominant over another in one context will be relatively subordinate to that color in another.

On a black ground the brighter colors, the hues nearer to white, will tend to preponderate in impression. Let a yellow and a violet dot be ranged symmetrically about the vertical axis on a black ground, the dominance of the yellow will be so extreme that an equilibrium of the field can be gained only by exaggerating the area assigned to violet (Plate D *e*).

But on a white ground the measures of contrast are reversed: the darker hues, the hues nearer to black, preponderate, and a contrary correction will be needed (Plate D *f*).

Among the colors which appear in the spectrum the several hues are of roughly equal saturation. They are very unequal in value. In their total range yellow is the brightest, violet the least bright. Orange and green are approximately equal at a value lower than yellow; red and blue are approximately equal at a value lower still.

Accordingly, when the degrees of saturation are equal, and the colors are laid on a neutral ground, an orange and a green, or a red and a blue, will provide a rough counterpoise for each other. In every case it is not the brightness or the darkness of a hue, but the measure of its contrast with the ground, which determines its relative stress, and it is simply false to speak of brighter colors as coming forward or of darker colors as retreating irrespective of their

contexts. Thus, against a neutral ground, hues of equal value stand equably side by side (Plate E *a, b*).

What shall be the measure of attraction of colors placed on a ground of positive hue? Suppose, on the palette, a red and a blue of equal value and of equal saturation, and let them be set together first on an orange field, then on a green (Plate E *c, d*). The result is anticipatable on grounds of the simultaneous contrast of colors. If the values of the two hues are in fact equal, the hue which is nearer to the complementary of the ground color will have a relative preponderance. Its saturation will have been relatively increased. The effective stress of the blue and the red will be visibly inverted as the field changes from orange to green: each glows dominant against its complementary, and becomes somber and subordinate as its affinity with the ground increases.

When therefore one speaks of Cézanne as constructing the importunate voluminousness of his spaces in terms of advancing or retreating colors, in terms of colors which come forward or recede according to their intrinsic brightness or warmth or saturation, one speaks foolishness. The property of advancing or receding is never the intrinsic property of a color: it is a property acquired from the context in which the color appears.

42. Abstraction and Representation in the Visual Arts: Degas' "Absinthe Drinkers"

There is no painting which can capture the noon brightness of a garden scene on a clear day. That effect is not available to the painter with the materials he uses. His best white pigment is seldom more than fifty to one hundred times the brightness of his best black. In the scene of nature that range is, in any absolute terms, contemptible. The light which is reflected from a cumulus cloud struck directly by the sun's full rays may on occasion be two thousand times as bright as a black object recessed in the deepest shadow.[9] That an

[9] Ralph M. Evans, *An Introduction to Color* (Wiley: New York, 1948), pp. 92–93. The ratios here given are physical ratios. The eye will by adaptation decrease the range of contrasts to which it sensitively responds. The ratio in ordinary photography (color-slide projection) is about 200 to 1. The real problem for the artist is set by the circumstance that his pictorial field is uniformly lighted as the scenes in nature never are.

artist should essay the scene at all must therefore appear, to those who are accustomed to calculate risks, an error of judgment. He labors after light with the tools of darkness. It is his afflicting circumstance that he sees more light than his tools can compass. The absolute light-values of nature are permanently denied to him. Yet those values neither are, nor have they ever been, the object of his effort. Like the indomitable Hotspur, he plucks bright honor from the pale-faced moon. For what he may succeed in seizing, in the materials available for his use, is never that white light, scalding and induplicable, reflected from a thunderhead. What he may succeed in seizing is a set of proportions, that only, a set of proportional relationships among colors in which, though the terms are different, the relative intervals between the terms are the same. That alone, in point of color, is what interests him, not the set of terms in nature which he can never equal, but the set of proportions which he can hold.

In short, he conquers by dividing. He imposes on the monstrous frame of nature a scale suited to his means. When an architect produces in draught the design of a building, he scales distances and areas by the same kind of systematic convention: he sets down every distance and every area by a constant fraction of itself. Every intended distance has been in consequence reduced; yet the relations between any two distances have been held in a constant ratio. The result is, that any interpreter equipped to observe the convention may in imagination expand the design to its physical estate.

It is just so with the artist's rendering of light-values. Suppose a leaf to reflect a measure of light midway between the deepest shadow and the light on the cloud. And suppose, on the painter's palette, a pigment-gray which falls midway between his pigment-white and his pigment-black. Then, though his white will not be equal to the cloud, nor his gray to the leaf, nor his black to the shadow, the relative values of these pigments in his field will be the same as the relative values of those objects in nature (Fig. 72).[10] There will remain, of course, a greater range of discriminable gradations of light in nature than his art can ever command, or his

[10] This diagram is a simplified rendering of Arthur Pope's Figure 43 in *The Language of Drawing and Painting* (Harvard University Press: Cambridge, Mass., 1929 [1949]), p. 101. In Figures 73 and 75 the initial suggestion is also his, though I have found it necessary so far to modify his diagrams that he might not own them. I acknowledge my extreme indebtedness to this excellent author.

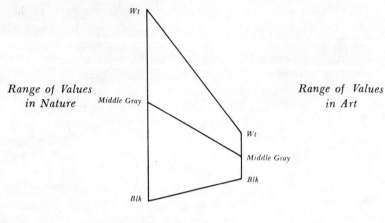

Figure 72

palette ever hold. But that difference need occasion no lament. It is no defect of art that art, when it relates itself to nature, must inevitably simplify it. In the means it uses nature is as prodigal as art is frugal. But the order of art—the order visually appreciable in it— is always equal to the order of nature, and normally, in point of manifest clarity, superior to it.

Were it the business of art to render the portrait of nature, that kind of reduction of lights to scale would define the artist's obligation, as it would define also the limits of his powers. But the artist is in his proper capacity as little concerned with imaging the actual relations which he discovers in nature as the architect. His business is to provide a system of scaled relations, not to copy one, to produce a vision of order, not to reproduce it. In the enactment of that role he may find it necessary to wrench nature from her habit. It is not nature's act, but his own, which is at stake. If he finds order in nature, he finds disorder there as well. Insensate nature, careless of his purposes, careless of him, harbors indifferently in its womb the knife that saves and the knife that wounds. The order in nature which an artist ever finds is an order which he, not nature, has selected. That it is nature's order which on occasion he selects is a matter of perfectly trivial consequence.

If art is made no better by its relation to nature, so neither is it made worse, and men who affirm the one should affirm also, and for the same reason, the other.

When it was objected to Michelangelo that his portrait sculpture of Giuliano de' Medici lacked likeness to its subject, he answered that that would not long be known. Men who find in that announcement the manifesto, that art is without content, have missed its point. We moderns have lost our capacity to seize the meaning of Aristotle's pregnant dictum, that art is a graver and more philosophic enterprise than history. Therefore we have diminished art. It has become for us a thoughtless empty form, a plaything of the ignorant, so that no one any longer sees the absurdity of urging that the art of Milton is less because he meditated Hell, the art of Bach because he meditated Heaven, or that either would be purer had its maker meditated nothing. Men ought for once to ask themselves whether they have actually escaped the contamination of those subjects in substituting, for Heaven and Hell, self.

The opposition between "abstract" and "representational" art, which so exercises our contemporaries, is at last without essential interest. For the thing that matters in an artist's vision of nature is not the fact which he encounters, but his manner of encountering it. And if there were in nature, as men observed its face, never any appreciable order which answered to our demand, it would be necessary then to invent what miscreant nature had left undone, a second nature, an order which, because nature nowhere afforded it, art therefore had instituted.

The matter of abstraction and representation in art is so confused in the common understanding, and even in the understanding of artists themselves, that it may be well to pause over it for a time. Some years ago I showed to a professed "abstractionist" a Piazzetta drawing. It was a pure tonal study, the act of a virtuoso in the art of tonality, which succeeded, in terms of pure lights and darks, in grays almost completely innocent of line, in representing a *Peasant Girl Holding a Cock*. His comment was: "No form." In what he intended he spoke truly enough. In what he said he spoke nonsense. For what he meant was, that he found in Piazzetta no attention either to edges or to lines, and therefore no emphasis upon the geometric shapes which alone he, the commentator, regarded as formal. Not finding these, he saw, alas, only a girl with a cock. But the meaning of form is not exhausted by geometry. An artist may order shapes; he may order lights. Usually, he will order both. But that is not the matter about which a spectator is competent to legislate. A Mondrian may interest himself in a pattern of shapes

divorced as far as possible from the distractions of color; a Kandinsky may interest himself in a pattern of colors divorced as far as possible from the distractions of shape. The two—color and shape— vary independently. Both are compatible with a formal ordering.

That first. If we would speak of abstraction, let us speak of it seriously, so that abstractionists shall not be committed to destroying each other.

The form of a work of art is the kind of order which is implicit in it. An artist works by ordering the materials of his art. He combines, he forms his materials, as the potter shapes his clay. He composes his effects out of materials which are at last merely given, and though he may select his materials from the broad world, he does never escape the limitations of the materials which his world affords. He produces the form, and never succeeds in producing more than the form, of things.

Therefore, since the form he produces is neither more nor less than the order which he implants in materials, he works by means of order or works not at all.

That is why representational art is so paradoxical a phenomenon. Art is order. Chaos is the total absence of order. A painter who set for himself the task of representing chaos would find himself obliged to adopt a latent order as his means. For though chaos were the manifest image he would produce, he can govern his own or another's vision of chaos only by means which are not chaotic, but orderly and controlled. The ruptured skein of Hell can be made to appear only upon a mantle which is seamless and untorn. A work itself chaotic, which was itself without structure, perfectly formless, vacant of all order whatever, would be no image of chaos: it would be the thing itself, a part of its profuse insensate disarray, an extension of chaos and an aggravation of it.

> Why, for this
> What need of art at all? A skull and bones,
> Two bits of stick nailed crosswise, or, what's best,
> A bell to chime the hour with, does as well.

Every work of art will have a *manifest order*, which is the kind of order that appears on its surface; it will have, besides, a *latent order*, which governs the presentation of that appearance.[11] Its

[11] The distinction was first drawn in these terms by Christopher Caudwell in *Illusion and Reality* (Macmillan: New York, 1937).

manifest order is the visible pattern to which a spectator attends; its latent order is the structure, the set of controls, which the artist has instituted to govern the spectator's attention.

Representation in art is always manifest; control is always latent.[12]

The two kinds of order may not coincide. The latent order may not be itself attended to, or even reflected on. It is nevertheless the order which is primarily in question wherever men discuss artistic form.

In a Classical work—in a Perugino, in a Raphael, in a Poussin (Plates 1, 6, 4, 34)—the manifest order and the latent order will tend to coincide. That is what ideally the Classic spirit wants, an affirmation of visible order, formal, posed, estranged from all the glut and miscellany of every day's poor accident. Therefore, the manifest order is assimilated to the latent order, from which accident has been systematically extruded. The controlling structure and the apparent structure, both are at one, and in such sensitive coincidence that, though it is in fact a fiction, and known for what it is, a staged tableau whose inscenation is too perfectly contrived to conceal the artifice that is in it, one nevertheless fills the lungs with its pure thin mountain air. It is all lucid and intelligible, and sufficient for him who finds his world so.

But what for him who does not? What for a painter who, like Degas, sees the casualness of things, the random order of uncalculated actuality, whose world appears neither posed nor composed, but on the contrary an order of accident and default, where design is wanting and providence is suspect, and man and thing are interfused, equated, democratized, seen obliquely as in the chance opening of an eye?

That was the apparent image which Degas wanted, and imperiously got. Never was artist more tyrannous in requiring a spectator to see as he, the artist, intended him to see. In such art a latent order underlies the manifest disorder. Who, for example, in the *Absinthe Drinkers* (Plate 45), which appears so wholly uncontrived, has ever thought to note, unless his attention has been called to it, that Degas found the omission of the table-legs artistically imperative? The disorder is a studied disorder, the casualness a studied casualness. All women in all times have known the secret of it;

[12] An inversion of this principle operates in contemporary art: see Chapter VII.

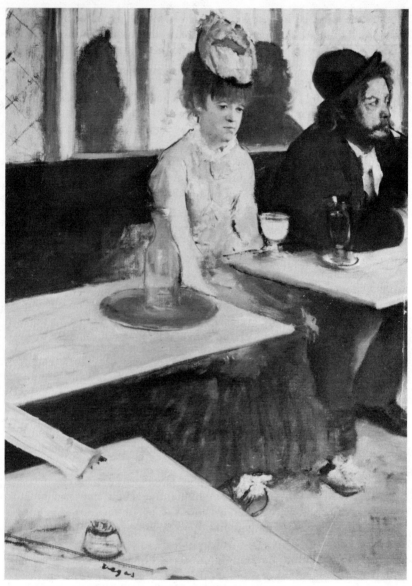

PLATE 45. *Edgar Hilaire Degas (1834–1917), "Absinthe Drinkers" (1876–1877), Louvre, Paris (Archives Photographiques—Paris).*

all men in all times have been vanquished by it. Women are female by the randomness of birth; they are feminine by an art in which randomness has no place. Their femaleness is never latent, their femininity always is, and it is the latter that men love. Just so, Degas intends his spectator to see an effect of randomness. How shall a spectator be made to see it? By means of randomness? Not at all. By an underlying firm structure, by a calculated order which, while it betrays all other things, is permitted on no account to betray itself. Therefore, in a Degas, you do not look to the structural axes of the field, for, as likely as not, nothing is placed upon them. Neither do you look to the figures: they are apt, by a judgment of Solomon, to be cut off by the frame. The controlling guides are invariably where they are least expected—in a cane or the tilt of a cigar, in the bow of a violin or a loose ballet slipper, in the repetition of the form of a laundress' water-bottle, in the shape of a pot-bellied stove.

Artists sometimes despair of spectators, that they look at works and fail still to see them. How should this come to pass? Their eyes are blind, physically dead? No, they are simply lazy and imperceptive, dead artistically. A lazy eye may cross a canvas, and even pick up a surface feature of it, as that it is a representation of a crucifixion, or of a bowl of fruit, or of a man, or of a landscape. The thing is seen; the art is not seen. For the art is not in what is shown, but in the showing of it. A vacant perception of the canvas grasps the subject not through its forms but independently of them, in spite of them. To see through form is to see artistically, as the artist sees, under the controls which he has provided, by means of the order which he has created, lest men see dust where there is an image of themselves.

43. *Values*

To produce an order of lights and darks, or, for that matter, to apprehend one, the artist requires a scale. For his art is at all events, whether or not he professes to represent an order which he discovers in nature, an essay in proportional relationships. He works in terms of discriminated intervals, and except as he may govern these, he governs nothing.

Suppose, then, in the range of his materials, the brightest white which his palette holds or his field affords, and let it be designated "*Wt*." And suppose, in the range of his materials, the darkest black which his palette holds or his field affords, and let it be designated "*Blk*." Then, between these two, there will fall a middle quantity of light, M, which has the property of being removed from *Blk* by the same interval by which *Wt* is removed from it. It is a pure matter of the visual proportions of light-values: $M : Blk : : Wt : M$.

The things proportioned are lights, not pigments. If the artist were able, independently of pigments, to render permanent his essay in light-values, he would not hesitate to eliminate pigments from his art. Even as he is obliged to work, for a given pigment there is always a possible substitute. But for a given value which his visual scale includes there is no substitute. It is for his purposes a unique quantity in relation to which scaled intervals may be declared, and without which no interval could be systematically calculated.

That is why it is necessary, for all clarity of statement, to distinguish the artist's scale of visual intervals from the pigments he employs on his palette for realizing them.

A woodcut manages its effect in terms of the physical extremes of black and white. Whatever falls below the middle light in nature is rendered as black; whatever falls above it is reserved as white; the point of division, which divides the two ranges from each other, is omitted (Fig. 73). The maker of such a block print employs but

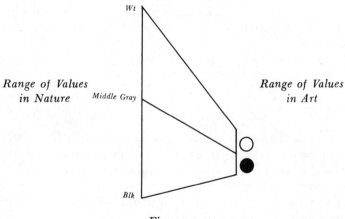

Figure 73

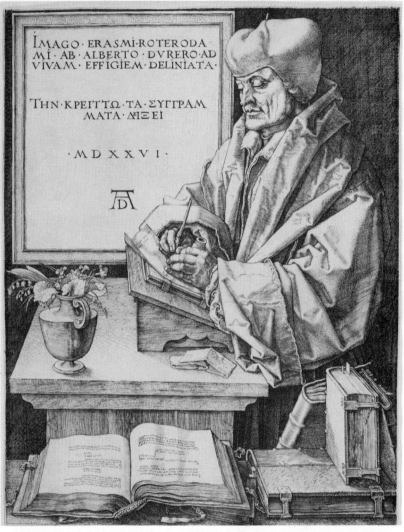

IMAGO · ERASMI · ROTERODA · MI · AB · ALBERTO · DVRERO · AD · VIVAM · EFFIGIEM · DELINIATA ·

ΤΗΝ · ΚΡΕΙΤΤΩ · ΤΑ · ΣΥΓΓΡΑΜ · ΜΑΤΑ · ΔΕΙΞΕΙ

· M D X X V I ·

PLATE 46. *Albrecht Dürer (1471–1528), "Erasmus of Rotterdam" (1526), Engraving, B. 107, The Metropolitan Museum of Art, New York, Mr. and Mrs. Isaac Fletcher Fund, 1919.*

PLATE 47. Pablo Picasso (1881–), "The Pipes of Pan" (1923), Ink, Collection of John Nicholas Brown.

PLATE 48. Käthe Kollwitz (1867–1945), "The Widow, II" (1923), Woodcut.

one pigment, the simple ink on his block, which he construes as *Blk*; for the second value, *Wt*, he relies on the simple white of his paper. His "palette," which includes *Blk* only, is therefore narrower than his physical scale, which includes *Wt* as well. But it is at last neither of these, neither the "palette" nor the physical scale, that counts. An emergent value—any intermediate gray which arises by fusion or by simultaneous contrast (Fig. 66)—is a positive term of his art, and his visual scale must be understood to include it.

In the visual scale of a Dürer engraving or a Rembrandt etching (Plate 23), though but a single pigment has been employed, the terms of light are as numerous, and the gradations as subtle, as in any more complex medium. That is one of the reasons why, in their own day, those prints were regarded as major art forms, as rich in their effects as oils, and for their intrinsic virtues as highly prized.

The marvel of that engraved portrait of *Erasmus*, which Dürer's burin caught (Plate 46), is in the hands. The hands are rendered in the same physical white as the plaque on the wall: in their apparent value they glow as it does not; they are alive as it is not. The whole figure is drenched in a light of its own—a motive suited to the great humanist who wrote once, out of an essential Christianity that is still a consternation to most Christians, "Saint Socrates, pray for me!"

A visual scale of two values is hardly anywhere to be found, and in fact I know of none except it be among the etchings and pen-drawings of Picasso, who eludes the effects of fusion and of simultaneous contrast by the sheer abstraction to a separating edge (Plate 47).[13]

For some purposes the extremes of *Wt* and *Blk* will suffice. That reduction is technically the most austere, as for some purposes it is artistically the most effective, reduction of all (Plate 48). But, ordinarily, an artist works within a more complicated and commodious scale, which includes *M* as a positive intermediate gradation. A three-step scale, limited to the three values, *Wt*, *M*, and *Blk*, is characteristic of Renaissance drawings. The Baroque required gradations more numerous, and it is customary, in exhibiting a scale of values adapted to the common uses of the art of painting until the end of the nineteenth century, to lay out a scale which incorporates at least nine degrees (Fig. 74): *Wt*, *Blk*, and *M*; a Light

[13] The ideal tendency (never the actuality) of a Whistler nocturne is an approximation to one value. The sole variations tend to appear in hues and saturations, and even these are very limited in range.

Figure 74

(Lt), which stands related to M as Wt is related to it; a Dark (D), which stands related to Blk as M is related to it; a High Light (HLt), midway between Lt and Wt; a Low Light (LLt), midway between Lt and M; a High Dark (HD), midway between M and D; and a Low Dark (LD), midway between D and Blk.[14]

The interest of these alternative scales is not at all in the number of their terms, but in the common demand for a scale, which they declare generally for all art. The number of terms in a scale will vary with artists and with the purposes of artists. It changes with men and with styles of mind. But the need for some scale, for a measure by relation to which calculable intervals may be declared, is simply the need for a definition of the terms with which the artist works. That need is constant. It remains fixed for all artists and for all purposes, for all men and styles of mind. An artist may employ a scale, and employ it even with the subtlest assurance, without ever having articulated it or named its terms. His intelligence disciplines his tact, not his tongue. But the painter who works *in fact* without a scale works necessarily without tact and without intelligence. He commits a default which no craft can remedy because the terms of craft have been abjured, which no ingenuity can conceal because the powers of ingenuity have been dissipated. For he makes what is in visual terms mere noise, an empty sequence of lights which obscures his path for himself and renders it opaque for another. The world of Velásquez or Vermeer may be immeasurably more complex than the world of Josef Albers, but in this matter they are at one, cheek by jowl allied. The world of each is principled, and it can be principled on the one condition that it be scaled.

The terms which appear in an artist's scale of values are simply the selection of tones of which he has chosen to make use. His least interval is, like any unit of measure, perfectly arbitrary. It will vary among artists, and may vary in the activity of a single artist from one work to another. But in any one work the terms of tonality will stand systematically related to each other in such a way that it is possible to observe in them the rule of proportions governing their intervals.

[14] The terms of this scale were named originally by Denman W. Ross in *A Theory of Pure Design* (Houghton, Mifflin: Boston and New York, 1907). The scale is repeated in Arthur Pope's *The Language of Drawing and Painting* (Harvard University Press: Cambridge, Mass., 1929 [1949]). It is exemplary, not absolute. Corot by his own declaration employed a scale of 20 gradations.

Thus, in the scale of Figure 74, for example, any term may be repeated simply, as when M is echoed by a recurrence of itself:

$$M : M.$$

Any two terms may be repeated simply:

$$Lt : D : : Lt : D.$$

Any interval may be repeated simply:

$Lt : LLt : : LLt : M$	(an interval of the second degree);
$HLt : LLt : : HD : LD$	(an interval of the third degree);
$Wt : LLt : : LLt : D$	(an interval of the fourth);
$Lt : D : : M : Blk$	(a fifth interval);
$HLt : D : : Lt : LD$	(a sixth);
$Wt : D : : HLt : LD$	(a seventh);
$Wt : LD : : HLt : Blk$	(an eighth);
$Wt : Blk : : Wt : Blk$	(the ninth).

The laboriousness of stating these matters must not be permitted to obscure what is fundamentally at stake, namely, that in these ratios a disciplined eye will discern, in the composition of an artist, visual affinities, factors of order in the work which he produces. The spectator who is able to acknowledge only that Lt is re-echoed by Lt has seen what is true, but he is exhausted where the artist starts.

One may not from this, however, anticipate, in a representational art, the degree of similitude which a work employing this scale will have to nature. The relations of these terms to each other gives no clue whatever to the way in which an artist will have distributed the tonalities he perceives in the natural scene. He, not nature, constitutes the series of correspondencies between the tonalities of art and the tonalities of nature, and he constitutes this series under the guidance of motives of expression which may have nothing to do with the actual scene he observes, which at all events vary independently of that actual scene. Art is not nature; neither is it science. It is, in the phrase of Émile Zola, "nature seen through a temperament." And if in the result the artist produces the semblance of nature, it is because nature reflects his mood, not he nature's.

In Figure 75 suppose the longer vertical to represent the range of light-values observable in nature; and the shorter vertical, the range of light-values in the painter's palette, such that Wt is the brightest light afforded, and Blk the least bright. Three master artists armed with the same palette, though they confront an identical scene, will

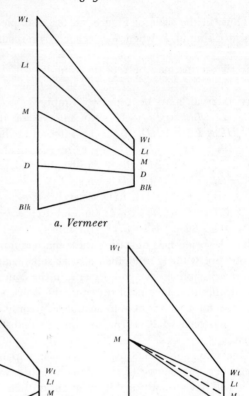

a. Vermeer

b. Monet *c. Rembrandt*

Figure 75

give very different renditions of it. Their difference does not lie
in the acuteness of men's eyes. Neither does it lie in the generosity of
their craft. It lies in the singularity of their temperaments, in the
singularity not of what they find in nature, but of what they demand
of it, in the singularity not of the means at their disposal, but of
what they would dispose. Therefore, though all were capable of
making the same proportional diminution of nature's values which
appears in Figure 75*a*, that mechanical equivalence does not result.
In Figure 75*b* the painter abstains from the use of any interval
greater than a seventh; he abstains, moreover, from the use of any

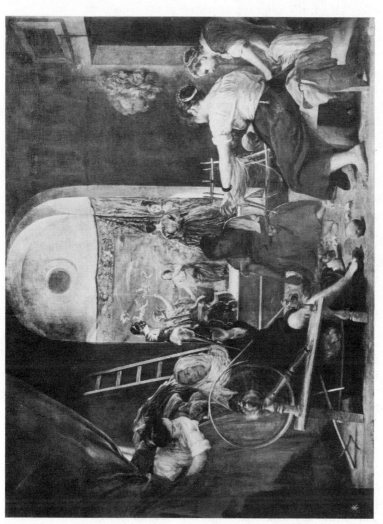

PLATE 49. *Velásquez (1599–1660), "The Weavers" (c. 1657), Prado, Madrid (Anderson).*

interval which includes *LD* or *Blk* as a term. The degrees of con-
trast which he chooses to countenance fall mainly within some five
intervals in the upper registers of his scale. The key is high, the
effect blond, the contrasts as muted as the light is diffused.

In Figure 75*c* the middle terms of the scale—*LLt, M, HD*—are
suspended, so that the lights pulse in the contrasts of *chiaroscuro*.
The illuminated parts of the surface move in intervals of the second
and third; the shadowed parts repeat them in a somber echo.
But between the upper and the lower registers a visible hiatus
appears: there is no interval of the fourth degree. The contrasts
between the two registers are pronounced and emphatic, measured
always at least in fifths and rising even, as occasion requires it, to
ninths.

The pictorial artist may, after the manner of an architect who
reduces a design to scale, make a proportional diminution of the
intervals he finds in nature. Intervals equal in nature will then be
equal in representation: the intervals themselves are diminished;
their ratios are constant. In the naturalist vision of Velásquez and
Vermeer and Chardin (Plates 49, 50)—three of the most dispas-
sionate eyes in the history of mankind—one finds approximations
to that mode of neutrality. The interest, here as always, is not in
the nature seen, but in the cast of mind which is turned upon it—in
the dispassionateness, the neutrality, of the seeing of it.

What in the terms of visual art is meant by the dispassionateness
of the eye of a Velásquez, or of a Vermeer, or of a Chardin? Let a
determinate source of light be assumed within the scene which is to
be represented, and suppose light from that source to fall upon a
represented surface, e.g., upon the uniform area of a table-top, the
gradations of light will immediately establish the spatial relations
of any part of that surface to any other part. The distances within
the represented space are articulated not only in terms of shapes
or sizes, but in terms of lights and progressions of lights. The space
is as perspicuously measured as any variation in the size or shape of
standard units could render it. It remains still measured even in the
passages where such recurrent clues of sizes and shapes are absent.
The prime key to the painting is its system of light intervals, all
measured, all graded, all lucidly calculable. And if you suppose this
to be the effect of mere nature, of nature aped and imitated, place
beside an open window a girl with a water-jug, or seat women
weaving tapestry in a lighted room, or let a man blow soap-bubbles

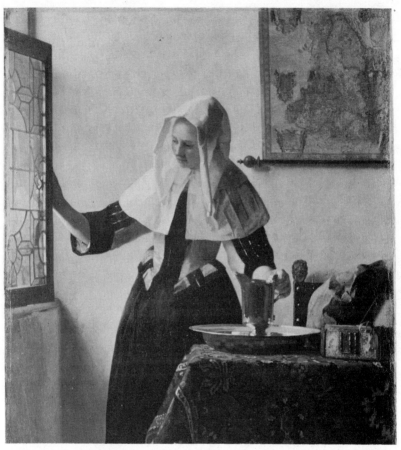

PLATE 50. Jan Vermeer (1632–1675), "Young Woman with a Water Jug,"
The Metropolitan Museum of Art, New York, Gift of Henry G. Marquand, 1889.

for a child in the out-of-doors, you will sense immediately by its absence that scale the luxury of whose presence you failed to see. The painting has a lyric clarity, a visual intelligibleness, a lucidity, of which ignorant nature knows nothing, and by the side of which even the best photograph will appear a dissipation.

44. *The Vision of Dignity and the Dignity of Vision: Rembrandt van Rijn*

The dignity of man is in his simplest act declared. But it is by no means so simply seen, and the capacity to see it is broadly diffused among mankind only in the hateful and vindictive seasons in which they have first desecrated it. Men see normally by deprivation and by ruin. Their sympathies are therefore most exercised only in tragic aftermath. With dust in their throats and rubble in their paths they gain the vision, but they gain it in a tragic hour, when they contemplate the desolations they are capable of, and find themselves appalled that they have done as groups what disgusts their sight as men. The starkest irony of men's moral condition is, that they honor the dignity of persons when they have most reason to regret it in themselves.

What then must the revelation be when a mind appears which is capable of seeing, and of making others see, the dignity of the human in his simplest act of every day? Rembrandt commands that power in his art. It is the reason why he is of all artists the one least capable of being countenanced in purely formal terms, in terms of pure design divorced from the function to which it has been committed.

Rembrandt's actual eminence is best seen beside those workers in *genre*, who were his contemporaries and compatriots, the Little Dutch, as they have come to be called, who set themselves the task of rendering the portrait of Holland. They took as the occasion for their art the common life, and celebrated it, the uncelebrated and voiceless familiar life not of pride or wealth or power, but of general issue, the life eternal of peasant and petty soldier and fish-stall keeper, rude, boisterous, unstarched and tousled, with its large appetite and open codpiece, brawling, bibbing, bussing, replete with the accident of existence and in love with it, in a universal sympathy for all its episodes. In a monumental art man stands opposite to nature in a world contrived by an artifice which sets him apart, so that his acts appear staged and elevated, and he appears, rid of

the grit beneath his feet and the smoke in his nostril, nobler than in fact he is. An authentic art of *genre* admits no such distinction. It sees man and thing implicated, and implicated on equal terms, in a common scene, denizens alike of a neutral space which includes them both, and extends beyond them both, life and still-life, man, earth, and plow, ship, sky, and the untamed sea, in a single nature. Between the detached reserve of monumental art and the random intimacy of *genre* there lies ordinarily the widest gap. The two worlds are, in the common habit of art among men, alien and mutually estranged.

In the art of Rembrandt they have been brought together. The familiar, the little, the incidental are seen with the plenitude of a monumentalizing vision, but seen with an intimate sympathy that is capable of embracing man's smallest act or path—the landscape because it is his scene, an old man of the ghetto because he is his kind, an old woman paring her nails because she performs his act, a beggar because he is capable of his suffering, a woman because she is equal to his love. Scenes of the Old Testament, the parables of the New, have neither the detachment nor the formality of icons. Too personal a vision for monuments, too inward a soliloquy for priests, they are the human scene, the thing itself, represented with the affecting directness of things near and known, contemporary and felt, incidents realized not by divorcing them from the ordinary life but by identifying them in it, as if to say that nothing is profane except to him who sees it with a profane eye (Plate 23).

What are his means? They are as powerful as they are simple. They are powerful because they are simple. He works, as everybody knows, as everybody has been taught to say, in *chiaroscuro*. He works in a distribution of lights and darks, which combines, with the gentlest gradations in the upper and lower registers of his scale, a suppression of the steps that link the two. The result is, that intervals of least degree stand boldly juxtaposed with the broadest intervals which his scale can command. Therefore, the surface should pulsate with lights like a thing disturbed. It does not. The surface is as uncontentious as a star. That is why Rembrandt's *chiaroscuro* is the statement of a problem, not the solution of one.

In itself, the device of *chiaroscuro* was in Rembrandt's day neither novel nor unheralded. Masaccio knew it.[15] Leonardo, by means of

[15] *The Fall of Man* (c. 1426), Brancacci Chapel, Santa Maria del Carmine, Florence. Fresco.

it, in that strange *Adoration* which he left unfinished, educated the eye of all Italy.[16] The inexhaustible old Titian discovered how profoundly dramatic were its possibilities, and for thirty years practiced his hand, that it might paint the starkest and most moving work of his whole life, which was the last work of his life.[17] After Caravaggio it had become part of the technical repertory of Baroque art at large. With the *staccato* effects of those jagged contrasts of the Baroque the art of Rembrandt has nothing in common except the technical means (Plates 51, 52). Its wide intervals of contrast he retains, but he refuses to scatter his contrasts. He congregates his lights. He congregates his darks. He works by concentration, canalizing the intervals of least degree. The surface of his canvas therefore divides itself visibly, in terms of light, according to a decisive principle of subordination. Relatively, considered as a whole, the canvas is dark, for the ratio of lights to darks has been diminished. But the spatial distribution of those lights has been at the same time sharply contracted. They are therefore dominant despite their unequal circumstance, the more emphatic as they are less diffused.

In the whole of this terse economy there is apt to be but a single hue employed. Warm, circumambient, golden, it permeates all things. In the darks it mutes itself almost to neutrality; in the lights it sings. Darks as well as lights are suffused by it. They do but re-echo it, ring changes in its terms. Therefore, despite their difference, they share a common bond, and stand indissolubly allied as variations on a single theme, though they stand separate at the extremities of his value-scale.

The effect must at last, as always in these matters, be seen in order to be known. For what language will convey the singularity of that light-image? One succeeds at best in conveying only the impression which a spotlight in the theater could equally produce. But that is to have omitted both its genius and its reticence. A spotlight does not transfigure; it simply isolates. What actually one responds to in the theater is not any new character seen in the object lighted, but the deprivation of light from all other things. It is the darkness only which is eloquent; the thing lighted is precisely as it was. The light which falls upon an actress imparts to her no single grace or character which she had not already in the common light of day, and would not have still were the common light of day

16 *Adoration of the Magi* (1481), Uffizi, Florence.
17 *Lamentation* (1573–1576), Accademia, Venice.

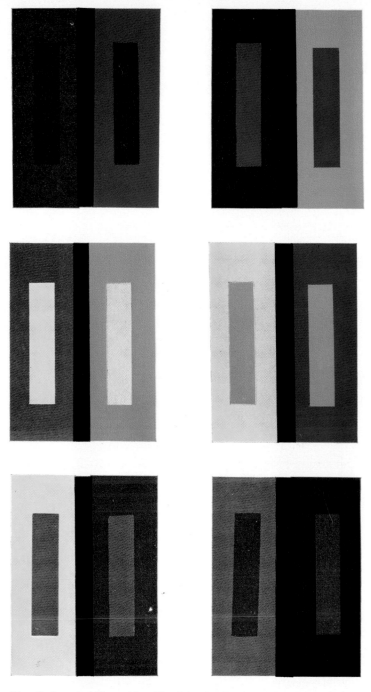

Plate C: In each field, on either side of the black line, the enclosed rectangles have been produced by an identical pigment. The apparent variation is the effect of simultaneous contrast.

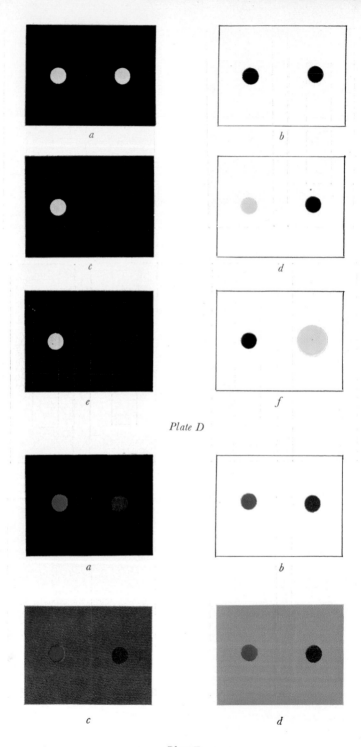

a *b*

c *d*

e *f*

Plate D

a *b*

c *d*

Plate E

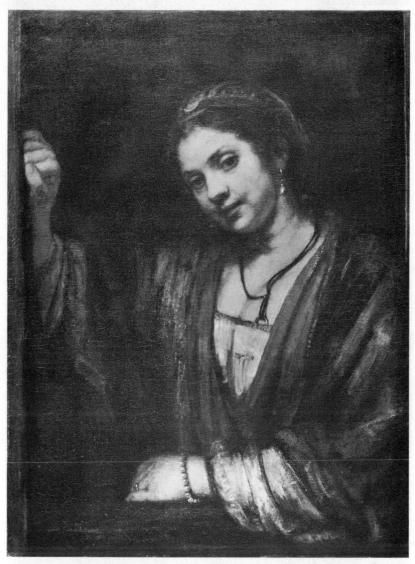

PLATE 51. Rembrandt van Rijn (1606–1669), "Hendrickje Stoffels" (c. 1658), Kaiser Friedrich Museum, Berlin.

restored. It works cosmetically, by omission and by concealment, concealing her world as she conceals her blemish. Such light is selective only with respect to the things it fails to strike. With respect to the things it strikes it marks no distinctions of status or of privilege. It falls without sentiment and without assessment, and will light an empty spot on the stage as neutrally and indifferently as a peopled one. One could, I suppose, if one had the patience of it, produce upon the figure of a woman that same distribution of lights which one sees in the portrait of *Hendrickje Stoffels* in the Kaiser Friedrich Museum in Berlin (Plate 51). But one shall not by the mere cancellation of physical lights have equalled it. For the lights retained, even with a patience inexhaustible, remain still an accident to that form. The woman is lighted; she is not light itself, emergent out of it, rising from it, as Aphrodite rose from the froth of the impregnated sea. In Rembrandt's image of Hendrickje the light is her proper element. It emanates from her. Freed from the order of mere things, she has become a source, a source of light, not an object vacantly reflecting it. She wears a necklace which holds a ring. Shall one suppose, in the shadow cast on the contour of Hendrickje Stoffels' breast, that accident is so solicitous of its course? So reticent a thing, it is one of the most passionate portraits in the world. The light has become the very medium and vehicle of a person, seen not as the physical eye sees, but as the heart feels.

Rembrandt sees with sentiment; he does not work with it. In the most merciless series of portraits which the world has ever known he turned an unrelenting vision, relentlessly detached, upon himself (Plate 52). It is, I suspect, the longest sustained, as surely it is one of the richest, of all soliloquies.

> I, painting from myself and to myself,
> Know what I do, am unmoved by men's blame
> Or their praise either.

He worked before a mirror; he grew old before it. The mirror, itself vacant, passive, reflected its indifferent lights from first to last. The features of him who stands before it change, his body ages and declines. The style ripens. That is the pregnant revelation of the series: as the one diminishes, the other takes its increase. The manner of seeing enlarges, gains breadth and depth and amplitude, discards its own accidents, purifies itself, as if, out of the nakedness that shrouds us all, in the solemnity of those features which years since

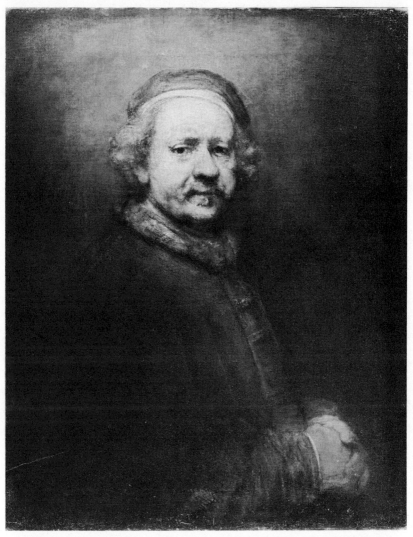

PLATE 52. Rembrandt van Rijn (1606–1669), "Self-Portrait" (1664), Repro-
duced by courtesy of the Trustees, The National Gallery, London.

had lost their capacity to surprise or to transfix was distilled the whole destiny of mankind, its grandeur and its independence, its pathos and its finitude. The most profound of the portraits are those in which the raw image counts least, and at last counts not at all, except as the mute occasion for exhibiting a covenant. What does it matter that Rembrandt was the sitter? Shall you not have had his presence, sovereign and unmistakable, and with the same economy, in any other subject? The equilibrium is all, and nothing of thinghood remains. The proper image of man is nowhere in nature, but in the allegiances which he has given to himself.

VII. The Contemporary Encounter

45. The Image of the Mirrorer

Renoir was accustomed to saying that nature is itself too impassive to inspire art: the source of the artist's inspiration is other art.

I know no statement that comes so close to realizing the way in which, typically, the artist relates himself to nature. In his image of nature the essential genius lies not in what he omits or in what he includes, but in what he institutes. It is the profound achievement of contemporary art, as also it is its presiding peril, that the contemporary artist has become aware of that. The contemporary artist has become aware, reflectively, that (in Renoir's own words) "with nature one can *do* nothing." Nature's raw flow exacts our obedience and will not suffer our command. Therefore such freedom as man has must be declared within nature's dispensation and can never be declared through it.

Art is a *doing*—an active doing, not a passive dumb arrest. What passively I meet in nature can never reveal what *I* am, nature's prank and stranger, toiled in space and tangled in time, who view nature as a thing apart. The thing met discovers the bare fact which nature has disposed in my path, the unwilled adventure of things which occurs now in my presence and would occur indifferently in my absence. With that I can do nothing, for it passes independently of my act: it does not solicit my permission, neither does it ask my forbearance. Sun still would rise, tide still would run, leaf and woman still would fade, if ignorant nature were without a witness to greet the one, to solemnize the other, or to regret the last. Nature does not include the circumstance that nature is observed. Therefore the thing I meet is never equivalent to my meeting of it, which implicates me as well as it, my encounter as

well as this dross encountered, and the coloration which encounter gives. Only art ever records this encounter, the encounter of the person implicated, his dumb feel of the push of things, of being in the midst of things, of his oneness with them and separateness from them, his last inward solitary impassioned sense of his own identity, accepting or rejecting, accepted or rejected, before his world.

It has always been so. That is what the artist alone among men has always intimately shown, what has made of art at all times an image of the human encounter, of man in his world, of the implicated human soul, which alone the artist shows and no other shows.

> To every natural form, rock, fruit, or flower,
> Even the loose stones that cover the highway,
> I gave a moral life: I saw them feel,
> Or linked them to some feeling: the great mass
> Lay bedded in a quickening soul, and all
> That I beheld respired with inward meaning.

Always it has been so. But the artist has not always been reflectively aware that it was so, that that was in fact his singular office, to provide an image of man's participation in the world, in which other men as well as he, and other men no less than he, could find an emblem and symbol of their own participation. That reflective awareness has produced the stamp and peculiarity of all distinctively contemporary art.

The contemporary artist works with an eye to what he institutes in the face of nature. For by that alone which he has instituted is his presence ever visible in nature's face. The thing imaged in art is never nature, but the human encounter.

Men would find no difficulty in that phrasing if they took their initial conception of art's image from design. An architect does never profess to imitate nature. Invariably the forms he contrives are limited by the materials in terms of which he is obliged to work. But within those limits, which nature has set, he is free to employ any form which his technique is equal to producing. The form which in fact he will produce, out of the total range of forms available to him, will be determined not at all by nature. The form of his building will be determined by the use to which the building is to be committed, by the function which it is designed to serve, as he conceives that function and conceives himself embracing it. That ordered space which issues from his design is the sheerest declaration of his freedom, for, by the form which he gives to it, imaginatively

he houses his life, submits nature to his habit, creates for himself a man-made environment which responds sensitively to his need. He is so far from imitating nature that he requires nature to imitate him. In the design which he imports into space his own image is implanted. He is visible in that order which he has freely improvised, exactly because that order has been freely improvised—because it is his institution and reflects his decision. The building not merely serves a use: it memorializes the use, declares it, and him in it.

The image in architecture is not the image of an ordinary portraiture. Physiognomy is not its object. Its object is the mode of encounter, the way in which space has been embraced into human purposes, suffused with the human presence, personalized. Such is the incontestable mark of architecture wherever it is found, that even in the physical absence of its occupant, his presence is still felt. His presence is its testament. In the stones of a building one sees stone; in the design of a building a character of men and a style of mind (Plates 11, 27, 33, 13).

Let that image visible in design be called the *primary image*. Any order which man has freely instituted preserves thus a primary image; in the style of its ordering it preserves a style of mind. In institutions of law, of economy, of science, of religion, a historian is able to rediscover, out of patterns requickened, the very spirit of the dead. But in orders of law and economy and science and religion that spirit is never, as in architecture, *presented*, sensuously felt as living presences are felt. That is art's creative novelty and distinction, and in this distinction architecture is the paradigm of all the arts. For all the arts alike—music no less than poetry, painting and sculpture no more than architecture—present this primary image in its sheer immediacy.

The arts we call fine arts are simply those free institutions in which the primary image is primarily at stake. The primary image has been in them deliberately premeditated, consciously aimed at, incorporated by design. Whatever other motives of politics or religion or documentation have entered into their production, the primary image is their artistic reason for being. They are therefore all without exception regarded as modes of expression.

The attempt to extricate the primary image and to render it in its purity has generated the distinctive intensity of all contemporary art. In itself the pursuit of that image is nothing new to art. There is no art which has at any time failed to convey it. But the contemporary

artist has discovered its pivotalness. It has become his focal concern, he has sought to make it his exclusive concern. He admits to but one obligation, to extrude from the primary image all accidental accompaniments which complicate it and obscure its transparency. Such at last is what he means by that simplicity which he will invariably announce as the first canon of his art.

The demand for simplicity (in an art otherwise so little simple!) is at the root of the contemporary artist's quarrel with representation. For in any representational art—in poetry and drama, in sculpture and painting—there will appear, in addition to the primary image, a *secondary image*, which is not identical with it. The primary image is the image of a mode of encounter; the secondary image is a residue, a resemblance, more or less literal, to the thing encountered. That residue is never, in a representational art, avoidable. It is the inescapable trace of mere fact which is retained in imaging the encounter itself. That is why the contemporary artist regards it with so profound a distrust, for it appears to him to betray his inability to extricate, clean of all dross and accident, the primary image which is his proper occupation.

The temptation to discount the secondary image, where an artist has in fact employed it, is nevertheless forbidden to him and to us. What makes no difference in art has no place in it; what makes a difference can never be discounted. The secondary image has an artistic value just in the measure that it affects the artist's mode of encounter. Functionally, it makes a difference to Rembrandt's mode of encounter whether the subject encountered be thing or person; it makes a difference to his mode of encounter whether the person encountered be Hendrickje Stoffels, or Jan Six, or himself (Plates 51, 52). The artistic value of the secondary image is never in what it *is*, but in what it *does*.

A painter who sets for himself the task of portraiture is not free to elect whether he shall represent the sitter. The demand to produce a likeness is part of his undertaking, cognate to his enterprise. He is free to practice the art of portraiture, or not to practice it. But if he practices it, this demand is an obligation which he acknowledges as incumbent upon him. The demand for similitude is to the art of portraiture what the demand for utility is to the art of architecture. It is simply that aspect of a portrait which the architect would describe as the painting's function, as its "program." Yet that demand, which the painter acknowledges, defines for him no

solution. It only states his problem. It limits his act, but it will not suffice to dictate his act. He regards the demand for a likeness simply as a limitation upon the range of solutions available to him. The solution he will in fact institute will be one which, while it preserves a likeness to a thing, preserves also his mode of encounter with a person. The image of the mode of encounter, the image of his way of relating himself to his subject, is the primary image which professionally concerns him, and at last alone concerns him. The resemblance to the thing encountered, to the mere fact of physiognomy that nature has afforded, is a secondary image, which is a residue of the encounter.

The secondary image is the despair of the modern artist. It confounds his theory, and in the contemporary scene to confound theory is to confound art itself, for there is no scene in which theory has at the hands of artists, for better and for worse, commanded such consequence or enlisted so passionate an obedience. Leonardo could recommend to the painter that it was his business to imitate nature's truth, to become like a mirror "a second nature," lest by imitating others' art he be no longer nature's child, but only nature's grandchild. Today Leonardo would not be heard. The contemporary artist conceives the whole weight of the modern experience to lie against the art of the Renaissance. It is not the business of art to mirror nature, and if perils be compared, the one peril worse than being grandchild to nature is, out of love of secondary images, to be grandchild to art.

The warp of a mirror will produce a deformation in all that is reflected from its surface. Therefore, the warp of a mirror is invariably counted as the mirror's defect, for it is the function of a mirror, simply and selflessly, to reduplicate the image that passes before it. Its function is to conceal its own function, to efface itself, in order that it might convey the virginal similitude of other things. Therefore, as a mirror would enact its function, it is forbidden to declare it. Any contribution on its own part, any new character it intrudes upon the image it conveys, will be regarded as a deformation of the image and imputed as a fault to itself.

For this reason, from a true mirror one may indirectly take knowledge of nature. Why should not art, which is like the mirror set in nature and on occasion reflects her face, be also regarded as a resource of knowledge of nature?

Art is never so regarded. The image in a mirror is viewed always as a natural incident, even if it be the image of a man; but the image

in a painting is viewed always as a human incident, though it be the image only of a still-life or a landscape. The reason is, that art begins where deformation begins, and ceases where deformation ceases. In art it is the deformation, and the deformation alone, that counts. At last the deformation is all that counts, for it alone can declare visibly the part which man has played before nature in relating himself to it (Plate 53).

Why, before a Van Gogh, do I remain so importunately aware, irrespective of its subject, that it is, whatever else it is, an image of human sympathy? It is sympathy that is imaged. The subject may be a landscape, it may be a still-life, it may be a man. All of these things I see in Van Gogh. All of them I ceremonially acknowledge. But it is never these which I find celebrated. Their reason for being in his art has nothing whatever to do with their actuality in nature. Their reason for being has only to do with their actuality in his encounter. The value which I assign to them in his art would remain perfectly undisturbed even if nature had never worn, these seventy summers past, that physiognomy in its landscape, or in its still-life, or in a man (Plate 54). Therefore, though I presume myself to mark a likeness, I have not the slightest interest in confirming it. The reference in art to a thing beyond art may be permitted to lapse. The verity of science is not the kind of verity which art has, or ever claims. The verity which it claims, and on occasion succeeds in having, consists in presenting the image of an encounter, which involves, besides a thing encountered, the way of the encounter and the person who embraces it—once Van Gogh, who pointed the way, now I, who adopt the way and traverse it after him. That way produces deformations everywhere. All things which it touches are transformed. Its virtue is, that the transformations are consistent, principled, as things never are. Van Gogh's way is all that is permanent in Van Gogh, all that is memorable in him. It is the part of him that, while he lived, remained constant as his subjects changed. It is the part that, when he dies, and his subjects with him, and only his works remain, we identify as the primary image which they convey. It is what technically is meant by *style*, the objective signature of a personality, which a personality leaves on all that in life it meets—on sunflowers, on cypresses, on wheatfields, on the night-sky. Van Gogh's sympathy is visible in that style, at once so generous and so pathetic a thing, so tumultuous yet so consistent and sustained, that men take from it an expansion of their own

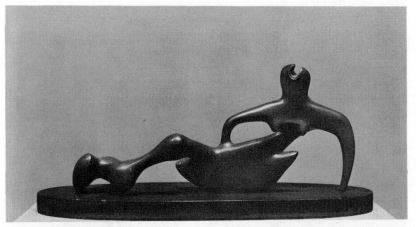

PLATE 53. *Henry Moore (1898–), "Reclining Figure" (1938), Cast lead, 13" long. Collection, The Museum of Modern Art, New York. Purchase.*

Now as in all seasons, the deformations in art are most extravagant in the modes of art known as Expressionist. The term "Expressionism" is technical. It signifies a deliberate wrenching of a form out of its natural habit with a view to making it convey, as here, not the thing, but the empathic response of the artist to it—the way in which the thing is felt. In this sense Grünewald and Bosch, El Greco and Goya, Van Gogh and Rouault, Kokoschka and Modigliani are Expressionists. All, despite their differences, exhibit a common mode. But the deformations of art need not have this stridency. The idealism of Greek art is in its own way a deformation of nature, not a halt imitation of it. Greek art is the reaching of the mind after a form, a perfected type, which is beyond the accident of mere nature. Between these extremes— between Expressionist art and Idealist art—all modes of representation may be ranged. Each mode images a style of encounter. Each is primarily the image of the style of a mind. Art is man's image of himself. That is why in art all landscapes are peopled, every still-life is an animation, and on the waters of every sea a spirit walks.

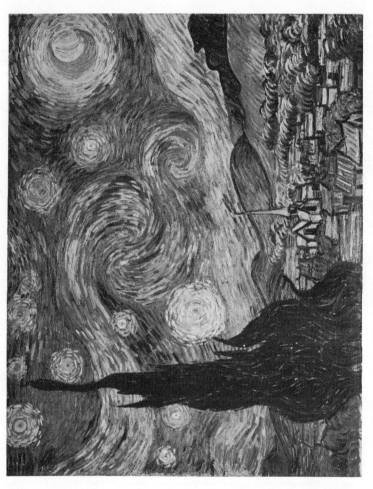

PLATE 54. Vincent Van Gogh (1853–1890), "Starry Night" (1889), Collection, The Museum of Modern Art, New York. Acquired through the Lillie P. Bliss Bequest.

experience which it lets them see, prophetically, in the transfigurations to which it leads.

46. The Illusion of Primitivism in Contemporary Art

Style is the testament which a historian sees, and rightly sees, as still vital in the art of the old masters which we inherit. It is the testament which the contemporary artist sees, and rightly sees, as alone vital in the tradition he would bequeath. The historian labors at a pure inheritance; the artist at a pure bequest. That is their only difference, but it is a decisive one. The artist works, as the historian is forbidden to work, as fierce partisan, as one who would perform the relevant act for his day, who would constitute, out of his dumb sense of rectitude, the primary image of his day. His institution announces his partisanship, as the institutions of the old masters announced theirs. His partisanship is his engulfing concern, as it was theirs also. That is why, where it suits his purposes, he will not hesitate to borrow from them, since they too confronted a world and as partisans took passionately their encounter with it. What he refuses to admit into his art is the abject inheritance, the vacant repetition, which mirrors a partisanship without being involved in it. He rejects another's image not as the image of that other, but as the image of himself, for whatsoever he has not fashioned he does not own, and as his partisanship is passionate, so his rejections must be passionate. A style must be refelt in order to be re-used, and to use it without being involved in it is to treat the partisanships of men, another's as well as one's own, as if they were mere nature. Such is the ground of the artist's perennial rejection of the Academy, even in a world where there is no Academy. The Academy requires him to take as his primary image an image merely secondary. Idolatrous, it would make an idolater of him as well. What difference does it after all make, if circumcision consists simply in the empty rite of inheritance, whether foreskins be severed in desecration of nature or in imitation of society?

The modern artist sees himself as a primitive. That is what prevents his ever being one.

The thing which the modern artist so devoutly admires in primitive art—its freshness, its breadth, its unpremeditated quality—

is permanently forbidden to him. He would make of his own mode of encounter something thus new in the world, creative, original, unheralded. Yet this awareness, which enables him to value his own uniqueness, is the thing least primitive in him.

A child is civilization's perennial primitive, spontaneous and unspoiled, who lisps childlike in the language of his parents without awareness of his childlikeness. He lisps as a bird sings. That is the authentic primitive in him, the essential unpondered simplicity, that though his language has been in fact borrowed, the deformation is original. The lisp is neither borrowed nor perfectly heard. The child is totally unaware of the distinction of the idiom he employs: he therefore cultivates the language, never the lisp. The parent who imitates the lisp of the child performs outwardly the same act. He never achieves outwardly the same simplicity. The conscious affectation inevitably betrays itself, for though the parent speaks as a primitive, he hears the special quality of which the child is ignorant. The true primitive is never aware of his own primitiveness. He is never therefore obliged to affect it, or by reflection to sophisticate its presence.

So to hear a child lisp is to encounter a style. To hear the lisp of the adult is also to encounter a style, but not the style of the lisp, but of the affectation of it.

The child who lisps turns his back on nature. The parent who lisps after him has done no such thing: he has only sought a different part of nature for imitation.

Poor inquiet Gauguin, there is such a pathos in his art, that he who found all Brittany spread before his feet should seek for innocence unspoiled in an island of the southern seas, or in the body of a Javanese for nature's pristine freshness. The germ that killed him he shall find in the one place as in the other. The innocence, the freshness—such innocence or freshness as he shall ever find—he shall find only in himself. And that is all of him that remains, the precious part, the indelible and uncontrite testament which he had already before ever his foot had touched the sand of the Marquesas (Plate 55).

Nature has its uses in art. But that precisely is the modern artist's perception: its value is only in its use, in affording the motive and occasion of the encounter which he images.

In representing that encounter the artist may submit to the appearances of nature, he may idealize those appearances, he may

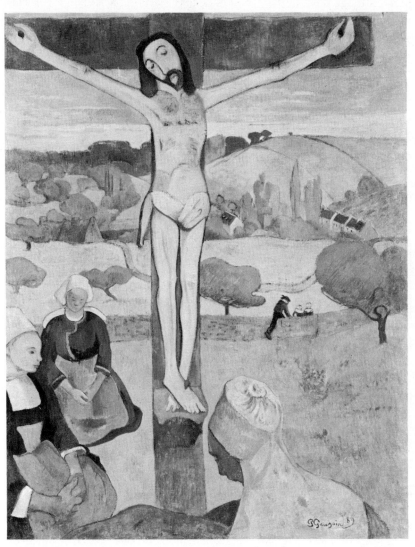

PLATE 55. Paul Gauguin (1848–1903), "The Yellow Calvary" (1889), Albright Art Gallery, Buffalo, New York.

estrange them in their setting, he may turn his back upon them. He
may do any of these things, and as he does the one or the other
there will appear incidentally, in the image he produces, a greater
or less resemblance to nature. But his art is in no case measured by
that resemblance. If he submits to appearances, what in fact he
images is not the appearances but the submission; if he turns his
back on those appearances, what in fact he images is not their
nothingness but his independence.

"We must create the world of things that no one sees,"
said Raoul Dufy. It is just so. That is why, in the twentieth
century, Marin can be said to discover Manhattan, Matisse
the Mediterranean, and Brancusi the flight of a bird (Plates 9,
30).

47. *The Primacy of the Mode of Encounter*

The idea of an abstract art, or of a non-objective art, fails now,
as it has always failed, to convey the positive achievement of
modern art. All art is abstract, all art is non-objective, if by those
descriptions one intends to convey that the value of art must not
be thought to lie in the secondary image. But that of course is not
all that the contemporary artist, who uses those descriptions, in-
tends, and the fault of those descriptions lies precisely in their
failure to communicate what positively he does intend. A lover
does not convey to his beloved his sense of her perfection by mark-
ing the defects of other women. So here, I am told nothing of
Cleopatra by being told that Antony hates snakes. The terms "ab-
stract" and "non-objective" are both grounded in the literalist con-
ception of art which the contemporary artist professes to disown,
and nothing is so detrimental to a broader understanding of his
art as the credit given to these terms which honor only his capacity
for omission. Strictly, the idea of an abstract or non-objective art
implies that the only thing at stake in art is the presence or absence
of a similitude to nature. That proposition may suffice for pur-
poses of polemical dispute. It is nevertheless false, false now as it has
always been false, and a serious artist can subscribe to it only at cost
of betraying that he is less than self-aware. He has failed to perceive
what the contemporary advance actually consists in. The genius of

modern art does not consist in what it abstracts from, but in what it abstracts to. It does not consist in what it rejects, but in what it affirms. What does it affirm? The thing it institutes, the style of its encounter, the primary image, its way.

The term which most nearly represents what the modern artist is engaged in doing is "construction." The term, alas, is too neutral. All art is constructive. All art constructs a primary image. Therefore, to describe contemporary art as constructivist is to state what is precisely true of it, but to leave unstated what is peculiarly true of it.

The term "construction" has nevertheless this value, that it enables one to see the image as proceeding from the artist's mode of encounter rather than from any borrowed characteristic of things. And if one holds to that perception, and describes the artist's constructive activity (in order to mark explicitly this emphasis) as "manifest," then *manifest construction* may serve as a description of the modern genius generally. Which is only to have said, style is its conscious prepossession. Modern art has learned to prize its own absolute artifice. There lies its valor. There lies also its peril and its risk. It is an art grown self-aware.

The characteristic demeanor of modern art depends upon an inversion. It inverts the place in art of the primary and the secondary image. The delicacy of that inversion in Cézanne prevented his contemporaries, as it still prevents some of us, from seeing in it the secret of his art. It is the very mark and signature of his centrality in the modern movement. Every Cubist work will simply make that inversion visible and explicit: the primary image obtrudes itself, the secondary image hides and must be extricated from it (Plates 18, 19). What was manifest in traditional art has become latent; what was latent has become manifest.

The simplest and most declarative statement of the inversion occurs in the Cubist experiment with scissors and paste—in the experimental art known as "collage." So far from attempting to conceal its relation to nature, the art of collage draws its elements, concrete and recognizable, from the domain even of artifacts—from newspaper print, from cane chair, from the litter of cabaret—so that the resemblance of the thing in art to a thing in nature is realized in the limiting case of actual identity. Therefore, since the field is but a platter of things, all of which are declaratively borrowed, the art of the work cannot be thought to belong to their actuality. It can belong only to their arrangement, to the order which has been

introduced adventitiously among them.[1] Thus avowedly estranged from their familiar places in nature, they can claim no meaning except the meaning which art has given them. Their accident is its contrivance, and as the one howls, so howls the other.

The howl of collage is its presiding fault, a fault which, even in its most sensitive performances, it cannot mend. Its means forbid any tempering of its effects. Pure artifice, it can never mute its artifice; therefore, there is a part of art—the reticency of art—which it can never own.

Yet that defect of collage does not diminish its interest as a phenomenon. Its proper value, as those who originally used it knew, is the critical value of an experiment. It is the sheerest revelation of the modern conception of the artistic function, which is manifest construction. It exhibits the primacy of the mode of encounter by an absolute excision of every other interest whatever. That is why it is everywhere so liable to be interpreted as an affront. It is nothing of the sort. But its limitations are both real and profoundly instructive. The success of a collage is measured exactly by the degree to which artistic performance has been severed from connection with any other human concern. It is pure art, if one pleases so to call it, but its immaculateness has been purchased, like a closeted virgin's, at cost of suspending the challenge to encounter which makes purity important.

Cézanne meditated no such consequence. The purity of Cézanne's art does not consist in suppressing the secondary image. The secondary image is not suppressed; on the contrary, it is *used*. The secondary image has the positive contributory value of enabling Cézanne to exhibit the signal distinction of his mode of encounter. Apart from it what is distinctive of his mode of encounter could never have been made apparent. For the distinction of his mode of

[1] The contemporary Expressionists employ an identical principle. The artifice of a Jackson Pollock does not consist in the laying-on of paint. The accident of the shapes is intended. The shapes are produced by declarative accident. Therefore, such art as is to be found in the work cannot be thought to lie in shapes, which, so far as they are controlled at all, are minimally controlled. The art must lie in the color-relations only. Color can be dissociated from shape in the art of painting only by declaring all shapes to be adventures of mere nature. Accordingly, in a Pollock, the shapes are construed only as parts of texture. The orchestration is in terms of color purely. It is perhaps well to say, in defense of the Expressionists, that the vision of meaninglessness is not itself meaningless. Neither is it, however, as some think, inexhaustible.

encounter is exactly its dispassionateness, its invariance before changes in the subjects it is turned upon. It remains constant irrespective of its subject. The subject therefore appears simply as a neutral *motif*.

Thus, Cézanne will paint the portrait of Madame Cézanne with the same severe disengagement from sentiment which he uses before an apple, or a rock-quarry, or a mountain. The difference between person and thing, between *thou* and *it*, is not permitted to occasion a difference in the mode of encounter which is turned unerrantly upon all that it meets, upon man as upon thing, upon man no less than upon thing.

Cézanne was himself timid of encounter with other persons. His portraits are so few for the reason that persons had seldom the patience of apples or mountains, and such patience was necessary for one who sought thus indomitably, as an article of contract, to realize his own sensations, the *petites perceptions* which he regarded as art's occasion. But that is why, when he finds a subject equal to that demand, either himself (Plate 56) or the forbearing Madame Cézanne, the portraits are a revelation. An apple simply rots, a mountain erodes. A person invariably challenges. I am spontaneously aware of being involved with persons in a way in which I am never aware of being involved with things. Therefore, to see person and thing together as of a kind, as belonging together in a common world, is a literal conquest. In my moral condition I never succeed in that conquest of equating man with thing. Just for that reason, whenever I attempt it, I experience the desolations of a moral abasement: I find that to diminish thee is to diminish me also. In the art of Cézanne that moral distinction is held in a deliberate suspense. Spinoza would have understood it. Cézanne's is the most profoundly naturalist sensibility in the history of all art. The image of his encounter is as inflexibly detached, as vacant of personal commentary or assessment, as a surgeon's description. The disengagement of this vision is equal to Velásquez'. The result which issues from it is incomparably more stable: it has the resistant hardness, the sheer objectivity, of a piece of grit.

There is, then, no encounter? He is not involved with his subject? No, that is the manifest character of his mode of involvement. It is precisely what you mean by Cézanne—that neutrality of encounter, that dispassionateness, which he so passionately affirmed as his way that no other has ever equalled it.

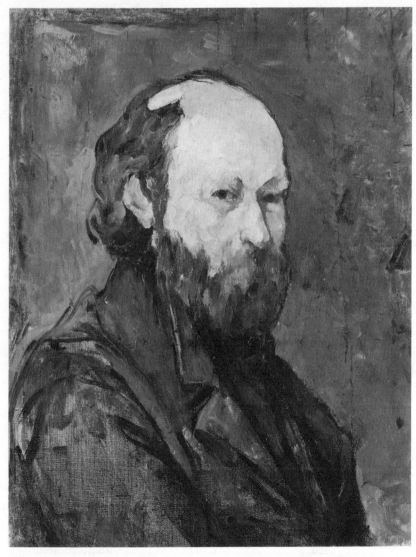

PLATE 56. Paul Cézanne (1839–1906), "Self-Portrait" (c. 1877), Duncan Phillips Memorial Gallery, Washington, D.C.

Modern art has been affected to its depths by the example of this lonely man. It has drawn from his example, it has always seemed to me, the least part of him. It has borrowed his technique. It has omitted his solemn grandeur. Technically, Cézanne constructs space out of color alone (Plate 57). Of line in the sense of line of contour—the line which by delimiting specific shape suggests a third dimension, as Ingres' line suggests it—there is none. The line about a piece of fruit begins, lapses, and begins again. Its discontinuousness forbids it to be interpreted as a demarcating edge. It is a shadow then? It does not behave as a shadow behaves. Its function is structural. It corresponds to nothing in the thing, but to a constructive demand in the painting. Its function is to cause the color adjacent to it and interior to its curve to assume its place as a plane in space. Cancel the contrast which those lines supply, those globules of fruit become simply accidents of light, the transient vicissitude which Monet recorded. Color may appear in painting either as the accident which impinges on a stable form or as the vehicle through which form is stably conveyed. Cézanne's color is the latter. That is why those lines which as a record of seen light are arbitrary are as a declaration of seen planes essential. Color is never for Cézanne a representation of light. It is invariably a means for representing space, each touch establishing a plane frontalized at its relative place in depth. That depth being fixed, the plane is tipped by shape. All that Cubism ever does is implicit in that technique (Plate 58).

The twentieth century, which has rightly seen in Cézanne's art a pure construction in space, has concluded that his secondary image is after all a superfluity, that it can be suppressed without loss, simply eliminated from the artistic enterprise, so that only the mode of encounter is preserved.

Of Cézanne's art that is not true. Cézanne's neutrality before his subject does not imply that his subject is nothing to him. In a world in which all things were perfectly indifferent neutrality would be no problem. It would be the most effortless of all achievements, exacting no labor, exciting no admiration. But in such a world neutrality would be never visible, never expressed. For neutrality can be experienced as a value only where you care, where something is at stake, where distinctions which on other occasions concern you are held deliberately in suspense. It is so with Cézanne. Cézanne's subject is not itself neutral: it is *he* who has neutralized it. Madame

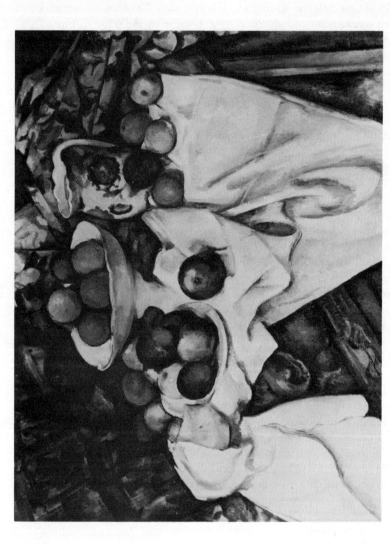

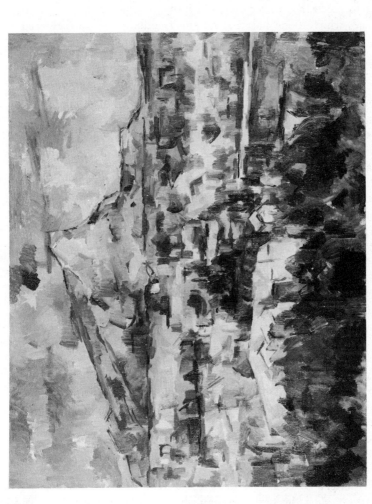

PLATE 58. Paul Cézanne (1839–1906), "Mont Sainte-Victoire" (c. 1905), George W. Elkins Collection, Philadelphia Museum of Art.

Cézanne, portrayed by a Renoir or a Van Gogh, would not be seen as Cézanne sees her. Not all art is thus dispassionate, stoically superior to the variations of things encountered, as his was, and one who has not seen this singularity of Cézanne has not seen him. Yet to see this is to see the contributory value of the secondary image, which alone has enabled this singularity to be registered.

48. The New Daedalus

All art, said Walter Pater, tends to the condition of music. The observation is very justly made. But it is a misunderstanding of music to suppose that its absoluteness depends on the absence of a secondary image. Its absoluteness depends on the presence of a primary image. The *Saint Matthew Passion* is not, I suspect, less absolute for being the Passion according to Saint Matthew. There are some things which even music cannot do in the absence of a secondary image, and to assimilate all art to the condition of music is to leave perfectly untouched the question, whether the secondary image is proper to art.

The secondary image is not, and can never be, the object of art. Like all of the means which the artist employs it vindicates its presence not by what it is but by what it does. Where it does nothing, artistically it is nothing. But where the affirmation of a primary image requires its use, no argument shall ever invalidate its use. In this connection the art of Cézanne is the crucial experiment. The contemporary world has still to learn from him that it is not necessary in art to destroy old temples in order to raise new ones.

Yet cannot there be an art such as Pater divined, a music of vision as pure as the music of hearing, an art of the pure human encounter, which exhibits a mode of encounter uncomplicated by secondary images?

There can without question be such an art, an art which with perfect generality exhibits the human encounter with space as music with perfect generality exhibits the human encounter with time (Plate 59). The idea of such a spatial art is as old as architecture. In our century, in painting and sculpture, we meditate the tentative first essays of a new art, a manifest construction of which no primitive artist ever dreamed—neither fetish nor ritual instrument, neither mere ornament nor mere decoration, but a pure and

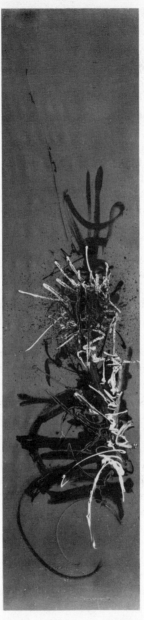

PLATE 59. *Georges Mathieu (1921–), "Montjoie Saint Denis!" (1954), Oil on canvas, 12′ 3⅝″ × 35½″. Collection, The Museum of Modern Art, New York. Gift of Mr. and Mrs. Harold Kaye. (Note: The title is a medieval French battle cry.)*

independent art consecrated to the task of conveying man's sense of participation in his world. Almost all that is theoretically original in the art of our contemporaries is an attempt to realize the implications of that concept.

Let it be said: nothing in theory can ever disallow the possibility of a pure music of vision. But this also needs saying, that it remains for artists to demonstrate the importance of that possibility. The importance of that possibility is not at all a matter for theory to settle. It is a matter which only experience can settle, and if experience will not settle it, nothing can settle it.

But I would remind those who aspire to settle it that it is not enough to produce bare forms. Neither is it enough to accede to the sleep of sociology, that art, if it have nothing else to recommend it, is after all, inevitably and always, a symptom of the times. The times have symptoms enough without the additions of art's essays. If symptom were wanted, if mere phenomenon were wanted, the rubble of war would answer the twentieth century's need. What the times require is not a symptom, but a symbol, of the human encounter.

In art, as in every other sphere of human endeavor, the exercise of freedom is a human problem—loyal where it enlarges human capacity, treasonable where it contracts it. Therefore art's freedom remains on all occasions its peril as well as its challenge. The new possibility remains still largely unexplored, still almost totally unrealized. It is still imperfectly assessed, or even assessable. If a judgment were drawn now, on the basis of what has been in fact accomplished, the judgment would have to be, that the limits of the new painting and sculpture are indescribably narrower than the limits of music, that in effect the possibility of a pure music of vision, though real, is, except in architecture, paltry. But that is to have made the mistake of supposing that the evidence is all presently at hand. It is not. It is still aborning, and the artist who acts for its sake acts in the faith that, by his effort or the effort of another, it can be brought to hand. Such is the risk of Icarus at all times, the valiant surmise that the wings on which his flight is borne shall not, in the heat of the sun, become his cerements.

Index

(Page entries in *italics* refer to pages on which Plates appear.)

Abramovitz, Max, *85*
Absinthe Drinkers (Degas), 197–199, *198*
Abstraction, 195–196, 230–231
Additive effects of light, 172–174
Adoration of the Magi (Leonardo), 214
Aesthetic detachment, 7–8
Affinity of forms, 74–78
Affinity of hues, 159–161
Alba Madonna (Raphael), 21
Albers, Josef, 206
Altamira, 13, 20n
Ambiguity, 93–95, *98, et passim*
Amiens Cathedral, 106, 111–119, *112, 114, 116*
Angelico, Fra, 78
Antibes, 13
Apollo and Daphne (Bernini), 121–125, *122*
Archipenko, Alexander, *94*
Areas, positive and negative, 30–33, *34,* 36–39, *98, et passim*
Aristotle, *124,* 195
Art, form-producing, 6
Art, liberal, 4
Art, technical conditions of, 4, 7
Art and self-knowledge, 7–9
Art and society, 2–4
Articulate wholeness, 107–111
Asymmetry, 42–50 *et passim*
Athena Promachos (Pheidias), 125
At the Moulin Rouge (Toulouse-Lautrec), 165–167, *166*
Axis, 28 *et seq., et passim*
Axis, cognate, 23–24
Axis, diagonal, 29, 42–47
Axis, horizontal, 29, 39–40
Axis, perpendicular, 29
Axis, vertical, 28–30, 35–38, 39
Axis, visual, 15–16
Axis of dynamic stress, 47

Axis of static stress, 47

Bach, Johann Sebastian, 195
Bacon, Francis, 7
Barlach, Ernst, *43*
Baroque, 5, 65, 214, *et passim*
Beethoven, Ludwig van, 105, 130
Beggar (Barlach), *43*
Bernini, Giovanni Lorenzo, 121–125, *122*
Bilateral symmetry, 40
Bird in Space (Brancusi), *124*
Birkhoff, George D., 78
Blue Period (Picasso), 154
Bosch, Hieronymus, *225*
Brahms, Johannes, 105
Brancusi, Constantin, *124,* 230
Brittany, 228
Broken color, 173–176
Buonarroti, Michelangelo: *see* Michelangelo Buonarroti
Buveurs d'Absinthe (Degas), 197–199, *198*

Caravaggio, Michelangelo da, 154, 214
Caudwell, Christopher, 196n
Cézanne, Hortense: *see Madame Cézanne*
Cézanne, Paul, 147–149, *148,* 161, 180, 192, 231, 232–238, *234, 236, 237*
Chardin, Jean Baptiste Siméon, 210
Chartres Cathedral, 170–171
Chevreul, Michel Eugène, 183n
Chiaroscuro, 210, 213–214, *et passim*
Christ Giving the Keys to Peter (Perugino), 30, *31*
Circus, The (Seurat), 87, *89*
Clarinet Quintet (Mozart), 105
Classicism, 5, 42, 137, *164,* 165, 197, *et passim*
Coleridge, Samuel Taylor, 4

Collage, 231–232

Color, 151 *et passim; see also* Equilibrium, Hue, Saturation, Simultaneous Contrast, Value

Color, physical basis of, 139–143, 159–161

Color, selective reflection of, 145–146, 149–150

Color circle, 162–163

Color harmony, 164–165 *et passim*

Color in equilibrium, 187–192, *Plates D, E*

Color spectrum, 143–144, 160n

Complementaries, 168–170

Complementarity, 5, 30–32, 33, *98*, 191

Composition in White, Black and Red (Mondrian), 55–57, *56*

Constable, John, 82

Constancy, perspicuous, 18, 24; *see also* Field

Contextual variations of color: *see* Simultaneous contrast

Continuous forms, 84–87

Contrast, qualitative, 79

Contrast, quantitative, 79

Contrast, simultaneous, 179–186 *et seq.*, *Plates A, B, C, et passim*

Contrast, transforming, 12–13, 146–150

Contrast of light and dark, 153–154

Corot, Jean Baptiste Camille, 206n

Cry, The (Munch), *157*

Cubism, 93, 231

Cyclical rhythm, 100–106

Dance, The (Matisse), *34*

Da Vinci, Leonardo: *see* Leonardo da Vinci

Debussy, Claude, 165

Degas, Edgar Hilaire, 197–199, *198*

Diagonal axis, 29, 42–47

Dimanche à la Grande-Jatte, Un (Seurat), 97, 135–137, *138*

Directional motives, 50–54, 60–63, 119–128

Dryden, John, 84

Dufy, Raoul, 230

Dürer, Albrecht, *201*, 204

El Greco, 87, *88*, *89*, 95, *99*, 154, 225

Emergent qualities, 95–100

Equilibrium, 5, 22, 26–28 *et seq.*, *et passim*

Equilibrium, apparent, 24–25

Equilibrium, asymmetrical, 44–45, 48–50

Equilibrium, color in, 187–192, *Plates D, E*

Equilibrium, dynamic, 42–47

Equilibrium, normative, 27–28

Equilibrium, static, 35, 40–42

Equilibrium, visual, 22–25, 40

Erasmus of Rotterdam (Dürer), *201*, 204

Erechtheion, 125

Eroica Symphony (Beethoven), 105

Evans, Ralph, 161, 192n

Execution of the 3rd of May, 1808 (Goya), 187, *188*, 190

Expression, 9, 221, 232n

Expressionism, *225*, 232n

Fall of Man (Masaccio), 213n

Field, 9 *et passim*

Field, active or at rest, 46–47

Field, constancies of the, 13, 24, 146–150

Field, pictorial, 10–25 *et passim*

Field, shape of the, 17–32

Field, stresses of the, 14, 18, 32–33, 47

Field for transformation, 12

Film art, 46n

Forms, positive and negative: *see* Areas

Forms, production of, 6

Frequency, 90

Fusion, 93, 97–100

Gare St. Lazare, 176

Gauguin, Paul, 228, *229*

Genre, 212–213

Giotto di Bondone, 93, *96*, 187

Golden Section, *56*

Gothic, 111–119 *et passim*

Goya (y Lucientes), Francisco José de, 153, 154, *156*, 187, *188*, 190, 225

Gray, Thomas, 141

Grünewald, Mathias, 225

Guernica (Picasso), 57

Hals, Frans, 184

Harmony of color, 164–165 *et passim*

Harrison, Abramovitz, and Associates, 85

Harrison, Wallace K., *85*

Hendrickje Stoffels (Rembrandt), *215*, 216, 222

Horizontal axis, 29, 39–40

Howe, George, *118*

Hue, 152–153, 159–165, 183–186, *et passim; see also* Color

Iktinos, *73*
Impressionists, 153, 154n, 173–177, *et passim*
Infant Jupiter Nursed by Amalthea, The (Poussin), 130–135, *134*
Ingres, Jean Auguste Dominique, 154, 235
Intensity, 90; *see also* Saturation
Intrinsic rhythm, 100–106
Inversion, 93
Ivins, W. M., Jr., 180n

James, William, 182
Jan Six (Rembrandt), 222

Kallikrates, *73*
Kandinsky, Wassily, 196
Kaufmann House (Wright), *132–133*
Keats, John, 82
Kokoschka, Oskar, *225*
Kollwitz, Käthe, 36, *37, 203*

Lamentation (Giotto), *96*
Lamentation (Titian), 214n
Lapith and Centaur (metopes), 102–104, *103*
Lascaux, 20n
Last Supper (Leonardo), 63–67, *64*, 84–87
Last Supper (Tintoretto), 84–87, *86*
Latent order, 196–197
Leonardo da Vinci, 60, 63–67, *64*, 84–87, 154, *155*, 213–214, 223
Lescaze, William, *118*
Light, 142, 153–154, 169–174, 192–194, *et passim; see also* Scale
Little Dutch, 212
Longinus, 9
Lower Manhattan (Marin), *62*

Madame Cézanne (Cézanne), 233, 235–238
Madonna and St. Anne (Leonardo), 84, *155*
Ma Jolie (Picasso), 90–93, *92*
Manet, Édouard, 16, 153
Manifest construction, 231
Manifest order, 196–197
Mannerism, 165
Marin, John, *62*, 230

Marquesas Islands, 228
Martel, C., 183n
Masaccio, 213
Mathieu, Georges *239*
Matisse, Henri, *34*, 153, 230
Medici, Giuliano de' (Michelangelo), 195
Michelangelo Buonarroti, 58–60, *59*, 78, 83, 144, 195
Milton, John, 5, 195
Modigliani, Amedeo, *225*
Modulation of color scale, 167–168
Mona Lisa (Leonardo), 84
Mondrian, Piet, 16, 21–22, 55–57, *56*, 195–196
Monet, Claude, 150–151, 153, 168, 173–177, *175*, 208, 235
Montjoie Saint Denis! (Mathieu), *239*
Mont Sainte-Victoire (Cézanne, 1885–1887), 147, *148*
Mont Sainte-Victoire (Cézanne, c. 1905), 237
Monumentality, *131*, 213
Moore, Henry, *131, 225*
Mother with Dead Child (Kollwitz), 36, *37*
Motive, visual, 78–79
Mozart, Wolfgang Amadeus, 105
Munch, Edvard, 154, *157*
Music, felt affinity in, 159
Music, interval in, 72–74
Music, modulation in, 167
Mystical Crucifixion (Perugino), 49–50, *51*

Negative areas, 30–33, *34*, 36–39, *et passim*
Nervi, Pier Luigi, *75*
Newton, Sir Isaac, 162

Objective wholeness, 108–111
Old Guitarist, The (Picasso), *158*
Order, manifest and latent, 196–197

Panathenaic Procession: see Processional Frieze of the Parthenon
Parthenon (Iktinos and Kallikrates), *73*, 102, 106–107, 109, 125
Parthenon, metopes (*Lapith and Centaur*), 102–104, *103*
Parthenon, Processional Frieze of the (Pheidias), 104, 121, 125–128, *126–127*
Passacaglia and Fugue in C Minor (Bach), 105

Pater, Walter, 238
Pattern, 69–74 *et passim*
Peasant Girl Holding a Cock (Piazzetta), 195
Percussive forms, 83–87
Perpendicular axis, 29
Perugino, 30, *31*, 42, 49, *51*, 197
Phaedrus (Plato), 71n
Pheidias, 125, *126–127*, 128
Philadelphia Savings Fund Society Building (Howe), 118
Piazzetta, Giovanni Battista, 195
Picasso, Pablo, 90–93, *92*, 154, *158*, 202, 204
Pictorial field, *10–25 et passim*
Pietà: see Lamentation
Pigment: *see* Color, Hue
Pipes of Pan, The (Picasso), *202*
Pissarro, Camille, 173, 176
Plato, 57, 169n
Poetry, rhythm in, 80–82, 100–102
Pollock, Jackson, 232n
Pontormo, Jacopo da, 165
Pope, Arthur, 153n, 193n, 206n
Positive areas, 30–33, *34*, 36–39, *et passim*
Poussin, Nicolas, 42, 130–135, *134*, 154, 197
Presentation of the Virgin (Titian), 17, 23n
Primary image, 221–224 *et seq.*
Primitivism, 227–230
Processional Frieze of the Parthenon (Pheidias), 104, 121, 125–128, *126–127*
Progression, 117–128
Propylaea, 125

Qualitative contrast, 79
Quantitative contrast, 79

Raising of Lazarus (Rembrandt), 100, *101*
Rape of the Daughters of Leucippus (Rubens), *91*, 111
Raphael, 17, 18, 21, 23n, *41*, 42, 197
Rattner, Abraham, 150–151, 169n
Reclining Figure (Moore, 1935), *131*
Reclining Figure (Moore, 1938), 225
Regression, 120–128
Regularity, 17–20, 70
Rembrandt van Rijn, 3, 100, *101*, 154, 204, 208, 212–218, *215*, *217*

Renoir, Pierre Auguste, 165–167, 176, 219
Repetition, 71
Representation, 194–199, 207–211, 222–223
Resurrection (El Greco), *88*
Rhythm, 80–82, 100–106, *et passim*
Rococo, 5 *et passim*
Romanticism, 5 *et passim*
Ross, Denman W., 206n
Rouault, Georges, *225*
Rubens, Peter Paul, 90, *91*, 111

Saint Matthew Passion (Bach), 238
Saint Patrick's Cathedral (Renwick, New York), 115
Saturation, 142n, 152–154, 185, 191–192, *Plate B*
Saturn Devouring His Children (Goya), *156*
Scale, 71–74 *et passim*
Scale, color, 161–165
Scale, light, 181–185, 192–194, 199–211
School of Athens (Raphael), 17, 23n, *41*, 42
Secondary image, 222–224 *et seq.*
Self-Portrait (Cézanne), 233, *234*
Self-Portrait (Rembrandt), 216–218, *217*, 222
Seurat, Georges, 11, 87, *89*, 97, 135–137, *138*, 176
Shape of the field, 17–32
Shinagawa, Takumi, *98*
Signac, Paul, 180
Simplicity, 17–19
Simultaneous contrast, 179–186 *et seq.*, *Plates A, B, C, et passim*
Socrates, 1, 2, 71, 204
Space for manipulation, 11–12
Spectator, implication of the, 7–8, 15–16, 108, 180
Spectrum, 143–144, 160n
Spinoza, Baruch, 233
Stability, visual, 17–35 *et passim; see also* Equilibrium
Stadium (Nervi), 75
Stained glass, 150n, 171
Starry Night (Van Gogh), 224, *226*
Static equilibrium, 35, 40–42
Still-Life (Cézanne), 233, *236*
Stravinsky, Igor, 105
Stress, 14, 18, 32–33, 47
Stress, dynamic and static, 47
Subtractive effects of pigments, 169–172

Sufficiency, 106–111, 123–125
Sullivan, Louis, 67
Sunday Afternoon on the Grande-Jatte (Seurat), 97, 135–137, *138*
Symmetry, 40–42, 55n, 77n, *et passim*
Symphony No. 7 (Beethoven), 105

Temptation and the Fall of Man, The (Michelangelo), 58–60, *59*
Theme and variation, *56*, 57, *89*, 129–137, *131*, *133*, *et passim*
Thrust, 58–67
Tintoretto, 65, 66, 84–87, *86*
Titian, 17, 18, 23n, 214
Tonalists, 154
Tonality, 153–154
Toulouse-Lautrec, Henri de, 135, *136*, 165–167, *166*
Transforming contrast, 12–13, 146–150

Uccello, Paolo, 137
United Nations Secretariat Building (Harrison, Abramovitz, and Associates), 84, *85*, 106

Value, 152, 153–154, 181–185, 192–194, 199–211, *et passim*
Van Gogh, Vincent, 153, 224–227, *225*, *226*
Variations on a Theme by Haydn (Brahms), 105

Velásquez, Diego, 206, *209*, 210, 233
Vermeer, Jan, 206, 208, 210, *211*
Vertical axis, 28–30, 35–38, 39
View of Toledo (El Greco), 95, *99*
Virgin of the Rocks (Leonardo), 84

Waterloo Bridge, 176
Waterloo Bridge, Gray Day (Monet), *175*
Weavers, The (Velásquez), *209*
Whistler, James Abbott McNeill, 204n
Whitehead, Alfred North, 140n
Whitman, Walt, 106
Wholeness, 5, 30–32, 106–111, 191
Widow, The, II (Kollwitz), *203*
Woman Combing Her Hair (Archipenko), *94*
Woman Fixing Her Stocking (Toulouse-Lautrec), *136*
Woodcut, 200–204
Woolworth Building (Gilbert, New York), 117
Wright, Frank Lloyd, *132–133*

Yellow and Purple (Shinagawa), *98*
Yellow Calvary, The (Gauguin), *229*
Young Woman with a Water Jug (Vermeer), *211*

Zola, Émile, 207

A CATALOGUE OF SELECTED DOVER BOOKS
IN ALL FIELDS OF INTEREST

A CATALOGUE OF SELECTED DOVER BOOKS
IN ALL FIELDS OF INTEREST

AMERICA'S OLD MASTERS, James T. Flexner. Four men emerged unexpectedly from provincial 18th century America to leadership in European art: Benjamin West, J. S. Copley, C. R. Peale, Gilbert Stuart. Brilliant coverage of lives and contributions. Revised, 1967 edition. 69 plates. 365pp. of text.
21806-6 Paperbound $3.00

FIRST FLOWERS OF OUR WILDERNESS: AMERICAN PAINTING, THE COLONIAL PERIOD, James T. Flexner. Painters, and regional painting traditions from earliest Colonial times up to the emergence of Copley, West and Peale Sr., Foster, Gustavus Hesselius, Feke, John Smibert and many anonymous painters in the primitive manner. Engaging presentation, with 162 illustrations. xxii + 368pp.
22180-6 Paperbound $3.50

THE LIGHT OF DISTANT SKIES: AMERICAN PAINTING, 1760-1835, James T. Flexner. The great generation of early American painters goes to Europe to learn and to teach: West, Copley, Gilbert Stuart and others. Allston, Trumbull, Morse; also contemporary American painters—primitives, derivatives, academics—who remained in America. 102 illustrations. xiii + 306pp.
22179-2 Paperbound $3.50

A HISTORY OF THE RISE AND PROGRESS OF THE ARTS OF DESIGN IN THE UNITED STATES, William Dunlap. Much the richest mine of information on early American painters, sculptors, architects, engravers, miniaturists, etc. The only source of information for scores of artists, the major primary source for many others. Unabridged reprint of rare original 1834 edition, with new introduction by James T. Flexner, and 394 new illustrations. Edited by Rita Weiss. 6⅝ x 9⅝.
21695-0, 21696-9, 21697-7 Three volumes, Paperbound $15.00

EPOCHS OF CHINESE AND JAPANESE ART, Ernest F. Fenollosa. From primitive Chinese art to the 20th century, thorough history, explanation of every important art period and form, including Japanese woodcuts; main stress on China and Japan, but Tibet, Korea also included. Still unexcelled for its detailed, rich coverage of cultural background, aesthetic elements, diffusion studies, particularly of the historical period. 2nd, 1913 edition. 242 illustrations. lii + 439pp. of text.
20364-6, 20365-4 Two volumes, Paperbound $6.00

THE GENTLE ART OF MAKING ENEMIES, James A. M. Whistler. Greatest wit of his day deflates Oscar Wilde, Ruskin, Swinburne; strikes back at inane critics, exhibitions, art journalism; aesthetics of impressionist revolution in most striking form. Highly readable classic by great painter. Reproduction of edition designed by Whistler. Introduction by Alfred Werner. xxxvi + 334pp.
21875-9 Paperbound $3.00

VISUAL ILLUSIONS: THEIR CAUSES, CHARACTERISTICS, AND APPLICATIONS, Matthew Luckiesh. Thorough description and discussion of optical illusion, geometric and perspective, particularly; size and shape distortions, illusions of color, of motion; natural illusions; use of illusion in art and magic, industry, etc. Most useful today with op art, also for classical art. Scores of effects illustrated. Introduction by William H. Ittleson. 100 illustrations. xxi + 252pp.

21530-X Paperbound $2.00

A HANDBOOK OF ANATOMY FOR ART STUDENTS, Arthur Thomson. Thorough, virtually exhaustive coverage of skeletal structure, musculature, etc. Full text, supplemented by anatomical diagrams and drawings and by photographs of undraped figures. Unique in its comparison of male and female forms, pointing out differences of contour, texture, form. 211 figures, 40 drawings, 86 photographs. xx + 459pp. 5⅜ x 8⅜. 21163-0 Paperbound $3.50

150 MASTERPIECES OF DRAWING, Selected by Anthony Toney. Full page reproductions of drawings from the early 16th to the end of the 18th century, all beautifully reproduced: Rembrandt, Michelangelo, Dürer, Fragonard, Urs, Graf, Wouwerman, many others. First-rate browsing book, model book for artists. xviii + 150pp. 8⅜ x 11¼. 21032-4 Paperbound· $3.50

THE LATER WORK OF AUBREY BEARDSLEY, Aubrey Beardsley. Exotic, erotic, ironic masterpieces in full maturity: Comedy Ballet, Venus and Tannhauser, Pierrot, Lysistrata, Rape of the Lock, Savoy material, Ali Baba, Volpone, etc. This material revolutionized the art world, and is still powerful, fresh, brilliant. With *The Early Work*, all Beardsley's finest work. 174 plates, 2 in color. xiv + 176pp. 8⅛ x 11. 21817-1 Paperbound $3.75

DRAWINGS OF REMBRANDT, Rembrandt van Rijn. Complete reproduction of fabulously rare edition by Lippmann and Hofstede de Groot, completely reedited, updated, improved by Prof. Seymour Slive, Fogg Museum. Portraits, Biblical sketches, landscapes, Oriental types, nudes, episodes from classical mythology—All Rembrandt's fertile genius. Also selection of drawings by his pupils and followers. "Stunning volumes," *Saturday Review*. 550 illustrations. lxxviii + 552pp. 9⅛ x 12¼. 21485-0, 21486-9 Two volumes, Paperbound $10.00

THE DISASTERS OF WAR, Francisco Goya. One of the masterpieces of Western civilization—83 etchings that record Goya's shattering, bitter reaction to the Napoleonic war that swept through Spain after the insurrection of 1808 and to war in general. Reprint of the first edition, with three additional plates from Boston's Museum of Fine Arts. All plates facsimile size. Introduction by Philip Hofer, Fogg Museum. v + 97pp. 9⅜ x 8¼. 21872-4 Paperbound $2.50

GRAPHIC WORKS OF ODILON REDON. Largest collection of Redon's graphic works ever assembled: 172 lithographs, 28 etchings and engravings, 9 drawings. These include some of his most famous works. All the plates from *Odilon Redon: oeuvre graphique complet,* plus additional plates. New introduction and caption translations by Alfred Werner. 209 illustrations. xxvii + 209pp. 9⅛ x 12¼.

21966-8 Paperbound $5.00

DESIGN BY ACCIDENT; A BOOK OF "ACCIDENTAL EFFECTS" FOR ARTISTS AND DESIGNERS, James F. O'Brien. Create your own unique, striking, imaginative effects by "controlled accident" interaction of materials: paints and lacquers, oil and water based paints, splatter, crackling materials, shatter, similar items. Everything you do will be different; first book on this limitless art, so useful to both fine artist and commercial artist. Full instructions. 192 plates showing "accidents," 8 in color. viii + 215pp. 8⅜ x 11¼. 21942-9 Paperbound $3.75

THE BOOK OF SIGNS, Rudolf Koch. Famed German type designer draws 493 beautiful symbols: religious, mystical, alchemical, imperial, property marks, runes, etc. Remarkable fusion of traditional and modern. Good for suggestions of timelessness, smartness, modernity. Text. vi + 104pp. 6⅛ x 9¼. 20162-7 Paperbound $1.25

HISTORY OF INDIAN AND INDONESIAN ART, Ananda K. Coomaraswamy. An unabridged republication of one of the finest books by a great scholar in Eastern art. Rich in descriptive material, history, social backgrounds; Sunga reliefs, Rajput paintings, Gupta temples, Burmese frescoes, textiles, jewelry, sculpture, etc. 400 photos. viii + 423pp. 6⅜ x 9¾. 21436-2 Paperbound $5.00

PRIMITIVE ART, Franz Boas. America's foremost anthropologist surveys textiles, ceramics, woodcarving, basketry, metalwork, etc.; patterns, technology, creation of symbols, style origins. All areas of world, but very full on Northwest Coast Indians. More than 350 illustrations of baskets, boxes, totem poles, weapons, etc. 378 pp. 20025-6 Paperbound $3.00

THE GENTLEMAN AND CABINET MAKER'S DIRECTOR, Thomas Chippendale. Full reprint (third edition, 1762) of most influential furniture book of all time, by master cabinetmaker. 200 plates, illustrating chairs, sofas, mirrors, tables, cabinets, plus 24 photographs of surviving pieces. Biographical introduction by N. Bienenstock. vi + 249pp. 9⅞ x 12¾. 21601-2 Paperbound $4.00

AMERICAN ANTIQUE FURNITURE, Edgar G. Miller, Jr. The basic coverage of all American furniture before 1840. Individual chapters cover type of furniture— clocks, tables, sideboards, etc.—chronologically, with inexhaustible wealth of data. More than 2100 photographs, all identified, commented on. Essential to all early American collectors. Introduction by H. E. Keyes. vi + 1106pp. 7⅞ x 10¾. 21599-7, 21600-4 Two volumes, Paperbound $11.00

PENNSYLVANIA DUTCH AMERICAN FOLK ART, Henry J. Kauffman. 279 photos, 28 drawings of tulipware, Fraktur script, painted tinware, toys, flowered furniture, quilts, samplers, hex signs, house interiors, etc. Full descriptive text. Excellent for tourist, rewarding for designer, collector. Map. 146pp. 7⅞ x 10¾. 21205-X Paperbound $2.50

EARLY NEW ENGLAND GRAVESTONE RUBBINGS, Edmund V. Gillon, Jr. 43 photographs, 226 carefully reproduced rubbings show heavily symbolic, sometimes macabre early gravestones, up to early 19th century. Remarkable early American primitive art, occasionally strikingly beautiful; always powerful. Text. xxvi + 207pp. 8⅜ x 11¼. 21380-3 Paperbound $3.50

ALPHABETS AND ORNAMENTS, Ernst Lehner. Well-known pictorial source for decorative alphabets, script examples, cartouches, frames, decorative title pages, calligraphic initials, borders, similar material. 14th to 19th century, mostly European. Useful in almost any graphic arts designing, varied styles. 750 illustrations. 256pp. 7 x 10. 21905-4 Paperbound $4.00

PAINTING: A CREATIVE APPROACH, Norman Colquhoun. For the beginner simple guide provides an instructive approach to painting: major stumbling blocks for beginner; overcoming them, technical points; paints and pigments; oil painting; watercolor and other media and color. New section on "plastic" paints. Glossary. Formerly *Paint Your Own Pictures*. 221pp. 22000-1 Paperbound $1.75

THE ENJOYMENT AND USE OF COLOR, Walter Sargent. Explanation of the relations between colors themselves and between colors in nature and art, including hundreds of little-known facts about color values, intensities, effects of high and low illumination, complementary colors. Many practical hints for painters, references to great masters. 7 color plates, 29 illustrations. x + 274pp.
20944-X Paperbound $2.75

THE NOTEBOOKS OF LEONARDO DA VINCI, compiled and edited by Jean Paul Richter. 1566 extracts from original manuscripts reveal the full range of Leonardo's versatile genius: all his writings on painting, sculpture, architecture, anatomy, astronomy, geography, topography, physiology, mining, music, etc., in both Italian and English, with 186 plates of manuscript pages and more than 500 additional drawings. Includes studies for the Last Supper, the lost Sforza monument, and other works. Total of xlvii + 866pp. 7⅞ x 10¾.
22572-0, 22573-9 Two volumes, Paperbound $11.00

MONTGOMERY WARD CATALOGUE OF 1895. Tea gowns, yards of flannel and pillow-case lace, stereoscopes, books of gospel hymns, the New Improved Singer Sewing Machine, side saddles, milk skimmers, straight-edged razors, high-button shoes, spittoons, and on and on . . . listing some 25,000 items, practically all illustrated. Essential to the shoppers of the 1890's, it is our truest record of the spirit of the period. Unaltered reprint of Issue No. 57, Spring and Summer 1895. Introduction by Boris Emmet. Innumerable illustrations. xiii + 624pp. 8½ x 11⅝.
22377-9 Paperbound $6.95

THE CRYSTAL PALACE EXHIBITION ILLUSTRATED CATALOGUE (LONDON, 1851). One of the wonders of the modern world—the Crystal Palace Exhibition in which all the nations of the civilized world exhibited their achievements in the arts and sciences—presented in an equally important illustrated catalogue. More than 1700 items pictured with accompanying text—ceramics, textiles, cast-iron work, carpets, pianos, sleds, razors, wall-papers, billiard tables, beehives, silverware and hundreds of other artifacts—represent the focal point of Victorian culture in the Western World. Probably the largest collection of Victorian decorative art ever assembled—indispensable for antiquarians and designers. Unabridged republication of the Art-Journal Catalogue of the Great Exhibition of 1851, with all terminal essays. New introduction by John Gloag, F.S.A. xxxiv + 426pp. 9 x 12.
22503-8 Paperbound $5.00

A HISTORY OF COSTUME, Carl Köhler. Definitive history, based on surviving pieces of clothing primarily, and paintings, statues, etc. secondarily. Highly readable text, supplemented by 594 illustrations of costumes of the ancient Mediterranean peoples, Greece and Rome, the Teutonic prehistoric period; costumes of the Middle Ages, Renaissance, Baroque, 18th and 19th centuries. Clear, measured patterns are provided for many clothing articles. Approach is practical throughout. Enlarged by Emma von Sichart. 464pp. 21030-8 Paperbound $3.50

ORIENTAL RUGS, ANTIQUE AND MODERN, Walter A. Hawley. A complete and authoritative treatise on the Oriental rug—where they are made, by whom and how, designs and symbols, characteristics in detail of the six major groups, how to distinguish them and how to buy them. Detailed technical data is provided on periods, weaves, warps, wefts, textures, sides, ends and knots, although no technical background is required for an understanding. 11 color plates, 80 halftones, 4 maps. vi + 320pp. 6⅛ x 9⅛. 22366-3 Paperbound $5.00

TEN BOOKS ON ARCHITECTURE, Vitruvius. By any standards the most important book on architecture ever written. Early Roman discussion of aesthetics of building, construction methods, orders, sites, and every other aspect of architecture has inspired, instructed architecture for about 2,000 years. Stands behind Palladio, Michelangelo, Bramante, Wren, countless others. Definitive Morris H. Morgan translation. 68 illustrations. xii + 331pp. 20645-9 Paperbound $3.00

THE FOUR BOOKS OF ARCHITECTURE, Andrea Palladio. Translated into every major Western European language in the two centuries following its publication in 1570, this has been one of the most influential books in the history of architecture. Complete reprint of the 1738 Isaac Ware edition. New introduction by Adolf Placzek, Columbia Univ. 216 plates. xxii + 110pp. of text. 9½ x 12¾. 21308-0 Clothbound $12.50

STICKS AND STONES: A STUDY OF AMERICAN ARCHITECTURE AND CIVILIZATION, Lewis Mumford.One of the great classics of American cultural history. American architecture from the medieval-inspired earliest forms to the early 20th century; evolution of structure and style, and reciprocal influences on environment. 21 photographic illustrations. 238pp. 20202-X Paperbound $2.00

THE AMERICAN BUILDER'S COMPANION, Asher Benjamin. The most widely used early 19th century architectural style and source book, for colonial up into Greek Revival periods. Extensive development of geometry of carpentering, construction of sashes, frames, doors, stairs; plans and elevations of domestic and other buildings. Hundreds of thousands of houses were built according to this book, now invaluable to historians, architects, restorers, etc. 1827 edition. 59 plates. 114pp. 7⅞ x 10¾. 22236-5 Paperbound $3.50

DUTCH HOUSES IN THE HUDSON VALLEY BEFORE 1776, Helen Wilkinson Reynolds. The standard survey of the Dutch colonial house and outbuildings, with constructional features, decoration, and local history associated with individual homesteads. Introduction by Franklin D. Roosevelt. Map. 150 illustrations. 469pp. 6⅝ x 9¼. 21469-9 Paperbound $5.00

THE ARCHITECTURE OF COUNTRY HOUSES, Andrew J. Downing. Together with Vaux's *Villas and Cottages* this is the basic book for Hudson River Gothic architecture of the middle Victorian period. Full, sound discussions of general aspects of housing, architecture, style, decoration, furnishing, together with scores of detailed house plans, illustrations of specific buildings, accompanied by full text. Perhaps the most influential single American architectural book. 1850 edition. Introduction by J. Stewart Johnson. 321 figures, 34 architectural designs. xvi + 560pp.
22003-6 Paperbound $4.00

LOST EXAMPLES OF COLONIAL ARCHITECTURE, John Mead Howells. Full-page photographs of buildings that have disappeared or been so altered as to be denatured, including many designed by major early American architects. 245 plates. xvii + 248pp. 7⅞ x 10¾. 21143-6 Paperbound $3.50

DOMESTIC ARCHITECTURE OF THE AMERICAN COLONIES AND OF THE EARLY REPUBLIC, Fiske Kimball. Foremost architect and restorer of Williamsburg and Monticello covers nearly 200 homes between 1620-1825. Architectural details, construction, style features, special fixtures, floor plans, etc. Generally considered finest work in its area. 219 illustrations of houses, doorways, windows, capital mantels. xx + 314pp. 7⅞ x 10¾. 21743-4 Paperbound $4.00

EARLY AMERICAN ROOMS: 1650-1858, edited by Russell Hawes Kettell. Tour of 12 rooms, each representative of a different era in American history and each furnished, decorated, designed and occupied in the style of the era. 72 plans and elevations, 8-page color section, etc., show fabrics, wall papers, arrangements, etc. Full descriptive text. xvii + 200pp. of text. 8⅜ x 11¼.
21633-0 Paperbound $5.00

THE FITZWILLIAM VIRGINAL BOOK, edited by J. Fuller Maitland and W. B. Squire. Full modern printing of famous early 17th-century ms. volume of 300 works by Morley, Byrd, Bull, Gibbons, etc. For piano or other modern keyboard instrument; easy to read format. xxxvi + 938pp. 8⅜ x 11.
21068-5, 21069-3 Two volumes, Paperbound $10.00

KEYBOARD MUSIC, Johann Sebastian Bach. Bach Gesellschaft edition. A rich selection of Bach's masterpieces for the harpsichord: the six English Suites, six French Suites, the six Partitas (Clavierübung part I), the Goldberg Variations (Clavierübung part IV), the fifteen Two-Part Inventions and the fifteen Three-Part Sinfonias. Clearly reproduced on large sheets with ample margins; eminently playable. vi + 312pp. 8⅛ x 11. 22360-4 Paperbound $5.00

THE MUSIC OF BACH: AN INTRODUCTION, Charles Sanford Terry. A fine, nontechnical introduction to Bach's music, both instrumental and vocal. Covers organ music, chamber music, passion music, other types. Analyzes themes, developments, innovations. x + 114pp. 21075-8 Paperbound $1.50

BEETHOVEN AND HIS NINE SYMPHONIES, Sir George Grove. Noted British musicologist provides best history, analysis, commentary on symphonies. Very thorough, rigorously accurate; necessary to both advanced student and amateur music lover. 436 musical passages. vii + 407 pp. 20334-4 Paperbound $2.75

JOHANN SEBASTIAN BACH, Philipp Spitta. One of the great classics of musicology, this definitive analysis of Bach's music (and life) has never been surpassed. Lucid, nontechnical analyses of hundreds of pieces (30 pages devoted to St. Matthew Passion, 26 to B Minor Mass). Also includes major analysis of 18th-century music. 450 musical examples. 40-page musical supplement. Total of xx + 1799pp.
(EUK) 22278-0, 22279-9 Two volumes, Clothbound $17.50

MOZART AND HIS PIANO CONCERTOS, Cuthbert Girdlestone. The only full-length study of an important area of Mozart's creativity. Provides detailed analyses of all 23 concertos, traces inspirational sources. 417 musical examples. Second edition. 509pp. 21271-8 Paperbound $3.50

THE PERFECT WAGNERITE: A COMMENTARY ON THE NIBLUNG'S RING, George Bernard Shaw. Brilliant and still relevant criticism in remarkable essays on Wagner's Ring cycle, Shaw's ideas on political and social ideology behind the plots, role of Leitmotifs, vocal requisites, etc. Prefaces. xxi + 136pp.
(USO) 21707-8 Paperbound $1.75

DON GIOVANNI, W. A. Mozart. Complete libretto, modern English translation; biographies of composer and librettist; accounts of early performances and critical reaction. Lavishly illustrated. All the material you need to understand and appreciate this great work. Dover Opera Guide and Libretto Series; translated and introduced by Ellen Bleiler. 92 illustrations. 209pp.
21134-7 Paperbound $2.00

BASIC ELECTRICITY, U. S. Bureau of Naval Personel. Originally a training course, best non-technical coverage of basic theory of electricity and its applications. Fundamental concepts, batteries, circuits, conductors and wiring techniques, AC and DC, inductance and capacitance, generators, motors, transformers, magnetic amplifiers, synchros, servomechanisms, etc. Also covers blue-prints, electrical diagrams, etc. Many questions, with answers. 349 illustrations. x + 448pp. 6½ x 9¼.
20973-3 Paperbound $3.50

REPRODUCTION OF SOUND, Edgar Villchur. Thorough coverage for laymen of high fidelity systems, reproducing systems in general, needles, amplifiers, preamps, loudspeakers, feedback, explaining physical background. "A rare talent for making technicalities vividly comprehensible," R. Darrell, *High Fidelity*. 69 figures. iv + 92pp. 21515-6 Paperbound $1.35

HEAR ME TALKIN' TO YA: THE STORY OF JAZZ AS TOLD BY THE MEN WHO MADE IT, Nat Shapiro and Nat Hentoff. Louis Armstrong, Fats Waller, Jo Jones, Clarence Williams, Billy Holiday, Duke Ellington, Jelly Roll Morton and dozens of other jazz greats tell how it was in Chicago's South Side, New Orleans, depression Harlem and the modern West Coast as jazz was born and grew. xvi + 429pp.
21726-4 Paperbound $3.00

FABLES OF AESOP, translated by Sir Roger L'Estrange. A reproduction of the very rare 1931 Paris edition; a selection of the most interesting fables, together with 50 imaginative drawings by Alexander Calder. v + 128pp. 6½x9¼.
21780-9 Paperbound $1.50

AGAINST THE GRAIN (A REBOURS), Joris K. Huysmans. Filled with weird images, evidences of a bizarre imagination, exotic experiments with hallucinatory drugs, rich tastes and smells and the diversions of its sybarite hero Duc Jean des Esseintes, this classic novel pushed 19th-century literary decadence to its limits. Full unabridged edition. Do not confuse this with abridged editions generally sold. Introduction by Havelock Ellis. xlix + 206pp. 22190-3 Paperbound $2.50

VARIORUM SHAKESPEARE: HAMLET. Edited by Horace H. Furness; a landmark of American scholarship. Exhaustive footnotes and appendices treat all doubtful words and phrases, as well as suggested critical emendations throughout the play's history. First volume contains editor's own text, collated with all Quartos and Folios. Second volume contains full first Quarto, translations of Shakespeare's sources (Belleforest, and Saxo Grammaticus), Der Bestrafte Brudermord, and many essays on critical and historical points of interest by major authorities of past and present. Includes details of staging and costuming over the years. By far the best edition available for serious students of Shakespeare. Total of xx + 905pp. 21004-9, 21005-7, 2 volumes, Paperbound $7.00

A LIFE OF WILLIAM SHAKESPEARE, Sir Sidney Lee. This is the standard life of Shakespeare, summarizing everything known about Shakespeare and his plays. Incredibly rich in material, broad in coverage, clear and judicious, it has served thousands as the best introduction to Shakespeare. 1931 edition. 9 plates. xxix + 792pp. 21967-4 Paperbound $4.50

MASTERS OF THE DRAMA, John Gassner. Most comprehensive history of the drama in print, covering every tradition from Greeks to modern Europe and America, including India, Far East, etc. Covers more than 800 dramatists, 2000 plays, with biographical material, plot summaries, theatre history, criticism, etc. "Best of its kind in English," New Republic. 77 illustrations. xxii + 890pp. 20100-7 Clothbound $10.00

THE EVOLUTION OF THE ENGLISH LANGUAGE, George McKnight. The growth of English, from the 14th century to the present. Unusual, non-technical account presents basic information in very interesting form: sound shifts, change in grammar and syntax, vocabulary growth, similar topics. Abundantly illustrated with quotations. Formerly Modern English in the Making. xii + 590pp. 21932-1 Paperbound $4.00

AN ETYMOLOGICAL DICTIONARY OF MODERN ENGLISH, Ernest Weekley. Fullest, richest work of its sort, by foremost British lexicographer. Detailed word histories, including many colloquial and archaic words; extensive quotations. Do not confuse this with the Concise Etymological Dictionary, which is much abridged. Total of xxvii + 830pp. $6\frac{1}{2}$ x $9\frac{1}{4}$. 21873-2, 21874-0 Two volumes, Paperbound $7.90

FLATLAND: A ROMANCE OF MANY DIMENSIONS, E. A. Abbott. Classic of science-fiction explores ramifications of life in a two-dimensional world, and what happens when a three-dimensional being intrudes. Amusing reading, but also useful as introduction to thought about hyperspace. Introduction by Banesh Hoffmann. 16 illustrations. xx + 103pp. 20001-9 Paperbound $1.25

POEMS OF ANNE BRADSTREET, edited with an introduction by Robert Hutchinson. A new selection of poems by America's first poet and perhaps the first significant woman poet in the English language. 48 poems display her development in works of considerable variety—love poems, domestic poems, religious meditations, formal elegies, "quaternions," etc. Notes, bibliography. viii + 222pp.

22160-1 Paperbound $2.50

THREE GOTHIC NOVELS: THE CASTLE OF OTRANTO BY HORACE WALPOLE; VATHEK BY WILLIAM BECKFORD; THE VAMPYRE BY JOHN POLIDORI, WITH FRAGMENT OF A NOVEL BY LORD BYRON, edited by E. F. Bleiler. The first Gothic novel, by Walpole; the finest Oriental tale in English, by Beckford; powerful Romantic supernatural story in versions by Polidori and Byron. All extremely important in history of literature; all still exciting, packed with supernatural thrills, ghosts, haunted castles, magic, etc. xl + 291pp.

21232-7 Paperbound $2.50

THE BEST TALES OF HOFFMANN, E. T. A. Hoffmann. 10 of Hoffmann's most important stories, in modern re-editings of standard translations: Nutcracker and the King of Mice, Signor Formica, Automata, The Sandman, Rath Krespel, The Golden Flowerpot, Master Martin the Cooper, The Mines of Falun, The King's Betrothed, A New Year's Eve Adventure. 7 illustrations by Hoffmann. Edited by E. F. Bleiler. xxxix + 419pp. 21793-0 Paperbound $3.00

GHOST AND HORROR STORIES OF AMBROSE BIERCE, Ambrose Bierce. 23 strikingly modern stories of the horrors latent in the human mind: The Eyes of the Panther, The Damned Thing, An Occurrence at Owl Creek Bridge, An Inhabitant of Carcosa, etc., plus the dream-essay, Visions of the Night. Edited by E. F. Bleiler. xxii + 199pp. 20767-6 Paperbound $1.50

BEST GHOST STORIES OF J. S. LEFANU, J. Sheridan LeFanu. Finest stories by Victorian master often considered greatest supernatural writer of all. Carmilla, Green Tea, The Haunted Baronet, The Familiar, and 12 others. Most never before available in the U. S. A. Edited by E. F. Bleiler. 8 illustrations from Victorian publications. xvii + 467pp. 20415-4 Paperbound $3.00

MATHEMATICAL FOUNDATIONS OF INFORMATION THEORY, A. I. Khinchin. Comprehensive introduction to work of Shannon, McMillan, Feinstein and Khinchin, placing these investigations on a rigorous mathematical basis. Covers entropy concept in probability theory, uniqueness theorem, Shannon's inequality, ergodic sources, the E property, martingale concept, noise, Feinstein's fundamental lemma, Shanon's first and second theorems. Translated by R. A. Silverman and M. D. Friedman. iii + 120pp. 60434-9 Paperbound $2.00

SEVEN SCIENCE FICTION NOVELS, H. G. Wells. The standard collection of the great novels. Complete, unabridged. *First Men in the Moon, Island of Dr. Moreau, War of the Worlds, Food of the Gods, Invisible Man, Time Machine, In the Days of the Comet.* Not only science fiction fans, but every educated person owes it to himself to read these novels. 1015pp. (USO) 20264-X Clothbound $6.00

LAST AND FIRST MEN AND STAR MAKER, TWO SCIENCE FICTION NOVELS, Olaf Stapledon. Greatest future histories in science fiction. In the first, human intelligence is the "hero," through strange paths of evolution, interplanetary invasions, incredible technologies, near extinctions and reemergences. Star Maker describes the quest of a band of star rovers for intelligence itself, through time and space: weird inhuman civilizations, crustacean minds, symbiotic worlds, etc. Complete, unabridged. v + 438pp. (USO) 21962-3 Paperbound $2.50

THREE PROPHETIC NOVELS, H. G. WELLS. Stages of a consistently planned future for mankind. *When the Sleeper Wakes,* and *A Story of the Days to Come,* anticipate *Brave New World* and *1984,* in the 21st Century; *The Time Machine,* only complete version in print, shows farther future and the end of mankind. All show Wells's greatest gifts as storyteller and novelist. Edited by E. F. Bleiler. x + 335pp. (USO) 20605-X Paperbound $2.50

THE DEVIL'S DICTIONARY, Ambrose Bierce. America's own Oscar Wilde—Ambrose Bierce—offers his barbed iconoclastic wisdom in over 1,000 definitions hailed by H. L. Mencken as "some of the most gorgeous witticisms in the English language." 145pp. 20487-1 Paperbound $1.25

MAX AND MORITZ, Wilhelm Busch. Great children's classic, father of comic strip, of two bad boys, Max and Moritz. Also Ker and Plunk (Plisch und Plumm), Cat and Mouse, Deceitful Henry, Ice-Peter, The Boy and the Pipe, and five other pieces. Original German, with English translation. Edited by H. Arthur Klein; translations by various hands and H. Arthur Klein. vi + 216pp. 20181-3 Paperbound $2.00

PIGS IS PIGS AND OTHER FAVORITES, Ellis Parker Butler. The title story is one of the best humor short stories, as Mike Flannery obfuscates biology and English. Also included, That Pup of Murchison's, The Great American Pie Company, and Perkins of Portland. 14 illustrations. v + 109pp. 21532-6 Paperbound $1.25

THE PETERKIN PAPERS, Lucretia P. Hale. It takes genius to be as stupidly mad as the Peterkins, as they decide to become wise, celebrate the "Fourth," keep a cow, and otherwise strain the resources of the Lady from Philadelphia. Basic book of American humor. 153 illustrations. 219pp. 20794-3 Paperbound $2.00

PERRAULT'S FAIRY TALES, translated by A. E. Johnson and S. R. Littlewood, with 34 full-page illustrations by Gustave Doré. All the original Perrault stories—Cinderella, Sleeping Beauty, Bluebeard, Little Red Riding Hood, Puss in Boots, Tom Thumb, etc.—with their witty verse morals and the magnificent illustrations of Doré. One of the five or six great books of European fairy tales. viii + 117pp. 8⅛ x 11. 22311-6 Paperbound $2.00

OLD HUNGARIAN FAIRY TALES, Baroness Orczy. Favorites translated and adapted by author of the *Scarlet Pimpernel.* Eight fairy tales include "The Suitors of Princess Fire-Fly," "The Twin Hunchbacks," "Mr. Cuttlefish's Love Story," and "The Enchanted Cat." This little volume of magic and adventure will captivate children as it has for generations. 90 drawings by Montagu Barstow. 96pp. (USO) 22293-4 Paperbound $1.95

THE RED FAIRY BOOK, Andrew Lang. Lang's color fairy books have long been children's favorites. This volume includes Rapunzel, Jack and the Bean-stalk and 35 other stories, familiar and unfamiliar. 4 plates, 93 illustrations x + 367pp.
21673-X Paperbound $2.50

THE BLUE FAIRY BOOK, Andrew Lang. Lang's tales come from all countries and all times. Here are 37 tales from Grimm, the Arabian Nights, Greek Mythology, and other fascinating sources. 8 plates, 130 illustrations. xi + 390pp.
21437-0 Paperbound $2.75

HOUSEHOLD STORIES BY THE BROTHERS GRIMM. Classic English-language edition of the well-known tales — Rumpelstiltskin, Snow White, Hansel and Gretel, The Twelve Brothers, Faithful John, Rapunzel, Tom Thumb (52 stories in all). Translated into simple, straightforward English by Lucy Crane. Ornamented with head-pieces, vignettes, elaborate decorative initials and a dozen full-page illustrations by Walter Crane. x + 269pp.
21080-4 Paperbound **$2.00**

THE MERRY ADVENTURES OF ROBIN HOOD, Howard Pyle. The finest modern versions of the traditional ballads and tales about the great English outlaw. Howard Pyle's complete prose version, with every word, every illustration of the first edition. Do not confuse this facsimile of the original (1883) with modern editions that change text or illustrations. 23 plates plus many page decorations. xxii + 296pp.
22043-5 Paperbound $2.75

THE STORY OF KING ARTHUR AND HIS KNIGHTS, Howard Pyle. The finest children's version of the life of King Arthur; brilliantly retold by Pyle, with 48 of his most imaginative illustrations. xviii + 313pp. 6⅛ x 9¼.
21445-1 Paperbound $2.50

THE WONDERFUL WIZARD OF OZ, L. Frank Baum. America's finest children's book in facsimile of first edition with all Denslow illustrations in full color. The edition a child should have. Introduction by Martin Gardner. 23 color plates, scores of drawings. iv + 267pp.
20691-2 Paperbound $2.50

THE MARVELOUS LAND OF OZ, L. Frank Baum. The second Oz book, every bit as imaginative as the Wizard. The hero is a boy named Tip, but the Scarecrow and the Tin Woodman are back, as is the Oz magic. 16 color plates, 120 drawings by John R. Neill. 287pp.
20692-0 Paperbound $2.50

THE MAGICAL MONARCH OF MO, L. Frank Baum. Remarkable adventures in a land even stranger than Oz. The best of Baum's books not in the Oz series. 15 color plates and dozens of drawings by Frank Verbeck. xviii + 237pp.
21892-9 Paperbound $2.25

THE BAD CHILD'S BOOK OF BEASTS, MORE BEASTS FOR WORSE CHILDREN, A MORAL ALPHABET, Hilaire Belloc. Three complete humor classics in one volume. Be kind to the frog, and do not call him names . . . and 28 other whimsical animals. Familiar favorites and some not so well known. Illustrated by Basil Blackwell. 156pp.
(USO) 20749-8 Paperbound $1.50

EAST O' THE SUN AND WEST O' THE MOON, George W. Dasent. Considered the best of all translations of these Norwegian folk tales, this collection has been enjoyed by generations of children (and folklorists too). Includes True and Untrue, Why the Sea is Salt, East O' the Sun and West O' the Moon, Why the Bear is Stumpy-Tailed, Boots and the Troll, The Cock and the Hen, Rich Peter the Pedlar, and 52 more. The only edition with all 59 tales. 77 illustrations by Erik Werenskiold and Theodor Kittelsen. xv + 418pp. 22521-6 Paperbound $3.50

GOOPS AND HOW TO BE THEM, Gelett Burgess. Classic of tongue-in-cheek humor, masquerading as etiquette book. 87 verses, twice as many cartoons, show mischievous Goops as they demonstrate to children virtues of table manners, neatness, courtesy, etc. Favorite for generations. viii + 88pp. 6½ x 9¼. 22233-0 Paperbound $1.50

ALICE'S ADVENTURES UNDER GROUND, Lewis Carroll. The first version, quite different from the final Alice in Wonderland, printed out by Carroll himself with his own illustrations. Complete facsimile of the "million dollar" manuscript Carroll gave to Alice Liddell in 1864. Introduction by Martin Gardner. viii + 96pp. Title and dedication pages in color. 21482-6 Paperbound $1.25

THE BROWNIES, THEIR BOOK, Palmer Cox. Small as mice, cunning as foxes, exuberant and full of mischief, the Brownies go to the zoo, toy shop, seashore, circus, etc., in 24 verse adventures and 266 illustrations. Long a favorite, since their first appearance in St. Nicholas Magazine. xi + 144pp. 6⅝ x 9¼. 21265-3 Paperbound $1.75

SONGS OF CHILDHOOD, Walter De La Mare. Published (under the pseudonym Walter Ramal) when De La Mare was only 29, this charming collection has long been a favorite children's book. A facsimile of the first edition in paper, the 47 poems capture the simplicity of the nursery rhyme and the ballad, including such lyrics as I Met Eve, Tartary, The Silver Penny. vii + 106pp. (USO) 21972-0 Paperbound $2.00

THE COMPLETE NONSENSE OF EDWARD LEAR, Edward Lear. The finest 19th-century humorist-cartoonist in full: all nonsense limericks, zany alphabets, Owl and Pussycat, songs, nonsense botany, and more than 500 illustrations by Lear himself. Edited by Holbrook Jackson. xxix + 287pp. (USO) 20167-8 Paperbound $2.00

BILLY WHISKERS: THE AUTOBIOGRAPHY OF A GOAT, Frances Trego Montgomery. A favorite of children since the early 20th century, here are the escapades of that rambunctious, irresistible and mischievous goat—Billy Whiskers. Much in the spirit of Peck's Bad Boy, this is a book that children never tire of reading or hearing. All the original familiar illustrations by W. H. Fry are included: 6 color plates, 18 black and white drawings. 159pp. 22345-0 Paperbound $2.00

MOTHER GOOSE MELODIES. Faithful republication of the fabulously rare Munroe and Francis "copyright 1833" Boston edition—the most important Mother Goose collection, usually referred to as the "original." Familiar rhymes plus many rare ones, with wonderful old woodcut illustrations. Edited by E. F. Bleiler. 128pp. 4½ x 6⅜. 22577-1 Paperbound $1.00

TWO LITTLE SAVAGES; BEING THE ADVENTURES OF TWO BOYS WHO LIVED AS INDIANS AND WHAT THEY LEARNED, Ernest Thompson Seton. Great classic of nature and boyhood provides a vast range of woodlore in most palatable form, a genuinely entertaining story. Two farm boys build a teepee in woods and live in it for a month, working out Indian solutions to living problems, star lore, birds and animals, plants, etc. 293 illustrations. vii + 286pp.

20985-7 Paperbound $2.50

PETER PIPER'S PRACTICAL PRINCIPLES OF PLAIN & PERFECT PRONUNCIATION. Alliterative jingles and tongue-twisters of surprising charm, that made their first appearance in America about 1830. Republished in full with the spirited woodcut illustrations from this earliest American edition. 32pp. $4\frac{1}{2}$ x $6\frac{3}{8}$.

22560-7 Paperbound $1.00

SCIENCE EXPERIMENTS AND AMUSEMENTS FOR CHILDREN, Charles Vivian. 73 easy experiments, requiring only materials found at home or easily available, such as candles, coins, steel wool, etc.; illustrate basic phenomena like vacuum, simple chemical reaction, etc. All safe. Modern, well-planned. Formerly *Science Games for Children*. 102 photos, numerous drawings. 96pp. $6\frac{1}{8}$ x $9\frac{1}{4}$.

21856-2 Paperbound $1.25

AN INTRODUCTION TO CHESS MOVES AND TACTICS SIMPLY EXPLAINED, Leonard Barden. Informal intermediate introduction, quite strong in explaining reasons for moves. Covers basic material, tactics, important openings, traps, positional play in middle game, end game. Attempts to isolate patterns and recurrent configurations. Formerly *Chess*. 58 figures. 102pp. (USO) 21210-6 Paperbound $1.25

LASKER'S MANUAL OF CHESS, Dr. Emanuel Lasker. Lasker was not only one of the five great World Champions, he was also one of the ablest expositors, theorists, and analysts. In many ways, his Manual, permeated with his philosophy of battle, filled with keen insights, is one of the greatest works ever written on chess. Filled with analyzed games by the great players. A single-volume library that will profit almost any chess player, beginner or master. 308 diagrams. xli x 349pp.

20640-8 Paperbound $2.75

THE MASTER BOOK OF MATHEMATICAL RECREATIONS, Fred Schuh. In opinion of many the finest work ever prepared on mathematical puzzles, stunts, recreations; exhaustively thorough explanations of mathematics involved, analysis of effects, citation of puzzles and games. Mathematics involved is elementary. Translated by F. Göbel. 194 figures. xxiv + 430pp. 22134-2 Paperbound $3.50

MATHEMATICS, MAGIC AND MYSTERY, Martin Gardner. Puzzle editor for Scientific American explains mathematics behind various mystifying tricks: card tricks, stage "mind reading," coin and match tricks, counting out games, geometric dissections, etc. Probability sets, theory of numbers clearly explained. Also provides more than 400 tricks, guaranteed to work, that you can do. 135 illustrations. xii + 176pp.

20335-2 Paperbound $1.75

MATHEMATICAL PUZZLES FOR BEGINNERS AND ENTHUSIASTS, Geoffrey Mott-Smith. 189 puzzles from easy to difficult—involving arithmetic, logic, algebra, properties of digits, probability, etc.—for enjoyment and mental stimulus. Explanation of mathematical principles behind the puzzles. 135 illustrations. viii + 248pp.
20198-8 Paperbound $1.75

PAPER FOLDING FOR BEGINNERS, William D. Murray and Francis J. Rigney. Easiest book on the market, clearest instructions on making interesting, beautiful origami. Sail boats, cups, roosters, frogs that move legs, bonbon boxes, standing birds, etc. 40 projects; more than 275 diagrams and photographs. 94pp.
20713-7 Paperbound $1.00

TRICKS AND GAMES ON THE POOL TABLE, Fred Herrmann. 79 tricks and games—some solitaires, some for two or more players, some competitive games—to entertain you between formal games. Mystifying shots and throws, unusual caroms, tricks involving such props as cork, coins, a hat, etc. Formerly *Fun on the Pool Table*. 77 figures. 95pp.
21814-7 Paperbound $1.25

HAND SHADOWS TO BE THROWN UPON THE WALL: A SERIES OF NOVEL AND AMUSING FIGURES FORMED BY THE HAND, Henry Bursill. Delightful picturebook from great-grandfather's day shows how to make 18 different hand shadows: a bird that flies, duck that quacks, dog that wags his tail, camel, goose, deer, boy, turtle, etc. Only book of its sort. vi + 33pp. 6½ x 9¼.　21779-5 Paperbound $1.00

WHITTLING AND WOODCARVING, E. J. Tangerman. 18th printing of best book on market. "If you can cut a potato you can carve" toys and puzzles, chains, chessmen, caricatures, masks, frames, woodcut blocks, surface patterns, much more. Information on tools, woods, techniques. Also goes into serious wood sculpture from Middle Ages to present, East and West. 464 photos, figures. x + 293pp.
20965-2 Paperbound $2.00

HISTORY OF PHILOSOPHY, Julián Marías. Possibly the clearest, most easily followed, best planned, most useful one-volume history of philosophy on the market; neither skimpy nor overfull. Full details on system of every major philosopher and dozens of less important thinkers from pre-Socratics up to Existentialism and later. Strong on many European figures usually omitted. Has gone through dozens of editions in Europe. 1966 edition, translated by Stanley Appelbaum and Clarence Strowbridge. xviii + 505pp.
21739-6 Paperbound $3.50

YOGA: A SCIENTIFIC EVALUATION, Kovoor T. Behanan. Scientific but non-technical study of physiological results of yoga exercises; done under auspices of Yale U. Relations to Indian thought, to psychoanalysis, etc. 16 photos. xxiii + 270pp.
20505-3 Paperbound $2.50

Prices subject to change without notice.
Available at your book dealer or write for free catalogue to Dept. GI, Dover Publications, Inc., 180 Varick St., N. Y., N. Y. 10014. Dover publishes more than 150 books each year on science, elementary and advanced mathematics, biology, music, art, literary history, social sciences and other areas.